文房具にまつわる言葉を
イラストと豆知識でカリカリと読み解く

文房具語辞典

誠文堂新光社

はじめに

　文房具の辞典を書かないかと言われ、直感的に、「これは絶対しんどいやつだ！」と思うと同時に「ああ、私が今やらねばならない仕事だ」と思いました。子供の頃から文房具が好きで、同人誌を作り、ホームページを開設し、気が付けばテレビ番組に出場し、文具王となっていました。そしてメーカーに勤め、実演販売や売場の企画をし、雑誌やテレビ、ラジオなどで文房具について語ってきました。文房具に関わる様々な立場をぐるぐる周りながら、いろんなことを学んできましたが、そういえば、それらを網羅してまとめたことがなかったなと。

　鉛筆、消しゴム、ボールペン……、誰でも知ってる文房具をあえて辞典として説明しなくても、鉛筆は鉛筆であって、普段はそれ以上説明しなくても充分伝わります。それをあえて、「黒鉛を主な原料とする棒状の筆記材を木製の軸に固定して……」というふうに説明していく。あたりまえの物事を短い文章できちんと定義する作業は、案外難しい。

　しかし、そうやってみんなが知ってる身近な文房具の定義を小難しく書いたところで、読んでみれば、そりゃそういうものだろう、ということになりがちです。ですから、できるだけ定義だけでなく、いつ、誰がといった、始まりや転機にまつわる重要なエピソードや、科学や工学からみた解説、業界内の豆知識などをぎゅうぎゅうに詰め込んでみました。

　この本の一つ一つの言葉の説明は短い文章ですが、実は簡単な説明から私なりの研究成果までを多層的に盛り込んでいますので、普段特に文房具にこだわりのない普通の人から、既に詳しいマニアな人、仕事で文房具に関わる人まで、全ての人に話すつもりで書いています。

　特に文房具にこだわりのない方は、普段使っている普通の文房具にまつわる言葉や文房具そのものに興味を持つ入り口として、小林さんのイラストを眺めながら、パラパラとめくって気になった単語やその意味を読んでみてください。文具店にいくのが楽しくなること請け合いです。

文房具を楽しんでいるファンの人は、それぞれの言葉の意味や歴史に触れることで、好きな文房具をより深く楽しんでください。それぞれの単語の解説は短いので、簡単に読めると思いますし、なるべく「へえ～」と思うようなエピソードを入れたつもりです。

　既に文房具についてかなり詳しいマニアな人は、知ってることが多いとは思いますが、できれば一つ一つを丁寧に読んでみてください。きっと、「あれ？　そうだっけ？」と思う部分が隠れていると思います。それぞれの項目を書くために調べた結果、ネットや雑誌によく書かれていることとは若干違った記述になっているところも多々あります。私としてはこれまでの定説にとらわれず、できるだけ正確な情報を探して書こうと、様々な資料にあたった結果です。この本は私の文房具研究の現時点でのまとめです。もしかしたら皆さんと見解が異なる所があるかもしれません、それを指摘するつもりで読んでいただければと思います（間違ってたら教えてください）。

　そして、文具に関わる仕事をする人やこれから始める人は、「ファイルとバインダーって何が違うの？」みたいな、なんとなく曖昧なまま使っている文房具用語をきちんと使い分けるための文房具の用語集として、手元に置いて時々開いていただければと思います。

　もちろん本書は辞典ですから、どこから、どんな読み方で読んでいただいても構いません。文房具に詳しい人もそうでない人も、広く深い文房具の世界を楽しむきっかけになればと思います。まずは難しいことは置いといて、適当に開いてみてください。

文具王
高畑正幸

この本の楽しみ方

① 見出し語

文房具にまつわる言葉の中から、知識を深め、勉強やデスクワークにも役立つ語を幅広く選びました。【 】内はひらがな、もしくはカタカナで読み方を表記しています。

①

ユニ
【ユニ】

②

①三菱鉛筆が1958年に発売した高級鉛筆。「unique（唯一の）」にちなんで名付けられた。1966年には、さらに上位の「ハイユニ」が登場。HB、Fを含む10B〜10Hの計22硬度を揃える。②三菱鉛筆が販売する商品全体のブランド名。特に海外では本来の社名以上にこのブランド名が企業名として広く認知されている。

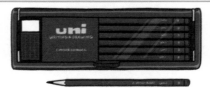

② 見出し語の 意味や解説

複数の意味を持つ語については、①、②……としてそれぞれの意味を記載しました。

※本書のデータは、2019年12月時点の情報を元に作成しています。その後に変更が行われたり、取り扱いの終了した商品・サービスがある場合もございますので、ご了承ください。

消しゴム
【けしゴム】

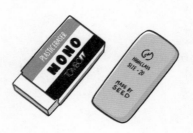

主に鉛筆やシャープペンシルで筆記した描線に擦りつけ、黒鉛を吸着して消去するために使う天然ゴムまたは軟質プラスチックを原料とする塊（→p87「字消し」参照）。最古の記録は1770年にイギリスのジョゼフ・プリーストリー（→p87）が、文具商エドワード・ネアンから購入したゴムが鉛筆で書いた文字を消し去ることについて記述しており、その消字（rub out）能力から、ラバー（rubber）と名付けたといわれている。現在主流のプラスチック消しゴムは、1952年に日本の堀口乾蔵が塩化ビニルによる字消しの製造法を特許出願しており、1956年には日本国内の複数のメーカーから発売されている。

③ **関連語句の掲載ページ**

別のページでとり上げている用語について、関連が深いものは記載されているページのリンクを表示しました。知識をより深める際に役立ちます。

④

墨
【すみ】

主に植物性の油を燃焼して得た煤と膠（→p128）を練り合わせて乾燥させた固形の顔料で、硯（→p91）で磨って水に溶かし、毛筆で筆記する。文房四宝（→p155）の１つ。菜種油などの植物油を原料とする「油煙墨」（ゆえんぼく）と松脂を多く含む松の木片を燃焼した煤から成る「松煙墨」（しょうえんぼく）に大別される。簡易に使用するため水に溶かした液状で販売される墨汁（液体墨）もある。印刷用語では黒色を意味する。

④ **ふりがな**

読みやすさを考慮し、本文に登場する難読語についてはふりがなを併記しています。

『文房具語辞典』
目次

綴じ込み付録
文房具年表

文房具の
基礎知識

［ アメリカ ］

クロス
アメリカ ロードアイランド州 リンカーン

クレヨラ
アメリカ ペンシルバニア州 イーストン

スリーエム
アメリカ ミネソタ州 セントポール

サンフォード
アメリカ イリノイ州
オークブルック

フィッシャー スペースペン
アメリカ ネバダ州 ボルダーシティ

シェーファー
アメリカ アイオワ州 フォート・マディソン

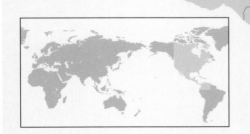

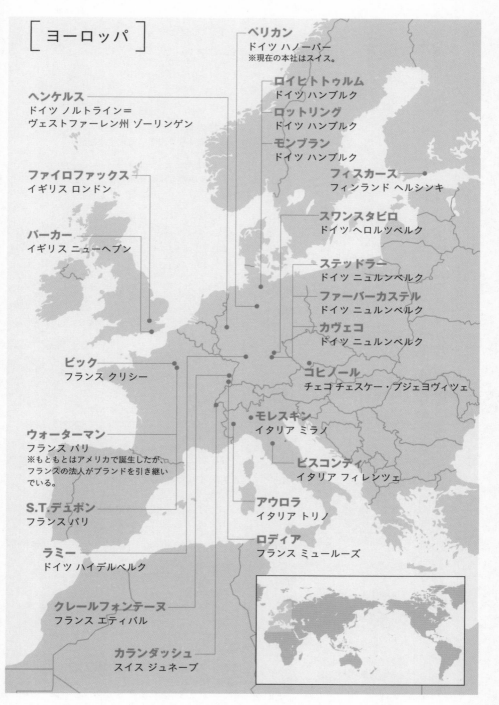

[ヨーロッパ]

ペリカン
ドイツ ハノーバー
※現在の本社はスイス。

ロイヒトトゥルム
ドイツ ハンブルク

ロットリング
ドイツ ハンブルク

モンブラン
ドイツ ハンブルク

ヘンケルス
ドイツ ノルトライン＝
ヴェストファーレン州 ゾーリンゲン

ファイロファックス
イギリス ロンドン

フィスカース
フィンランド ヘルシンキ

スワンスタビロ
ドイツ ヘロルツベルク

パーカー
イギリス ニューヘブン

ステッドラー
ドイツ ニュルンベルク

ファーバーカステル
ドイツ ニュルンベルク

カヴェコ
ドイツ ニュルンベルク

ビック
フランス クリシー

コヒノール
チェコ チェスケー・ブジェヨヴィツェ

モレスキン
イタリア ミラノ

ウォーターマン
フランス パリ
※もともとはアメリカで誕生したが、
フランスの法人がブランドを引き継い
でいる。

ビスコンティ
イタリア フィレンツェ

S.T.デュポン
フランス パリ

アウロラ
イタリア トリノ

ラミー
ドイツ ハイデルベルク

ロディア
フランス ミュールーズ

クレールフォンテーヌ
フランス エティバル

カランダッシュ
スイス ジュネーブ

株式会社呉竹
奈良県奈良市南京終町 7 丁目576

株式会社あかしや
奈良県奈良市南新町78番地 1

カモ井加工紙株式会社
岡山県倉敷市片島町236番地

株式会社レイメイ藤井
福岡県福岡市博多区古門戸町 5 丁目15番

ナカバヤシ株式会社
大阪本社：大阪府大阪市中央区北浜東1-20

寺西化学工業株式会社
大阪府大阪市旭区生江 2 丁目13番11号

コニシ株式会社
大阪府大阪市中央区
道修町 1 丁目 7 番 1 号

株式会社シード
大阪府大阪市都島区内代町 3 丁目 5 番25号

株式会社ミツヤ
大阪府東大阪市加納 7 丁目18番47号

株式会社リヒトラブ
大阪府大阪市中央区農人橋
1 丁目 1 番22号

クツワ株式会社
大阪府東大阪市長田中 3 丁目 6 番40号

コクヨ株式会社
大阪府大阪市東成区大今里南 6 丁目 1 番 1 号

株式会社共和
大阪府大阪市西成区橘
3 丁目20番28号

株式会社ソニック
大阪府大阪市生野区新今里 1 丁目11番 3 号

不易糊工業株式会社
大阪府八尾市竹渕東 2 丁目62番

株式会社サクラクレパス
大阪府大阪市中央区
森ノ宮中央 1 丁目 6 番20号

株式会社中島重久堂
大阪府松原市三宅中 7 丁目 3 番28号

※2019年12月時点での各社の公式サイトの情報をもとに作成しています。

・ショウワノート株式会社
富山県高岡市佐野850

・シヤチハタ株式会社
愛知県名古屋市西区天塚町4丁目69番

株式会社キングジム
東京都千代田区東神田2丁目10番18号

ツバメノート株式会社
東京都台東区浅草橋5丁目4番1号

サンスター文具株式会社
東京都台東区浅草橋5丁目20番8号
CSタワー9階

ヤマト株式会社
東京都中央区日本橋大伝馬町9丁目10番

株式会社トンボ鉛筆
東京都北区豊島6丁目10番12号

ゼブラ株式会社
東京都新宿区東五軒町2丁目9番

ナカバヤシ株式会社
東京本社：東京都板橋区東坂下2丁目5番1号

ニチバン株式会社
東京都文京区関口2丁目3番3号

マルマン株式会社
東京都中野区中央2丁目36番12号

株式会社ライオン事務器
東京都中野区東中野2丁目6番11号

ぺんてる株式会社
東京都中央区日本橋小網町7丁目2番

プラス株式会社
東京都港区虎ノ門4丁目1番28号
虎ノ門タワーズオフィス12階

株式会社デザインフィル
東京都渋谷区恵比寿1丁目19番19号
恵比寿ビジネスタワー9階

セメダイン株式会社
東京都品川区大崎1丁目11番2号
ゲートシティ大崎イーストタワー

プラチナ万年筆株式会社
東京都台東区東上野2丁目5番10号

オート株式会社
東京都台東区蔵前4丁目5番9号

北星鉛筆株式会社
東京都葛飾区四つ木
1丁目23番11号

カール事務器株式会社
東京都葛飾区立石
3丁目7番9号

ヒノデワシ株式会社
東京都墨田区東向島
1丁目7番8号

・セーラー万年筆株式会社
東京都墨田区江東橋
4丁目26番5号
東京トラフィック錦糸町ビル5階

ライフ株式会社
東京都千代田区東神田1丁目5番6号

マックス株式会社
東京都中央区日本橋箱崎町6丁目6番

株式会社パイロットコーポレーション
東京都中央区京橋2丁目6番21号

三菱鉛筆株式会社
東京都品川区東大井5丁目23番37号

文房具の 基礎知識 ③

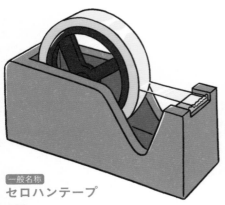

一般名称
セロハンテープ

商標
セロテープ

権利者　ニチバン株式会社

一般名称
油性マーカー

商標
マジックインキ

権利者　株式会社内田洋行

一般名称
接着剤

商標
ボンド

権利者　コニシ株式会社

一般名称
オイルパステル

商標
クレパス

権利者　株式会社サクラクレパス

一般名称
接着剤

商標
セメダイン

権利者　セメダイン株式会社

一般名称
付箋紙

商標
ポスト・イット

権利者　スリーエムカンパニー

文具にまつわる 有名な商標と一般名称

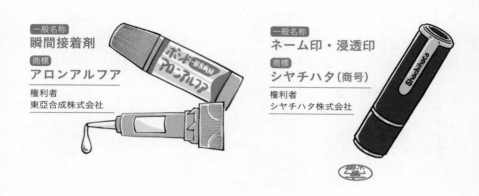

一般名称
瞬間接着剤
商標
アロンアルフア
権利者
東亞合成株式会社

一般名称
ネーム印・浸透印
商標
シヤチハタ（商号）
権利者
シヤチハタ株式会社

［ 色彩のみからなる商標 ］
※下に掲載している各配色はイメージです。

MONO
（株式会社トンボ鉛筆）

ユニ／ハイユニ
（三菱鉛筆株式会社）

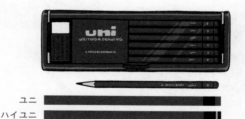

ユニ
ハイユニ

［ 立体商標 ］

ボンド　木工用
（コニシ株式会社）

ジャポニカ学習帳
（ショウワノート株式会社）

ハイマッキー
（ゼブラ株式会社）

文房具の基礎知識 ④

パイロット
PILOT

1918年
株式会社並木製作所

1938年
パイロット萬年筆株式会社

1989年
株式会社パイロット

2003年
株式会社パイロット コーポレーション

プラチナ万年筆
PLATINUM

1919年
中田俊一が万年筆事業に着手

1924年
中屋製作所

1942年
プラチナ萬年筆株式会社

1947年
プラチナ産業株式会社

1962年
プラチナ萬年筆株式会社

セーラー万年筆
SAILOR

1911年
国産万年筆（14金ペン）の製造をはじめる

1932年
株式会社セーラー万年筆 阪田製作所

1960年
セーラー万年筆株式会社

三菱鉛筆
MITSUBISHI

1887年
眞崎鉛筆製造所

1918年
大和鉛筆株式会社

1925年
眞崎大和鉛筆株式会社

1952年
三菱鉛筆株式会社

ゼブラ
ZEBRA

1897年
石川ペン先製作所

1963年
ゼブラ株式会社

トンボ鉛筆
TOMBOW

1913年
小川春之助商店

1939年
トンボ鉛筆商事株式会社（営業） 株式会社トンボ鉛筆製作所（製造）

1964年
株式会社トンボ鉛筆

サクラクレパス
SAKURA

1921年
日本クレイヨン商会 桜クレイヨン商会

1934年
クレパス 本舗株式会社桜商会

1945年
株式会社サクラクレパス

ぺんてる
Pentel

1946年
大日本文具株式会社

1971年
ぺんてる株式会社

コクヨ
KOKUYO

1905年
黒田表紙店

1914年
黒田国光堂

1961年
コクヨ株式会社

2004年
コクヨS&T

2015年
コクヨ株式会社

社名の変遷

プラス
PLUS

1948年 千代田文具株式会社
1959年 プラス株式会社
2001年 プラスステーショナリー分社
2010年 プラス株式会社に合併

デザインフィル
ミドリ、MIDORI

1950年 株式会社みどり商会
1963年 株式会社ミドリ
2007年 株式会社デザインフィル

マックス
MAX

1942年 山田航空工業株式会社
1945年 山田興業株式会社
1955年 マックス工業株式会社
1964年 マックス株式会社

シヤチハタ
Shachihata

1925年 舟橋商会
1941年 シヤチハタ工業株式会社
1999年 シヤチハタ株式会社

ニチバン
NICHIBAN

1918年 歌橋製薬所
1934年 株式会社歌橋製薬所
1944年 日絆工業株式会社
1948年 日絆薬品工業株式会社
1961年 ニチバン株式会社

ヤマト
YAMATO

1899年 ヤマト糊本舗
1948年 ヤマト糊工業株式会社
1970年 ヤマト株式会社

ライフ
LIFE

1946年 齋藤商店
1963年 ライフ株式会社

シード
SEED

1915年 株式会社 三木康作ゴム製造所
1950年 シードゴム工業株式会社
2002年 株式会社シード

丸善雄松堂
MARUZEN

1869年 丸屋商社
1880年 責任有限丸善商社
1893年 丸善株式会社
2016年 丸善雄松堂株式会社

※2019年8月時点の情報による

［万年筆の構造と各部の名称］

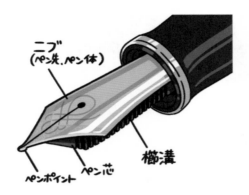

- ニブ
 (ペン先,ペン体)
- ペンポイント
- ペン芯
- 櫛溝

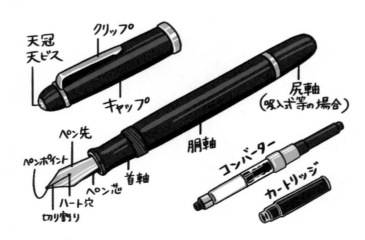

- 天冠
 天ビス
- クリップ
- キャップ
- 尻軸
 (吸入式等の場合)
- ペン先
- ペンポイント
- ハート穴
- 切り割り
- ペン芯
- 首軸
- 胴軸
- コンバーター
- カートリッジ

万年筆の仕組み

[万年筆のインク吸入方式]

回転吸入式

中にあるピストンをネジで引き上げる方式。容量が大きく使い勝手がよい。高級万年筆に多い最も一般的な方式の一つ。

カートリッジ式

専用の使い捨てインクカートリッジでインクを供給する方式。インクの予備を携帯しやすく、手を汚さず交換できるので便利だが、インクの選択肢が限られる。

コンバーター式
（共用式）

インクカートリッジと互換のコンバーター（ピストン付き小型インクタンク）を装着して、吸入式と同様の使い方ができる方式。カートリッジと共用できるので「共用式」とも。

アイドロッパー式

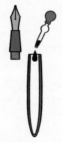

胴軸内に直接インクを流し込む方式。シンプルで容量が大きいメリットはあるが、インク充填にスポイトなどの器具が必要。携帯時のインク漏れを防ぐために栓をつけたものが「インキ止め式」。

レバー式

内蔵のゴム製インクタンクをレバーで押しつぶしてから解放することでインクを吸入する。ボタン型やノック型など、ゴムチューブの押し方にさまざまな種類がある。

プランジャー式

ピストンを押し下げる際にピストンより尻軸側が負圧になり、ピストンが首軸付近まで押された所で弁が解放され、インクが一気に吸入される。

ボールペンのインクの種類

ボールペンのインクは、溶媒によって大きく3種類に分けられます。

	［油性］	［ゲル］	［水性］
	油	水＋増粘剤	水
溶媒	油	水 ＋ 増粘剤	水
	ボールに付着したインクが、ボールの回転で引き出されて紙に押し当てられて転写される。	タンク内では固体のインクがボールの回転の摩擦で液状化し流出。紙上で再度固化する。	ボールが紙に触れることで毛細管現象で紙にインクが流出。
メリット	筆圧に強く、基本耐水。小型化しやすく、インクの減りが遅いので、マルチペンなどを作りやすい。	タンク内でインクが流動しないので顔料系（多色・不透明・特殊）インクに適している。極細化しやすい。速乾性を持たせやすい。	ボールを回転させる筆圧がほとんど不要。書き出しから濃い筆跡が得られる。
デメリット	インクの粘性が高く、書き心地が重い、鮮やかな色が作りにくい。	インクの減りがはやい。	滲みやすく極細化が難しい。インクの減りが早い。染料系は水に弱い。

その他のインク

［低粘度油性］
油性でありながら低粘度。書き心地が滑らか。

［エマルジョン］
油の中にとても小さな水滴を分散させた溶媒を使ったインク。中間的な書き心地。

ペン先の種類

［ペン先の太さの表記］

UEF	Ultra Extra Fine	ウルトラ エクストラ ファイン	超極細
EF	Extra Fine	エクストラ ファイン	極細
F	Fine	ファイン	細字
MF	Medium Fine	ミディアム ファイン	中細
SU	Stub	スタブ	縦太横細（縦線は太字、横線は中細字）
M	Medium	ミディアム	中字
B	Broad	ブロード	太字
BB	Broad Broad	ブロード ブロード	極太
C	Coarse	コース	極太（パイロットコーポレーションとプラチナ万年筆の呼称）
Z	Zoom	ズーム	極太（セーラー万年筆の呼称）
MS	Music	ミュージック	音楽（縦線が太く、横線が細い）

※　頭にS（Soft）がつくと「軟調」になります。
※　他にもさまざまな特殊ペン先があります。

［いろいろなペン先］

ボールペン

コーンチップ、
バレット（砲弾型）チップ　　ニードルチップ　　パイプチップ　　シナジーチップ

マーキングペン

バレット（砲弾型）
チップ　　チーゼル（鑿型）
チップ　　ブラッシュ（筆）
チップ　　プラチップ、
プラペンチップ　　ミリペン、（ライン）
ドローイングペン

どんな手帳が良いかは、書きたい内容や生活・仕事のリズムによっても変わります。あなたにピッタリの手帳を見つけてください!

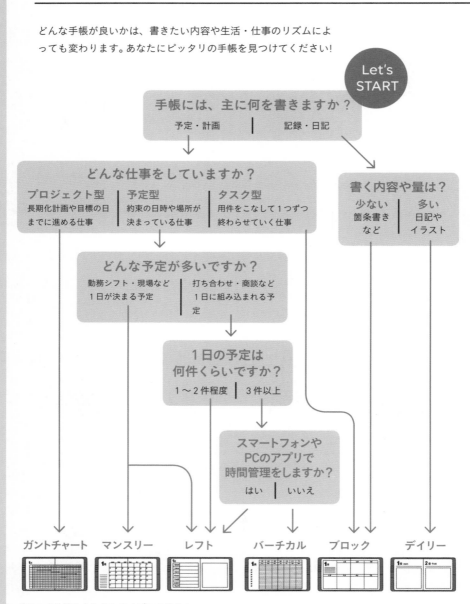

Let's
START

手帳には、主に何を書きますか?
予定・計画 | 記録・日記

どんな仕事をしていますか?

プロジェクト型
長期化計画や目標の日までに進める仕事

予定型
約束の日時や場所が決まっている仕事

タスク型
用件をこなして1つずつ終わらせていく仕事

書く内容や量は?
少ない箇条書きなど | 多い日記やイラスト

どんな予定が多いですか?
勤務シフト・現場など1日が決まる予定 | 打ち合わせ・商談など1日に組み込まれる予定

1日の予定は何件くらいですか?
1〜2件程度 | 3件以上

スマートフォンやPCのアプリで時間管理をしますか?
はい | いいえ

ガントチャート　マンスリー　レフト　バーチカル　ブロック　デイリー

＊これらを組み合わせたタイプもあります。

手帳の選び方と種類

[手帳の種類]

1カ月の予定を パッと一覧

マンスリー・ブロック

1カ月の予定を一覧しやすく、週・曜日のイメージもしやすいのでもっともポピュラーなフォーマット。各種ウィークリーと併用されることも多く、大まかな予定の把握には最適。月曜はじまりの方が一般的だが、カレンダーと同じ日曜はじまりのものもあるので、注意が必要。

長期の プロジェクト管理などに

マンスリー・ガントチャート

横軸に日付をとり1か月を流れとして捉えるフォーマット。1つの項目が複数の日にまたがったり、ある項目が終了しないと次の項目に取りかかれないような連続的な予定の進捗を管理するのに向いている。またグラフ用紙的にも使えるので、日々の変化を記録するにも便利。

1週間管理の 無難な定番

ウイークリー・レフト
（ホリゾンタル）

左ページに1週間を縦に配置。右ページはメモなどフリーに使えるタイプ。会社勤めなどある程度規則正しいリズムをベースに会議や商談などの用件がときどき入るような人に。箇条書きでは書ききれない用件を右ページにメモできるので、見開きで週の概要が把握できる。

1日1日のやることを 管理

ウイークリー・ブロック

1週間を縦横に分割することで、1日の枠が細長くなりすぎず、箇条書きにもメモにも使える。予定を「時間」で管理するのではなく、ToDoなどの「項目」で管理したり、簡単な日記やメモなどを書き留めておくのにちょうどいい。土日が合わせて1枠になっているものもあるので注意。

1日の時間を 視覚的に把握

ウイークリー・バーチカル

1日の時間軸を縦にとり、開始時間だけでなく、予定時間の長さを面積として把握しやすいフォーマット。1日に何件もの予定をこなしたり、日によって仕事の予定が不規則に変動する人に、また、時間効率アップやすき間時間の活用など、時間を効率的に使いたい人に向いている。

予定管理よりも 日々の記録に

デイリー

分厚く重くなりがちなのが弱点だが、記入スペースがゆったりとれるので、予定よりもむしろ日々の記録として使うのに向いている。趣味や生活の日記的に楽しんでいる人が多いが、業務や商談のノートとして確かな日付と共に記録されていることには大きな意味がある。

粘着テープの種類

[粘着テープの種類]

一般名称	セロハンテープ	PPテープ	メンディングテープ	マスキングテープ
基材	セロハン	ポリプロピレン	アセテート	和紙
基材原料	植物	石油	植物＋石油	植物
粘着剤	ゴム系	アクリル系	アクリル系	アクリル系
粘着力	◎	◎	○	○（剥離可）
色	黄透明	透明	透明	不透明
表面	ツヤあり	ツヤあり	ツヤなし	ツヤなし
強度	△	○	×	△
ちぎる	×	×	×	○
耐候性	×	◎	○	○
それぞれの説明	植物系。裂けやすい。黄ばんだり長期保管には不向き。	石油系。強く透明度が高く耐候性にも優れる。切りにくい。	ツヤのない透明で紙に貼るとほとんど見えなくなる。裂けやすい。	本来は塗装などの養生用。密着性が高くきれいに剥がせる。

一般名称	クラフトテープ	布テープ	養生テープ
基材	紙	化学繊維	化学繊維
基材原料	植物	石油	石油
粘着剤	ゴム系	ゴム系	ゴム系
粘着力	◎	◎	○（剥離可）
色	茶	不透明	半透明
表面	半光沢	ツヤあり	ツヤあり
強度	△	○	○
手でちぎる	○	○	○
屋外での使用	×	△	△
それぞれの説明	安価で段ボールの梱包には適しているが重ね貼りや文字書きには不向き。	粘着力が強く、重ね貼りも可。手でまっすぐにちぎれる。	糊残りせず剥がせる。手でまっすぐにちぎれる。

他にも特殊なテープや、異なる性質のテープがたくさんあります。

両面テープ

製本テープ

トビラ雑学 **1** ＞ 折刃式カッターのサイズ

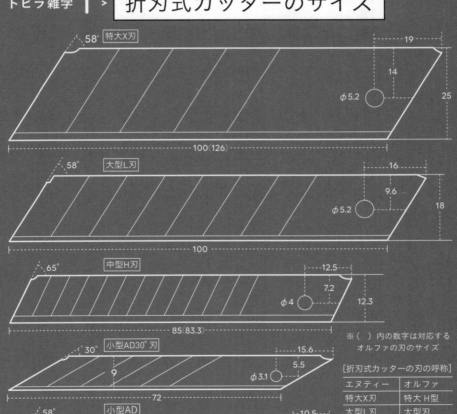

58° 特大X刃
19
14
φ5.2
25
100(126)

58° 大型L刃
16
9.6
φ5.2
18
100

65° 中型H刃
12.5
7.2
φ4
12.3
85(83.3)

30° 小型AD30°刃
15.6
5.5
9
φ3.1
72

58° 小型AD
10.5
5.5
9
φ3.1
80

※（　）内の数字は対応する
　オルファの刃のサイズ

[折刃式カッターの刃の呼称]

エヌティー	オルファ
特大X刃	特大 H型
大型L刃	大型刃
中型H刃	M厚型刃
小型AD30°刃	小型30度刃
小型A刃	小型刃

アーム筆入
【アームふでいれ】

1965年にサンスター文具が発売した筆入れ。材料に当時まだ珍しかった高強度プラスチック ポリカーボネートを使用したことで、一般的なペンケースと比べ圧倒的に割れにくい。ペンケースを象に踏ませ「象が踏んでも壊れない」と謳ったテレビCMが1967年に放送されると爆発的なヒット商品に。後継モデルは現在でも定番商品として発売されている。

ISO（国際標準化機構）
【アイエスオー（こくさいひょうじゅんかきこう）】

スイスに本部を置く非政府機関。世界中で同じ品質、同じレベルの製品やサービスを提供可能にするための国際規格（ISO規格）を制定。文房具に関しては「シャープ ペンシル」（ISO9177）や「鉛筆の黒色芯-分類及び直径」（ISO9180）などの規格の他、製品・サービスの品質向上に関する「品質マネジメントシステム」（ISO9001）、環境リスクの低減を目指す「環境マネジメントシステム」（ISO14001）などがある。

ISOT（国際文具紙製品展）
【アイエスオーティー（こくさいぶんぐかみせいひんてん）】

1990年から続く日本最大規模の文房具紙製品の国際見本市。国内外のメーカーが多数出展し商談を行う。東京ビッグサイトで開催（1995年以前は幕張メッセ）。日本文具大賞の表彰などを行う。現在は一般公開されていないが、公募のサポーター制度を利用すれば見学できる（通称イソット）。

iFデザイン賞
【アイエフデザインしょう】

1953年にドイツのハノーファーに設立されたデザイン振興のための国際的な組織インダストリー・フォーラム・デザイン・ハノーファー（iF）が主催する、工業製品を対象とした世界的に権威のあるデザイン賞。日本の文房具も多数受賞している。

アイレット
【アイレット】

鳩目（→p139）のこと。

青写真
【あおじゃしん】

露光により青色に発色する塩鉄類を利用した複写技法。青地に白の線（ネガ）になる。機械や建築などの設計図面の複写に多用されたため、将来の計画や構想を指す言葉として文学的に用いられることが多い。ジアゾコピー（→p78）の普及によって使われなくなった。

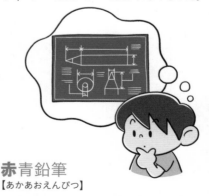

赤青鉛筆
【あかあおえんぴつ】

１本の鉛筆の前後に赤と青の芯を内蔵し両端から削ることで２色を使い分けることのでき

る色鉛筆。訂正・校正作業などに用いられる。明治時代に日本に輸入された「VERMILION（バーミリオン）」と「PRUSSIAN BLUE（プルシアンブルー）」の2色鉛筆が「朱藍鉛筆」と呼ばれたのがはじまり。赤：青の比率は5：5の他、赤の使用頻度を考慮した7：3のものもある。

アジ紙
【アジがみ】

東欧の雑貨などを扱う店「チャルカ」の久保よしみ、藤山なおみが提唱した味わいのある紙を意味する造語。個性、味わい、趣き、背景、ストーリーのある紙のこと。さらに紙そのものだけではなく、印刷された文字や図柄、その意図、手に入れるまでのエピソード、紙に関わりのある人たちとの出会いまで含めて、五感に触れ、心が動いた紙を指す。

葦ペン
【あしペン】

乾燥させた葦の茎を斜めに切り落とし、先端を切り割ってつくった簡素なつけペン。古代エジプトでパピルスに筆記するため、煤煙を膠で溶いたものをインクとして用いた。現代のつけペンや万年筆のルーツといわれる。

あじろ綴じ
【あじろとじ】

無線綴じの一種。折り丁（普通16頁ごとで折り畳まれた状態の本文）のノドにミシン目状の切り込みを入れ、スリットに接着剤を浸透させて綴じる製本方法。対になる本文がつながっていることとスリットに接着剤が深く浸透することから、枚葉を重ねて接着する無線綴じよりも丈夫。

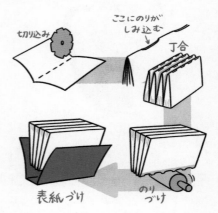

切り込み　　ここにのりがしみ込む　丁合

表紙づけ　　のりづけ

アスクル
【アスクル】

東京に本社を置く通信販売会社。主に法人事業所に対し事務用品を中心とする商品を販売。社名は当時画期的だった翌日配送サービスに由来。1993年のサービス開始が文具の流通に与えた衝撃は大きい。現在は個人向けの通信販売も行っている。

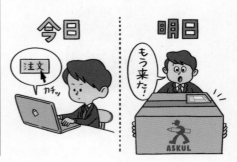

今日　　明日
注文　カチッ　もう来た！　ASKUL

厚さゲージ
【あつさゲージ】

薄く平らなものの厚さを測る測定器具。紙やフィルムなどの厚さをレバー操作で素早く測定できるのが特徴。紙製品製造や印刷関連の現場では必携品。図のようなダイヤルタイプが一般的で、0.01mm単位の測定が可能。

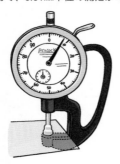

アラビア糊
【アラビアのり】

アラビアゴムノキの樹液を主成分とした淡黄透明色の液状糊。小瓶の先端につけられた海綿を通して塗布するものが事務用として明治時代から昭和30年代まで広く使われた。現在は化学合成された液体糊（→p37）に取って代わられたが、片面塗布後乾燥させたものは水で濡らすと接着できる再湿糊として封筒の口糊加工にも使用される。

アルマイト
【アルマイト】

アルミニウムの表面に厚い陽極酸化皮膜をつくることでアルミニウム表面の硬度、耐食性、耐摩耗性を向上させる処理。皮膜表面には規則正しく並んだ微小な穴が形成されるので染料を浸透させると金属光沢を持ったまま着色を施すこともできる。筆記具の軸などに採用されることが多い。

ALLEX事務用はさみ
【アレックスじむようはさみ】

林刃物が1973年から製造する事務用はさみ。2枚のステンレス鋼板で構成されたシンプルな造形と指穴に装着されたカラフルな樹脂リングが特徴。板材からプレス加工してつくることで量産性を向上させた画期的なはさみであり、渡辺篤治がデザインしたその形状は誰もが知る量産事務用はさみの原形でありながら今なお古さを感じさせない。「ALLEX」はALL EXPAND（すべてにおいて発展していく）を意味する造語。

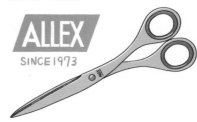

アロンアルフア
【アロンアルフア】

1963年に東亞合成が発売したシアノアクリレート系瞬間接着剤。強さを証明する奇抜な実験調のテレビCMが印象的で瞬間接着剤の

代名詞的存在となる。現在は「ボンド アロンアルフア」としてコニシが販売。

暗記ペン
【あんきペン】

効果的に暗記学習を行うためのラインマーカーと色透明シートのセット。マーカーとシートの色は互いに補色の関係で、重ねると黒く見えるため、教科書などの文字列の上にマーカーでラインを引き、シートをかぶせるとマーカー部分を一時的に隠蔽することができる。1982年にゼブラ「チェックペン」が発売され、学生の学習スタイルに大きな影響を与えた。当初は赤マーカー×緑シートの組み合わせだったが、緑マーカー×赤シートなども登場。現在は赤ボールペンで書いた文字や最初から赤文字で印刷された参考書などを赤シートで消す方法が主流。

井口直樹
【いぐちなおき】

（生没年不詳）1873年に日本政府の伝修生として藤山種廣（→p148）と共にウィーン万国博覧会に派遣され、ドイツの鉛筆製造機を見て帰国。1874年に起業し欧州の機械を簡素化した機械を考案し小池卯八郎（→p68）に技術を伝承。国産の鉛筆開発の端緒を開いた。

石丸治
【いしまるおさむ】

セーラー万年筆社員、インクブレンダー。2005年より全国の小売店やイベントにて「インク工房」として活動。バーテンダーのような出で立ちでシェイカーを振り、客の注文にあわせたオリジナルの色を調合するスタイルで人気。

意匠権
【いしょうけん】

知的財産権の中でも代表的な産業財産権（工業所有権）の１つ。製品外観の形状・模様・色彩など、工業上利用することができるデザインの創作について、特許庁の審査により新規性や創作非容易性などが認められたものに対し与えられる権利。「意匠登録」と呼ばれることが多い。意匠はあくまで美感を起こさせる外観についてのもので、機能を満たすために必要なデザインは含まれない。

市浦潤
【いちうらじゅん】

株式会社ラカ代表、著述家。日本におけるアメリカ文房具の紹介・評論の先駆け。幼少期よりアメリカ文化に触れ、アメリカ留学後、企業のコンサルティングを行う傍らアメリカ文房具の輸入販売や評論を行う。著書に『文房具―知識と使いこなし』（新潮文庫）がある。

一貫斉国友藤兵衛
【いっかんさいくにともとうべえ】

(1778-1840) 近江国・国友村の鉄砲鍛冶、発明家。1828年に軸内に墨液を貯えた毛筆「御懐中筆」を発明。

一筆箋
【いっぴつせん】

主に物品を送るときなどに添える略式の手紙として挨拶や御礼など簡単なメッセージを書くために用いる小型の便箋。短冊形で、長形封筒に折らずに入るサイズのものが多い。

伊東屋
【いとうや】

1904年創業の東京都中央区銀座に本店を構える文房具専門店。店先に飾られたコーポレートシンボルの巨大な赤いクリップと共に、日本を代表する老舗文房具専門店として有名。本店は2015年にリニューアルされG.Itoyaと呼ばれる。

糸かがり綴じ
【いとかがりとじ】

糸綴じの一種。複数の折り丁を、糸を使ってかがり縫いのような方法で連結する製本方法。分厚い冊子をつくることができ、ページの開きがよいため、ハードカバーのノートや手帳などに使われる。

イリドスミン
【イリドスミン】

イリジウムとオスミウムの合金。非常に硬く磨耗しにくい上に耐食性が高いことから、万年筆の先端（ペンポイント）に使われる、とても高価な希少金属。ものすごく硬い上に融点が3000℃近くで加工が難しい。粉末材料をプラズマで溶かして滴が球形に固まったものをペン先に電気溶接する。

色鉛筆
【いろえんぴつ】

主に顔料を蝋などで固めた芯を、木または紙巻きの軸に入れた画材。鉛筆とは芯の製法・組成が異なる。一般に軟質の芯は太く、かつては加工や品質の安定性の観点から六角ではなく丸軸が主流だった。

イロブン
【イロブン】

文房具ライターきだてたく（→p57）が提唱する文房具のカテゴリー「色物文房具」の略。本来の目的達成には全く不必要な機能や異常な外観、過剰な装飾などを備え、道具としての存在度外視で笑いを誘う文房具の総称。同氏の提唱するカテゴリーには青少年の健全な育成に有害な文房具「エロブン」もある。

岩絵の具
【いわえのぐ】

鉱石を粉砕してつくった顔料。日本画用の画材として使用される。一般的には粉末状で、そのものには固着する成分が含まれておらず、膠と混ぜて絵の具として使用する。同じ鉱石由来でも粒子の大きさによって色合いが異なる。

印影
【いんえい】

印章（→p34）を紙に押して写された印面の文字や図像の痕跡。

印鑑
【いんかん】

印の真偽を鑑定するためにあらかじめ役所や銀行などに届け出しておく特定の印影のこと。印章（はんこ）そのもののことを指す意味で使用されることが多いがこれは誤用。

インキ消し
【インキけし】

筆記具の筆跡を化学的に無色化する主に2種1組の薬液。普通万年筆用（水性染料、及びブルーブラックインク用）を指すが、ボールペン用（油性染料インク用）もある。万年筆用の1液はシュウ酸水溶液で、ブルーブラックインクの酸化鉄を還元して無色化、2液は次亜塩素酸ナトリウム水溶液で染料の色素を酸化漂白する。ボールペン用の1液は次亜塩素酸ナトリウム溶液で色素を酸化漂白、2液は油溶性インクの溶剤でインクを溶かす。どちらも顔料系インクには効果がない。

インク
【インク】

筆記・描画・着色・印刷などに使用される顔料・染料などを含む有色の液体またはそれに準じる状態の物質。「インキ」とも。

インクジェット対応
【インクジェットたいおう】

表面に特殊な塗工を施し、インクジェットプリンタのインクの発色や定着性などを向上させた印刷用紙、はがきなど。プリンターとの相性は抜群だが水性筆記具などでは過剰にインクを吸収してしまったり、スタンプの乾きが悪いなどの特性があるので注意が必要。

インク壺
【インクつぼ】

つけペンで使用するインクを取り分けて机上に置くためのガラスや陶器などでつくられた小さな容器。

インクブレンダー
【インクブレンダー】

インクを調合する人（→p31「石丸治」参照）。

インクフロー
【インクフロー】

筆記具のインクの流れ、吐出・湧出のこと。万年筆など筆記具においてインクの吐出量の多寡を表現するのに使う。

印章
【いんしょう】

石、木、動物の角、金属などの素材（印材）の一面に反転した文字や図像を彫刻したもので、個人や官職、団体を象徴する。文書などの責任や権威のありかを証明するために、印面に顔料を塗布し紙面に押し当てることで印面の形状を写し取る。印、判、印顆（いんか）ともいう。

インスタントレタリング
【インスタントレタリング】

透明なフィルムの裏面に特殊な粘着処理を施した文字や記号が印刷されたもので、紙などに乗せてフィルムの上から擦って圧力をかけると文字や記号のみが転写される。1961年イギリスのレトラセット社が発売。手軽に高品質な書体を表現できるので、ワードプロセッサーが一般化する以前にはデザイン業界のみならず一般家庭でもカセットテープのラベルやインデックスカードの作成などに多用されたが、電子ラベルライターや家庭用プリンターの普及で衰退した。

インデックスラベル
【インデックスラベル】

書類の索引、見出しとして貼り付けるラベルシール。中央に折り目のある蝶番状になっていて、文字を記入して粘着面を内側に折ってページの縁に突出する形で貼り付けるもの

が一般的。記入面を保護するラミネートフィルム付きのものやプリンターに対応したものなどさまざまなタイプがある。「口取紙」とも。

印肉
【いんにく】

印章を捺すために用いる顔料と植物油をヨモギなどの植物繊維に染み込ませ練り合わせた色材。

ウォーターマーク
【ウォーターマーク】

透かし（→p90）のこと。

ウォーターマン
【ウォーターマン】

フランスに本拠を置く万年筆ブランド。アメリカのルイス・エドソン・ウォーターマンが世界ではじめて毛細管現象を応用して、インクをペン先に運びつつ等量の空気を取り入れる、現在の万年筆の基本構造を備えた「ザ・レギュラー」を1883年に開発し、翌年創業（アイデアル・ペン・カンパニー）した。1904年にはクリップ付きキャップを開発。1926年にフランスのジフ・ウォーターマンが設立され、1954年にアメリカ法人が倒産した後は、ジフ・ウォーターマンがブランドを引き継いだ。

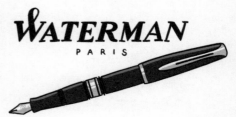

薄墨
【うすずみ】

薄く摺った墨。墨で書いた色が薄いもの。葬儀の香典袋・不祝儀袋などに文字を書く際には「涙が硯に落ちて墨が薄くなってしまった」「急なことで墨を摺る時間もなく駆けつけた」などの意味から、薄墨を使うのがならわしとされる。筆ペンにも薄墨タイプのものが販売されている。

内田洋行
【うちだようこう】

日本の東京に本社を構える、情報システム・オフィス構築などを手がける専門商社。1910年に内田小太郎が満州（現在の中国東北部）大連市に、測量製図器械や文房具・事務用品を満州鉄道に販売する御用商として創設（翠苔号）。多くの欧米の文房具を日本に紹介し、また国産化を進めた。1951年に米国産業視察団に参加した社長の内田憲民が持ち帰り、国内メーカーに研究開発させたことで寺西化学工業の「マジックインキ」や、マックスの「SYC10」（小型ホッチキス）などが生まれたことでも知られる。

梅棹忠夫
【うめさおただお】

（1920-2010）生態学者、民族学者であり、情報学者、未来学者。フィールドワークや研究の経験から編み出した情報カード（→p58「京大式情報カード」参照）を使った実践的な情報処理の指南書『知的生産の技術』（岩波書店）は未だ情報処理の基本として読み継がれるロングセラー。その後の知的活動に大きな影響を与えた。

梅皿
【うめざら】

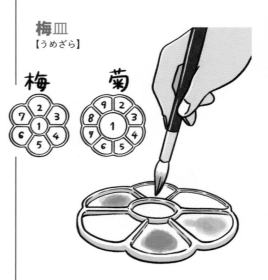

主に陶器でつくられた、梅の花に似た形の絵の具皿。7つの区画に分かれていて絵の具を薄めたり混色したりするためのパレットとして使われる。9つの区画を持つ「菊皿」もある。

裏紙
【うらがみ】

不要になった使用済みコピー用紙や片面印刷物などの未使用面を筆記用紙などとして再利用する場合の紙の総称。一時はエコロジーの観点から推奨されたが、情報漏洩などの危険性から禁止されることも多い。

裏抜け
【うらぬけ】

筆記具のインクが紙に浸透して裏面にまで到達すること。特にノートや手帳の用紙におい

て、裏抜けのしにくさは性能の指標の１つ。

裏技
【うらわざ】

身近にある道具を非公式、あるいは本来想定していない方法で使うことで生活を便利にする知恵の総称。1997〜2007年に放送された人気テレビ番組「伊東家の食卓」によってブームになった。文房具に関しても書けなくなった筆記具を復活させる方法や消えないインクを消す方法など紹介されることがあるが効果が不確実な俗説も含まれるため注意が必要。多くの裏技は広く発表されるとほどなく専用のアイデア商品が発売され、裏技としての意味を失う。

永
【えい】

書に必要な８種の技法すべてが永の字に含まれているという意味の「永字八法」という言葉があり、トメ、ハネ、ハライなど、運筆のさまざまなバリエーションが含まれるため、万年筆などの試し書きなどでよく書かれる文字。楷書を意識しないのであればこの文字にこだわる意味はあまりない。

曳糸性
【えいしせい】

粘度の高い液体や高分子を含む液体を滴下させたり引き上げたときに液体が糸を引く性質。油性ボールペンのインクにおいて、インクのボテを防ぐ上で、ペン先を紙から離したときに余分なインクをペンに引き戻す性質として重要。

エイジング
【エイジング】

ものを使い込むことによって見られる経時変化。あるいは使い込んで経時変化したように外観を見せかけるための加工。

液体糊
【えきたいのり】

液体の事務用糊の総称。多くはポリビニルアルコールと水を主成分とする。ペースト状の澱粉糊（→p120）や固形のスティック糊（→p92）などと区別するために用いる。「液状糊」「水糊」とも。

SKU
【エスケーユー】

Stock Keeping Unit（ストック・キーピング・ユニット）の略。商品の種類を数える流通上の最小単位。バーコードごとに1と数えるとわかりやすい。同じ商品でもパッケージや入り数が異なれば区別して数える。1つの銘柄のボールペンでも、ボール径が3種で、色が5色、ブリスターと裸売りがあれば3×5×2＝30SKU。40種類の消しゴムでもバーコードがすべて同じなら1SKU。

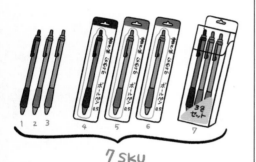

絵手紙
【えてがみ】

葉書の裏面に毛筆などを使って身近なものの絵を描き、短い言葉を添えた手紙のスタイル。言葉として広まるきっかけは、書道家の小池邦夫（日本絵手紙協会名誉会長）が1979年発行の芸術誌『季刊　銀花』の企画として6万枚の直筆絵手紙を発表したことといわれている。

絵日記
【えにっき】

文章に絵を添える日記の様式。日本においては、初等教育で児童に日々の出来事を記録させる方法の1つとして普及している。夏休みなど長期休暇中の宿題とされることが多い。ページの上半分に絵、下半分に文章を書かせる形式が一般的で、絵日記専用の学習帳が市販されている。

絵の具
【えのぐ】

主に絵画などの描画・着彩に使われる、顔料と固着剤や溶剤などを混合したものの総称。顔料や溶剤の種類、また保存、使用される形態によって非常に多くの種類がある。学校教育では水溶性のチューブ入り水彩絵の具が多

く使われる。チューブ入り絵の具は19世紀に開発されたもので、錫張りの鉛チューブが長く使われていたが現在は安全性の問題からポリエチレンなどの樹脂製や樹脂でラミネートしたアルミ製のチューブが増えている。

F104Jスターファイター
【エフひゃくよんジェイスターファイター】

F-104はロッキードが開発した超音速ジェット戦闘機。1961〜1986年に日本の航空自衛隊に採用された日本向け改良型F-104Jは三菱重工がライセンス生産を担当したことと、極端に翼が小さく細長い胴体形状から、「三菱鉛筆」の愛称で呼ばれた（筆記具メーカー「三菱鉛筆」とは何ら関係ない）。

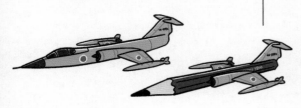

エボナイト
【エボナイト】

ゴムに多量の硫黄を加えて加硫してつくる硬質な材料。万年筆の軸、喫煙パイプや楽器のマウスピースなどに使われる。1839年にチャールズ・グッドイヤーによって発明されたもので、耐候性、耐薬品性、機械加工性、絶縁性が高く、石油由来のプラスチックが普及する以前は多くの用途に使用されたが、現在ほとんどの用途はプラスチックなど別の素材に置き換わっている。他の素材と擦り合わせると負に帯電しやすい性質が強く、科学の教科書では静電気の項目で紹介されることが多い。

エマルジョン
【エマルジョン】

水と油のように相互に混ざり合わない液体の一方の中にもう一方が小さな液滴として分散した状態。両者に親和性のある物質（乳化剤）を添加することで乳化剤が液滴を取り囲むように分布し分散状態で安定する。水の中に油が分散している「水中油滴型」に牛乳やマヨネーズ、逆の「油中水滴型」にマーガリンやバターなどがある。ゼブラがはじめてボールペン「スラリ」のインクに油中水滴型エマルジョンを採用。しっかりした手応えとなめらかさの両立を謳っている。

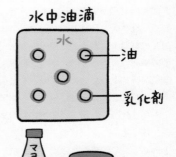

水中油滴

水　油　乳化剤　マヨネーズ　保湿クリーム

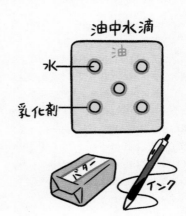

油中水滴

油　水　乳化剤　バター　インク

エラストマー
【エラストマー】

「elastic（弾力のある）」と「polymer（重合体）」を組み合わせた造語で、ゴム弾性を有する高分子材料の総称。広義では天然ゴム（加硫ゴム）やシリコーンゴムなど（熱硬化性エラストマー）も含むが、狭義ではスチレン系やオレフィン系などの熱可塑性エラストマーを指す。後者の意味で使われることが多い。

塩化ビニル樹脂
【えんかビニルじゅし】

クロロエチレン（塩化ビニル）を重合したもの（ポリ塩化ビニル）に可塑剤などの添加剤を加えた熱可塑性樹脂。「塩ビ」「ビニール」とも。現状最も消字率の高いプラスチック字消しの材料でもあるが、染み出した可塑剤が他の樹脂に移行して溶かすなどの問題がある。安価で可塑剤の量によって硬さを自在に調節できるため用途は多岐にわたり、文具や玩具にも多く使われたが、ゴミ焼却時のダイオキシン類の発生や可塑剤のフタル酸エステルが人体に与える影響などが疑われたため使用に反対する運動が起こり、現在は多くの製品が他の熱可塑性樹脂に置き換えられている。

エンディングノート
【エンディングノート】

死後身近な人に読まれることを想定して、生前に書き記すノート。終末医療や死後の身辺についての希望から、財産、各種契約などの情報など遺族に必要な情報、また個人の人生の記録などを記す。記録される内容はさまざまだが、死を意識しつつも、人生を振り返る意味で比較的早期から書きはじめる人も多い。遺書のような法的根拠はない。

鉛筆
【えんぴつ】

黒鉛を主な原料とする棒状の筆記材を木製の軸に固定して持ちやすくした筆記具。芯の黒鉛を擦りつけて筆記する。現在は芯を挟んだ木製の支持部ごと切削して芯を露出させて使用するものが一般的だが、その起源は木製の軸の先端に黒鉛の塊をはめ込んで使うもので、最古の記述はスイスのコンラッド・ゲスナーの1565年の著書に登場する。16世紀後半にイギリスのケスウィックの指物師が黒鉛の棒を木材にはめ込んだとされる（いくつか説がある）。1794年にフランスのニコラ・ジャック・コンテ（→p129）が黒鉛と粘土を混ぜて焼いた芯を発明し、現在の製法の基礎が確立した。

鉛筆削器
【えんぴつけずりき】

鉛筆の一端を切削して芯を露出させ筆記可能な状態にする道具。用途に合わせて仕組みも

形状も多様。日本には明治時代に紹介されたが、1960年に浅沼稲次郎（日本社会党委員長）が演説中に17歳の少年にナイフで刺殺された事件以降、銃刀法の改正や学童の刃物所持を追放する運動が起こり、肥後守（→p143）などのナイフに代わって急激に普及したといわれている。

鉛筆彫刻
【えんぴつちょうこく】

鉛筆や鉛筆の芯を素材とした彫刻。日本では山崎利幸がプロ鉛筆彫刻家として活動している。

エンボス加工
【エンボスかこう】

文字や図像、模様などを凹凸で表現した型を紙や皮などに裏から強く押しつけ、紙に凸模様を付ける加工法。凹みで表現する場合は「デボス（空押し）」という。意匠的な効果として使われることが多いが、印刷の代用や偽造防止の他、機能的な目的で使われることもある。

エンボッサー
【エンボッサー】

紙などにエンボス加工を施す装置・器具。社名やブランド名、団体名などを押すことで、書類などの偽造防止の他、意匠的な効果やブランドの誇示などの目的で使用される。

オエステ会
【オエステかい】

西日本の文具専門店のネットワーク。2009年に発足（2019年現在12社が参加）。「オエステ」はスペイン語で「西」を意味する。各種情報共有の他、国内メーカーとコラボしたオリジナル商品の開発なども行っている。

OEM
【オーイーエム】

「original equipment manufacturer」の略。「相手先ブランド名製造」と訳される。元来他社ブランドの製品を受託生産するメーカーの意味だが、製造メーカーが自社ブランドではなく他社のブランドの製品を製造することや、他のメーカーの製品を自社のブランドで販売することの意味で使われることも多い。高い技術力を持つ他メーカーに製造を委託することは文房具にもよくある手法で、多くのメーカーが部分的に他社で製造した製品を自社ブランド品として販売している。

OHP
【オーエイチピー】

「overhead projector(オーバーヘッドプロジェクター)」の略。透明なフィルムに書かれた文字や図表などを、強力な光源の真上に乗せ、レンズとミラーを介して壁面のスクリーンに拡大投影する装置。1960年代から普及し会議や授業などで資料を提示するのに使用された。シートの作成や操作が容易で全国の学校や多くの会社に普及したが、PCや書画カメラの画像を直接投影できるビデオプロジェクターの普及によって置き換えられほとんど使用されなくなった。

OA
【オーエー】

「オフィスオートメーション（office automation）」の略。オフィスにコンピューター・FAXなどの情報機械を導入することで、オフィスにおける事務処理を自動化すること。1980年代前半から多くの企業が取り組み、事務作業を省力化、効率化し、生産性向上を目指した。情報機器やそれに関連する製品をOA機器、OA用品などという。

オークション
【オークション】

場に出された物品に対して支払われる対価を購入希望者間で競わせる販売方式。最も高い値を提示した者が購入する方式が一般的。文房具ファンの間では「ヤフオク!」や「eBay」などのネットオークションを指すことが多い。骨董、廃番品や希少品などの入手方法の1つとして有効だが人気商品や限定商品の高額転売などが問題視されることもある。

OKB48選抜総選挙
【オーケービーフォーティーエイト せんばつそうせんきょ】

2011年から続くボールペンの人気投票。OKBは「お気に入りボールペン」の略。予め選抜された日本のボールペンシーンを代表する48本の中から投票する。全国各地の試し書き会場で投票する「握手会投票」と、Webサイトで投票する「Web投票」がある。プロデューサーは放送作家の古川耕。初期は雑誌の企画だったが5回目以降は、文具王の

高畑正幸が主催。

OHTO
【オート】

東京に本社を構える筆記具・文具メーカー。1919年に中田藤三郎が薬剤や顔料の粉砕で創業（中田鳳華堂）、終戦後ボールペンの開発に着手し、1949年に鉛筆型木軸ボールペンを発売。安価で実用的な使い切りボールペンを広めた。1964年には世界初の水性ボールペンを開発。ペン先を細く2段階に切削したボールペン芯「ニードルポイント」、連射式クリップの「ガチャック」などで有名。

オートマチック開閉
【オートマチックかいへい】

手帳やノートのページの角部に予めミシン目を入れておき、過去のページの角を切り捨てることで、角に指を当てて開けば、切られていない最初のページ、即ち現在使用中のページが即座に開ける仕組み。クオバディスの手帳に施されていることで有名。同社の英語表記は「Tear-off corner（ちぎり取る角）」だが日本語では「オートマチック開閉」。他社からも同様の手帳は販売されているが、「コーナーカット」「コーナーミシン目カット」など、統一された呼称がない。

終わったページがすぐわかる！

オープン価格
【オープンかかく】

メーカーが商品の希望小売価格を定めないこと、またその場合の小売価格。店頭表示価格は販売店が決定する。メーカー希望小売価格からの大幅な値引き表示が加熱、常態化したことから主に家電に対し公正取引委員会から二重価格問題として指摘があり、2000年頃から増加した価格提示方法。文房具でも高額商品や電子文具などを中心に採用するメーカーが増加している。

小川春之助
【おがわはるのすけ】

(1885-1957) トンボ鉛筆の創業者。1913年に文具商として小川春之助商店を開業。その後鉛筆の製造販売に移行し、養父の作太郎がかつて勤めていた大日本鉛筆が考案し登録期限が切れていたトンボのマークを商標とし、現在の礎を築いた。

お道具箱
【おどうぐばこ】

頭に「お」がつくと、幼稚園児や小学生の学用品としての道具（はさみ・糊・クレヨンなど）を収納する目的の箱を意味する。学校で銘柄を指定される場合も多い。主に紙やプラスチックでつくられたシンプルな身蓋の箱だが、最近はそのまま学校の机の引き出しとして使えるものや仕切りがつけられるものなども登場。

オフセット印刷
【オフセットいんさつ】

現在最も普及した印刷方式の1つで、版から一旦中間転写体にインクを移したものを紙に転写するため、オフセットと呼ばれる。感光剤を塗布した薄いアルミの板に光を当てて製版し水が載りやすい部分とそうでない部分をつくる。版を湿らせるとインクは水のない部分にのみ載るのでそれを転写する。書籍やチラシなどの印刷だけでなく、ノートや手帳の本文印刷にも多用されている。

お迎えする
【おむかえする】

念願のものを購入し、自分の手元に迎えること。購入したものを擬人化した謙譲表現。文房具に限らずネットを中心にしばしば見られる表現だが、文房具の場合は特に万年筆に対してに多用される。

折り紙
【おりがみ】

紙を折って動植物などの形をつくる日本伝統の遊び。またそれに使う正方形の専用紙。貼り絵などの絵画工作材料としても使われる。片面に着色や印刷が施された洋紙が一般的だが、和紙やセロファン、樹脂フィルムなどさまざまな素材のものもある。金銀色のものは紙にアルミ箔を貼り合わせてつくる。最近では折り紙を収納し持ち運ぶ専用の「折り紙ケース」も販売されている。

折刃式カッター
【おるはしきカッター】

1956年に岡田良男が考案した日本では最も普及しているカッターナイフの一方式。細長い平行四辺形の長辺に切れ刃を持ち、短辺と平行な細い溝を等間隔に施した刃体をハンドルに内蔵する簡易汎用ナイフ。刃をスライドして必要量露出させて使用する。刃の先端が摩耗・損耗した際、刃体に施された溝に力をかけて破断し新たに生じた角を先端として使うことにより、交換や研ぎ直しをすることなく1つの刃体で何度も鋭い切れ味を利用することができる。

オルファ
【オルファ】

日本の大阪に本社を構える刃物メーカー。1956年に世界初の折刃式カッターナイフを発明した岡田良男が、日本転写紙（現在のエヌティー株式会社）に在籍した後1967年に日本転写紙と特許を共有した状態で独立して設立（岡田工業）。コーポレートカラーでもある黄色はカッターナイフが目立つための色でもある。1979年には世界初の円盤状の刃を押しつけて切るロータリーカッターを発売。

オレフィン
【オレフィン】

ポリプロピレン（PP）やポリエチレン（PE）など、構造内に炭素の二重結合を持つ不飽和炭化水素の総称、ポリオレフィン。特にゴム弾性を持つオレフィン系エラストマーは、環境ホルモンとして有害と考えられる可塑剤を含まず、燃焼時に有害な塩素ガスなどを発生しないため、ポリ塩化ビニルの代替材料として文房具にも多く使われるようになった。

オレンジ・ビック
【オレンジ・ビック】

1961年に発売されたフランスのビック社の油性ボールペン。オレンジ色のボディと黒いキャップで世界的に有名。ボールに非常に硬い金属、タングステンカーバイドを使用することで0.8mmの細いペン先を実現し、従来品と差別化するために胴軸の色を当時採用されたばかりのコーポレートカラーであるオレンジにした。

mini column 　S型とE型、右開きと左開き

　ノートやファイル、バインダーなどにおける綴じ方向の呼称は、いつも混乱を招く元になります。口頭でファイルを注文する際など、案外きちんと伝えるのは難しいものです。じつは綴じ方には、長方形の長短どちらの辺を綴じるかと、左右どちらに開くか（あるいは上か）という2つの情報があり、これらを誤解のないように端的に説明することが大切です。
　まず、長短どちらの辺を綴じるかについては、綴じる側または挟む部分が長辺にあるものを「S型」(Side opening) と呼び、短辺にあるものを「E型」(End opening) と呼びます。そして、その綴じた辺が表紙に向かって左・右・上のどちらにあるかで、本文の進行方向が決まり、罫線の向きや使い方が決まります。普通、横書きなら左から右へと書いてページを右から左にめくるので、左開き・左綴じといい、縦書きなら右から左に進むので、ページは左から右にめくる、つまり右開き・右綴じです。左開き・右開きは、どちらがどちらだったか不安になることもありますが、左綴じが左開き、右綴じが右開きであることを覚えておけば取り違えることを防げます。ちなみに縦に開く場合は、上、ではなく天綴じとなります。また、寸法を表記する際には、綴じてある方を先に書くのが国際的な慣行なので、同じA4でもS型は297mm×210mm、E型なら210mm×297mmとなります。

インクとインキ

　どちらも同じインクの意味ですが、インキの方がちょっと古い印象があり一般用語としてはあまり使われていないように思います。最近輸入された外来語は英語をベースにカタカナ化されたものが多いですが、戦前までに物や技術と一緒に輸入された言葉は、その輸入元の言語に由来することが多く、インクの場合も、江戸時代後期には印刷技術と一緒にオランダから輸入されているので、英語のインク（ink）ではなく、オランダ語のインキ（inkt）と言われ、印刷業界では印刷機で使う色材は未だにインキと呼ぶことが多く、文具でも明治頃の資料ではインキが主流で、ぺんてるやパイロットなどは今でもインキで通しています。

　同様に、昨今ボールペンのインクに多く使われるゲルという概念もドイツ語のゲルと英語のジェル（表記はどちらもgel）があり、筆記具ではゲルを採用するメーカーが多数派。このためゲル状の色材の呼称はドイツ語・オランダ語・英語が混在していますが、不思議なことに英語で統一した「ジェルインク」を採用する大手筆記具メーカーはゼブラだけです。

インクとインキ

メーカー名	ゲル	ジェル	インク	インキ
パイロットコーポレーション	○			○
ぺんてる	○			○
寺西化学工業	○			○
サクラクレパス	○			○
セーラー万年筆	○		○	
プラチナ万年筆	○		○	
三菱鉛筆	○		○	
オート	○		○	
コクヨ	○		○	
ゼブラ		○	○	

か行

トビラ雑学 2 >

クリップのサイズ

ダブルクリップのサイズ

口幅	名称
51mm（コクヨのみ50mm）	超特大
41mm	特大
32mm	大
25mm	中
19mm	小
15mm	小小（プラス、コクヨ製は「豆」）
13mm	豆（プラス、コクヨ製は「極豆」）
10mm	粒（プラス、コクヨ製は該当製品なし）

ゼムクリップのサイズ

全長	名称
15mm	ミニ
23mm	小
28mm	大
33mm（ライオン製は35mm、コクヨ製は34mm）	特大35mm
50mm	特大35mm（コクヨ製は「ジャンボ」）

※ライオン、プラス、コクヨの製品データによる
※原寸大

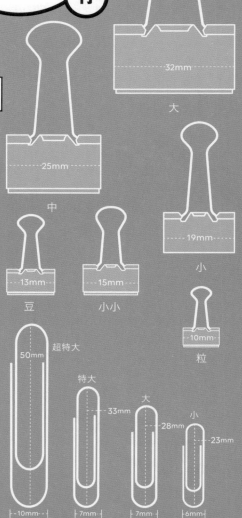

大　32mm

中　25mm

小　19mm

小小　15mm

豆　13mm

粒　10mm

超特大　50mm　10mm

特大　33mm　7mm

大　28mm　7mm

小　23mm　6mm

加圧式ボールペン
【かあつしきボールペン】

インクに押し出し方向の圧力をかけることによりインクの逆流やかすれを防止する構造を持つ油性ボールペン。インクタンクに窒素ガスや空気を密閉して隔壁を押す常時加圧式（フィッシャースペースペン「スペースペン」、三菱鉛筆「パワータンク」など）と、ピストンを内蔵しノックボタンを押下する際に空気を圧縮して加圧する一時加圧式（トンボ鉛筆「エアプレス」、パイロットコーポレーション「ダウンフォース」など）がある。重力に依存せず筆記が可能なため、上向き筆記や低温環境、濡れた紙面などへの筆記にも強い。無重力の宇宙船内でも使用可能（→p94「スペースペン」参照）。

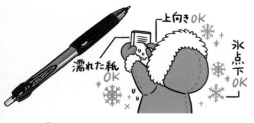

カード文具
【カードぶんぐ】

携帯時の外観が板状で、クレジットカードに近いサイズの長方形の薄型文房具の総称。カード電卓や拡大鏡などをはじめ、筆記具をはめ込んだような比較的単純なものから、複数の機能を持つもの、ステープラーなど組み立てて使用する複雑な機構を持つものまでそのバリエーションは多岐にわたる。システム手帳に収納して携帯できるツールとして1980年代後半から1990年代にかけて流行した。

カートリッジ
【カートリッジ】

保守や消耗品の交換、機能の変更などのために、必要とされる要素を1つにまとめた交換可能な部品。文房具の交換部品の多くはシンプルな消耗品のため、単に「リフィル」（→p183）や「替え○○」と呼ばれることが多いが、特に万年筆やマーキングペンの場合はインクのみを補充する方式などと区別するため、インクが含まれた容器ごと交換するものをカートリッジと呼ぶ。

カートン
【カートン】

厚紙を意味する語に由来し、厚紙やダンボール製の箱の意。製造や物流の現場では製品を出荷する際の外箱や、その外箱1箱分の分量の意味で使われる。

カーボン紙
【カーボンし】

耐久性のある薄い紙の裏面に蝋などと混ぜた着色剤を塗布した感圧紙で、文字や図などの複写に用いられる。2枚の紙の間に挟み込んで上の紙に筆記すると筆圧が加わった部分の

裏面に塗布された着色剤が下の紙に付着し、筆記内容が複写される。

ガイドパイプ
【ガイドパイプ】

シャープペンシルの先端にある金属製のパイプ。製図用ではパイプ側面をテンプレートや定規に当てて正確にならうため、平行部が長く突出しているのが普通。筆記時の先端の見通しをよくする効果もあり、一般筆記用シャープペンシルにも採用される。芯の操り出し操作の頻度を抑制するため、芯を保護しつつ芯の摩耗に伴って後退するスライドタイプもある。

開封の儀
【かいふうのぎ】

購入した文房具をうやうやしく開封する行為。多くはSNSなどにその開封行為そのものを収録した動画や画像をアップするなどして他者に発信することまでが含まれる。

海綿
【かいめん】

主に海綿動物門 尋常海綿綱 角質海綿目モク

ヨクカイメン（沐浴海綿）科（学名Spongia officinalis）の海生生物を腐敗させ、そのやわらかく弾力に富んだ海綿質繊維の骨格を取り出して漂白したもの。古代ギリシャ時代より体を洗うスポンジなどとして使用されたが、文房具としては指濡らし（→p175「モルトケース」参照）のための保水材や、アラビア糊（→p30）の瓶の塗り口などに使用された。現在はほぼポリウレタンなどの合成樹脂を発泡成形してつくられる合成スポンジに置き換えられている。

天然のスポンジ

ギュー!!

カウネット
【カウネット】

東京に本社を構える通信販売会社。2000年にコクヨが立ち上げた連結子会社で主に法人事業所に対し事務用品を中心とする商品を販売。個人向けには2005年よりマイカウネットを開始。

kaunet
カウネット

角形2号
【かくがたにごう】

封筒の規格寸法の一つ。横240×縦332mm。A4サイズの書類やクリアホルダーなどを折らずに入れることができ、定形外郵便及び運送各社のメール便の規格内で発送可能なため、事務用封筒として最も一般的に使用されるものの1つ。

学習帳
【がくしゅうちょう】

主に学童が学習に使用することを目的とした
ノート。1902年に鐘美堂の中村寅吉が発売
した罫入り雑記帳がはじまりとされ、1909
年には科目ごとに異なる罫線を持った「教育
的雑記帳」がつくられている。その後、表紙
にイラストや写真を用いたり表紙の裏や見返
しに時間割表、コラムや豆知識など、学習に
関連する記事を掲載するようになる。1970
年にショウワノートが小学館のジャポニカ大
日本百科事典と提携して発売したジャポニカ
学習帳によって現在の学習帳のイメージの典
型が完成した。

学童文具
【がくどうぶんぐ】

小学生向け文房具の総称。新入学時に買い揃
える指定の文房具をはじめ、学習帳、コンパ
ス、三角定規、分度器など特定の年次や学科
で必須のものから、自宅学習、学習塾などで
使われる文房具などまで含まれ、大きな市場
を形成している。

学納文具
【がくのうぶんぐ】

学校教材として学校に納品される文房具。学
校で共用されるものや学校から配布されるも
のの他、学校で注文表を配布して注文をとり
まとめ、一括購入されるものなど。一般の店
頭では販売されていない仕様のものが多く、
市販とは異なる「学納価格」が設定されてい
る。

カシオミニ
【カシオミニ】

カシオ計算機が1972年に12800円で発売した
電子卓上計算機。当時一般的だった卓上据置
型電卓の半分以下の価格、ポケットに入る小
型サイズで、乾電池駆動。当時ブームだった
ボウリングのスコア計算に使うことを想定し
たもので、個人でも購入できる価格帯で外出
先でも使える仕様は当時の電卓のイメージを
大きく変え、発売後10カ月で100万台を販売。
個人用電卓という新たなジャンルを開拓しそ
の後の市場に大きな変化をもたらした。CM
のキャッチフレーズ「答一発、カシオミニ」
も話題に。

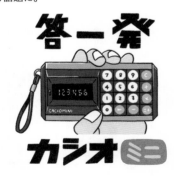

カスタマイズ
【カスタマイズ】

ユーザーの好みや使い勝手に合わせて製品の
仕様を変えること。市販の筆記具のグリップ
などを加工して持ちやすくするなどの機能的

na改造から、互換部品の交換、ステッカーやマスキングテープなどによる外観の加飾までさまざま。注文時に多くの選択肢から部品や色柄などの組み合わせなどを選んで購入できる場合その選択行為もカスタマイズと呼ばれる場合がある。

数取機
【かずとりき】

ボタンを押した回数を加算表示する装置。交通量調査や野生動物の個体数調査、棚卸など、目視で数量を計測する際などに使用される。「計数器」「カウンター」とも。

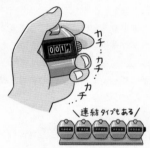

カチ…カチ…カチ……

連結タイプもある

風邪を引く
【かぜをひく】

空気や湿気に触れて変質することで、特に文房具では輪ゴムやゴム印などのゴムやプラスチックなどが経年劣化などにより弾力を失ってボロボロになったり、接着剤などが劣化して接着力を失うなど、主に高分子材料からなるものが劣化により本来の機能を果たさなくなること。

片岡義男
【かたおかよしお】

小説家・エッセイスト・写真家。ハワイに移住した祖父、そこで生まれたアメリカ軍人の父を持ち、幼少期からアメリカ文化

に触れて育つ。『スローなブギにしてくれ』など小説で有名だが、『文房具を買いに』(東京書籍)、『万年筆インク紙』(晶文社) など、主に舶来品 (→p138) を中心に、文房具をテーマにしたエッセイも多数ある。

カッターナイフ
【カッターナイフ】

和製英語で、交換式の刃を持つ小型ナイフの総称。特に折刃式 (→p44) を指すことが多い。オルファとエヌティーが有名。この類の交換式ナイフは日本ではほとんどが折刃式だが、海外では台形の交換刃 (前後に向きを変えて2回使える) なども多い。

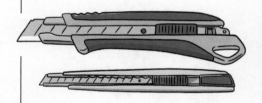

カッティングマット
【カッティングマット】

カッターナイフで軽作業をする際、机上を保護するために敷く軟質樹脂製の板。机を保護するだけでなく、刃先を自由な方向に進めるためや、刃の先端を保護する効果もある。切りたいものに対して充分余裕のある大きなものを選びたい。

活版印刷
【かっぱんいんさつ】

凸版印刷の一種。活字を組み並べてつくった版にインクを塗布し紙に押す印刷方法を指すが、近年は活字を使用せずに製作された樹脂や金属の凸版の印刷も含まれる場合がある。本来は文字版の再利用による印刷コストの低減や効率化のための手法だったが、写真植字やオフセット印刷（→p44）などの普及により実用としてはほとんど役目を終えた。しかし印刷面に印圧による凹凸のある独特の風合いが好まれ、芸術性の高い印刷表現の１つとして名刺やグリーティングカードなどに使用されることがある。

カドケシ
【カドケシ】

10個の立方体を空間上に市松模様状に配置し互いに接する辺で結合した形状の消しゴム。カドが28個ある。2003年に発売されヒットした。2002年コクヨデザインアワード佳作

（神原秀夫）作品の商品化で、消しゴムの形状に新たな可能性を示した点で文房具業界に与えた影響は大きく、その後カドを意識させるデザインの消しゴムが各社から発売されるきっかけとなった。2003年グッドデザイン賞、2005年MOMAデザインコレクションに選定された。

金型
【かながた】

製品の部品を成形するための金属製の型の総称。樹脂や金属の量産品をつくる上で重要な設備工具。板状の素材を挟み込んで塑性加工するプレス金型や、溶解した素材を高圧で流し込んで成型する射出成形金型、高温で軟化した素材を空気圧などで押し当てて成形するブロー成形金型など、さまざまな種類がある。製品単価に対して非常に高価で初期投資に占める割合が高い場合が多い。

曲尺
【かねじゃく】

直角に曲がった金属製のものさし。大工道具の１つで、表面は通常の目盛りだが、裏面は縮尺が√2倍の「角目」と、1/πの「丸目」と呼ばれる目盛りが振られている。長さを測る、直線を引く、直角を作図するといった使用法の他に、木材断面の円周に角を当てて直角の線を引き、円周と交わった２点を結んだ

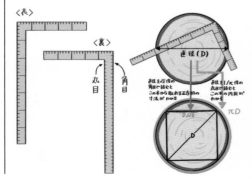

直線（直径）の長さを角目で測ればその木材から切り出せる最大の正方形の寸法が、丸目で測ればその木材の円周が簡便に求められる。

画板
【がばん】

絵を描くときに用紙を載せる板。ベニヤやプラスチックの板に用紙を固定するクリップが取り付けられ、四隅には紐を通す穴があるものが多く、屋外で使用する際などは一辺を腹に当てて支え、首や肩に紐をかけて保持した状態で絵を描く。デッサンやクロッキーなどに使われるカルトン（→p56）も画板の一種。

画鋲
【がびょう】

紙を壁面や机上に固定するために用いる、円盤状の金属板の中央に垂直に短い針を取り付けたもの。起源は不明だが17世紀中頃には普及していた。「二重画鋲」の呼称が一般的だが、これは戦時中レコード盤などを代替材料として画鋲をつくる際に、2枚の円盤で針を挟み込んでつくったことに由来する。現在は円盤は1枚だが、取りやすいように円周に

沿って二重のような型押しが施されているものが多い（プラスチック製の頭部を持つものは、p149「プッシュピン」参照）。

紙
【かみ】

一般的には、植物の繊維を叩きほぐして水に分散させた後、絡み合わせて簀の子や網などで脱水・乾燥し膠着させて薄いシート状に成形したもの。書写材料の他、包装などさまざまな用途に利用される。紀元前2世紀頃中国で発明され、世界中に広まった。日本には610年に高句麗から渡来した曇徴が製紙技術を伝えた。世界各地でさまざまな植物を原料とした紙がつくられたが、1840年にドイツのケラーが木材から繊維を取り出す方法を発明して以降木材を原料とする洋紙が大量生産されるようになり、現在は紙のほとんどを木材由来の洋紙が占める。

紙で手を切る
【かみでてをきる】

紙の縁に指を滑らせてしまって皮膚が切れると、刃物以上に痛さが続くことがある。指先は神経が集中している上に、紙の小口は刃物に比べてギザギザした厚みのある鋸のような形状で組織が破壊されることや、紙に含まれる物質が皮膚内に残留すること、浅いと出血しないため修復が遅いこと、その後も普段の作業で書類などものに触れやすいことなど、さまざまな要因による。

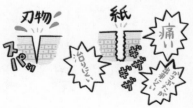

紙粘土
【かみねんど】

元来は「紙を主原料とした粘土のような性質（可塑性）を持つ素材」の意味だが、現在は炭酸カルシウムや結合材を主原料としてパルプを加えて練り合わせたものが主流。炭酸カルシウムの代わりに微小な樹脂製の中空球体を用いることで劇的に軽量化された軽量紙粘土と呼ばれるものもある。素材の変遷はあるが、全体としては、白く可塑性のある造形素材で、乾燥すると硬化し軽くなり、容易に着彩できるという共通した特徴を持つ。

紙目
【かみめ】

一般に紙は製造過程でパルプの流れる向きに沿って繊維の向きが揃いやすく、この異方性を「紙目」または「紙の流れ目」と呼ぶ。流れ目と平行には折れやすく裂けやすく反りやすいが垂直方向には折れにくく裂けにくく反りにくい。紙の長辺に沿って平行に繊維が流れている場合、その紙を縦目（T目）、紙の短辺に沿って平行に繊維が流れている場合、横目（Y目）の紙と呼び、寸法を表示する場合は、縦目の場合は短辺を先（例：210×

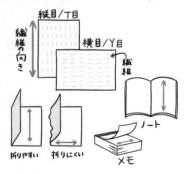

297mm）横目の場合は長辺を先（例：297×210mm）に表記する。紙目に逆らうと折りまげにくいので、ノートやメモなどでは紙目がめくる方向と垂直になるように使うのが普通。

ガムテープ
【ガムテープ】

本来はクラフト紙の基材に、アラビアガムを主成分とする水溶性の再湿糊を塗布した幅広の封かん用テープで糊面に水を付けて貼り付けるものを指すが、現在はクラフトテープ（→p61）を指して誤用されることが多い。

画用紙
【がようし】

絵を描くのに用いる厚手の洋紙。描画材や用途に合わせて表面の平滑度や吸水性などによってさまざまな種類がある。日本では四六判（788×1091mm）を基準に半裁を繰り返して切り分けた数によって「四つ切り」「八つ切り」と呼ばれる寸法で販売されるのが一般的。原料段階で着色された「色画用紙」は、工作などの材料としても使用されることが多い。

烏口
【からすぐち】

嘴状に配置された先端が尖った二枚の金属板の間に表面張力でインクを保持し平行移動させることで、均一な幅の線を正確に引くことができる製図用筆記具。板の間隔をネジで調整することにより、線幅を調節することが可能。

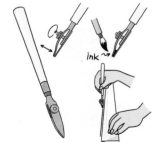

ガラスペン
【ガラスペン】

ガラス製のペン先を持つつけペン。紡錘形のペン先には表面に、毛細管現象でインクを保持する溝が軸方向に施されている。破損しやすい弱点はあるが、強酸インクにも腐蝕しない、顔料インクや墨汁でも詰まらず使用できる、インクの保持量が多く一度に筆記できる距離が長い、先端に方向性がなく誰でも使える、など優れた点も多い。特に、水洗いするだけですぐに別のインクに替えて筆記できる特長は、多種のインクを楽しむのに適している。ペン先にガラスを使う筆記具は、布に印を付ける用途で19世紀半ばのアメリカには存在しており、19世紀後半にはドイツで現在と同様の溝付きのペン先を持つものが登場している。日本では1902年に風鈴職人の佐々木定次郎が高価な輸入ペン先の代用品としてつくりはじめたとされ、第二次大戦中まで墨汁でも使える鋼ペンの代用品として実用されたが、現在は趣味性の高い筆記具として楽しまれている。

ガラス棒
【ガラスぼう】

先端が球形か半球状になったガラス製の棒。溝のついた定規とセットで使う。定規に直接当てて使うことのできない毛筆や烏口などの

筆記具で直線を引くために、箸を持つ要領で筆記具とガラス棒を平行になるように持ち、ガラス棒を定規の溝に合わせてスライドさせて使う。

カランダッシュ
【カランダッシュ】

スイスのジュネーブに本拠を構える筆記具メーカー。1915年に鉛筆工場として創業（ジュネーブ鉛筆製造所）。1929年に世界初の自動給芯機構を持つ全金属製クラッチペンシル「フィックスペンシル」を開発。鉛筆のような六角軸デザインが特徴の「849コレクション」や「エクリドール」で有名。

カリグラフィー
【カリグラフィー】

文字を美しく書く、美的様式を持った書法の総称。1～2世紀の古代ローマ碑文の文字が起源とされ、写本などを美しく書く技術としてさまざまな書体や様式が発達。その後の活字やフォントの書体にも大きな影響を与えている。通常は西洋や中東などのペンを使って筆記する書法を指し、東洋の毛筆による「書道」とは区別されるが、広義では書道や文字を使った抽象絵画なども含む場合がある。

カルトン
【カルトン】

①商店、金融機関、券売所などで、個人顧客との間で金銭、証券などの授受をする際に使用する小さなトレー。小銭や紙幣などを取り上げやすいよう、底面全面に柔軟性のある突起が敷き詰められているものも多い。

②デッサンやクロッキーをする際、用紙をクリップなどで固定し下敷として用いる厚紙製の画板（→p53）。一辺が蝶番状に接続された２枚組で周囲を紐で綴じるタイプのものが多く、２枚の間に作品や未使用の用紙などを入れて保管、保護する用途でも使用される。

カレンダー
【カレンダー】

主に１年の日付を順に記載した暦表を指し、月日、曜日や祝祭日などを容易に確認できるようにしたもの。日本ではグレゴリオ暦に基

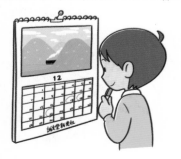

づき１年を12カ月に分け、七曜を横に並べた表形式が一般的だが、旧来の六曜や二十四節気なども表示されることがある他、日付を一列に並べたものや、１日が１枚の紙に印刷された冊子状で毎日１枚を破り取る「日めくりカレンダー」など多種多様。暦表と共に写真や絵画が印刷されるものが多く、壁に掛ける簡易的な美術品としての側面もある。

河原徳右衛門
【かわはらとくえもん】

(不詳-1888)明治初期、小池卯八郎（→p68）と前後して独力で鉛筆を開発。日本ではじめて鉛筆製造を工業化した１人。多くの弟子を養成し、輩出した多くの鉛筆製造業者はその後の業界の基礎をつくった。

顔彩
【がんさい】

日本画で使う絵の具（岩絵の具（→p33）などの顔料を膠や澱粉などで練ったもの）を小さな陶器に入れて固めた固形絵の具。水を含ませた筆で溶かすだけで簡単に使用できる。

感熱紙
【かんねつし】

熱による化学反応で顕色する物質（ロイコ染料と顕色剤）を塗布した紙で、局所的に温度を制御できる印字装置によって文字や絵を印刷することができる。インクやトナーなどを印字装置側に必要とせず装置が小型化できる

ことが特長で、ファクシミリなどの印字用紙に多く採用された。現在でもレシートや切符類などに多用されているが、温度変化の他、圧力・紫外線・ラインマーカーのインクや糊の成分などと反応して容易に顕色あるいは褪色してしまうので、長期の保存には向かない。多くは1色しか表現できないが、2007年にアメリカのZINK imagingが開発した感熱紙には反応温度と顕色が異なる複数の物質が含まれ、印字ヘッドの温度制御によってフルカラー印刷を可能にしている。

カンペンケース
【カンペンケース】

ブリキ製のペンケース。「カンペン」とも。多くは身と蓋が蝶番状に連結されたシンプルな構造で、主に学童向けとして1980年代に大流行した。ファンシー文具（→p146）ブームとも重なり、キャラクター商品が多数販売された。上下を分割するトレーを内蔵したり双六などのゲーム要素を採り入れたものまでさまざまな種類が販売されたが、授業中に落とすと大きな音をたてることなどが問題視された。その後カラーペンなどが普及するにつれ所持する筆記具が増えると、人気はより大容量な布製のポーチ型ペンケースに移行した。

菅未里
【かんみさと】

文具ソムリエール。各種メディアにて文房具や文房具の使い方・楽しみ方などの紹介や講演・執筆の他、商品の監修なども行っている。著書に『毎日が楽しくなる きらめき文房具』（KADOKAWA）、『文具に恋して。』（洋泉社）など。

顔料
【がんりょう】

描画や着色に使う、溶媒に溶けない有色で不透明な物質。

顔料系
【がんりょうけい】

色剤として顔料を用いたインクや絵の具、またそれを使った筆記具などのこと。一般に耐水性があり、染料に比べて隠蔽力が高く、紙など下地の色にかかわらず鮮やかに発色する。マーキングペンなどは顔料の沈殿を防ぐために寝かせて保管するのがよいとされる。

きだてたく
【きだてたく】

色物文具コレクター（→p33「イロブン」参照）。文房具ライターとして雑誌・WEBなどで活躍。文房具トークユニット「ブング・ジャム」の1人。著書に『イロブン 色物文具マニアックス』（ロコモーションパブリッシング）、『愛しき駄文具』（飛鳥新社）など。

キッズデザイン賞
【キッズデザインしょう】

特定非営利活動法人キッズデザイン協議会が主催する、子供や子供の産み育てに配慮した製品・空間・サービス・活動・研究を対象とするデザイン賞。受賞した商品などには「キッズデザインマーク」を表示することができる。

キャップレス
【キャップレス】

パイロットが1963年から発売しているキャップのない操出式万年筆。回転操出式にはじまり、1964年にはノック式が発売されている。片手で使える利便性が人気。

キャンパスノート
【キャンパスノート】

コクヨが1975年から発売している大学ノートを中心とする紙製品ブランド。メインの無線綴じノートは、1975年の発売以来、1983、1991、2000、2011年に改良を加えてリニューアルし、現在は5代目。現在はリングノートやルーズリーフなど、綴じ方の他、ドット入り罫や、ドット入り文系線・ドット入り理系線など、罫のバリエーションも多い。

鳩居堂
【きゅうきょどう】

1663年に京都で薬種商として創業した、京都本能寺前町と東京銀座にそれぞれ本店を構える和紙製品、書画用品、香の老舗専門店。1942年に販売部門の京都鳩居堂と東京鳩居堂、製造部門の鳩居堂製造に分社化。

京極夏彦
【きょうごくなつひこ】

日本の作家。著作のページ数が多いことで有名。氏の著作はブックカバーなどをつくる際のある種の限界目安ともなっており、「京極も大丈夫です」というのはブックカバーの対応力を示すセールストークの1つ。

京大式情報カード
【きょうだいしきじょうほうカード】

梅棹忠夫（→p36）が提唱したB6サイズの情報カード。厚みのあるケント紙で表は横罫、裏面は白紙。梅棹が自身の研究で実践した情

報整理の経験から設計し特注していたが、『知的生産の技術』上梓以降注目を集め、同仕様のものが梅棹の知らぬ間に商品として市販されていた。著書内では「京大型」と表記されている。

キルビメーター
【キルビメーター】

先端に付いている小さな車輪が転がった距離を表示する装置。図面に当てて測定したい曲線をなぞることにより、その曲線の長さを計測できる。特に地図上の経路距離を測るのに用いることが多く、複数の縮尺表示が用意されているのが普通。先端の回転を歯車で物理的に拡大表示するダイヤル式と、縮尺を自在に変更できるデジタル式がある。「曲線計」「マップメーター」「マップメジャー」とも。

キン肉マン消しゴム
【キンにくマンけしゴム】

ゆでたまごの漫画『キン肉マン』の登場キャラクターをかたどった小型の塩化ビニル樹脂製人形。1983〜1987年にバンダイからカプセル型自販機の景品として発売され、爆発的

な人気商品に。「消しゴム」の名が付いているが硬く、消字能力は極めて低い。「キンケシ」と呼ばれた。

金封
【きんぷう】

冠婚葬祭時に贈る金銭を納めるための、主に和紙で金銭を包むように折られた折り紙の総称（祝儀袋、不祝儀袋、熨斗袋、香典袋などを含む）。目的に応じた水引や熨斗などの装飾があしらわれる。折り方や装飾は、用途や地域、宗派などによってさまざまな様式がある。

金ペン
【きんペン】

ペン先の主材に金を主とする合金が使用されている万年筆。酸性の強いインクを使用しても腐蝕しにくいことややわらかく書き心地がよいなどのメリットがある反面、非常に高価。金はやわらかく実用強度が得られないことから、14K（含有率58.5%）〜18K（含有率75%）程度の合金が使われることが多い。

斤量
【きんりょう】

「連量」（→p186）と同義。かつて尺貫法時代に重量の単位として「斤」を使用していたことから、連量の意味で現在でも慣習的に使われることがある。

クーピーペンシル
【クーピーペンシル】

サクラクレパスがフランスのベニヨール・ファルジョンと共同開発し1973年から販売する木部を持たない色鉛筆。全体がポリエチレンを主とする芯の材料で形成されている。一般的な色鉛筆に対し、芯が太く折れにくく、1974年に特許を取得した独自の配合で筆記性を保ちつつも消しゴムで消えやすいことを特徴とした。当初から高級感のある缶入りで削器が付属しており「全部が芯」と謳ったテレビCMで人気商品に。現在でもほとんどデザインを変えておらず、全芯色鉛筆の代名詞的存在。

串田孫一
【くしだまごいち】

(1915-2005) 日本の詩人、哲学者、随筆家。文房具の業界紙『月刊事務用品』への連載が書籍化された著書『文房具』(白日社)[後に増補され『文房具56話』(ちくま書房)に]は文房具エッセイとして有名。

鯨尺
【くじらじゃく】

江戸時代から主に和裁に使われた尺で、鯨尺の1尺は曲尺(→p52)の1尺2寸5分。1891年に度量衡法で25/66m(約37.9cm)と定められた。1958年の尺貫法廃止に伴い法定計量単位ではなくなり、1959年に計量法により製造、使用が禁止されたが、1976年の永六輔らの尺貫法復権運動により1977年に計量行政審議会で議論が行われ、「尺相当目盛り付長さ計」(尺相当の長さの目盛りが付いているが、値はメートルのものさし)はメートル法によるものさしとし、合法であるという判断がなされている。

楠田枝里子
【くすたえりこ】

日本の司会者、エッセイスト。日本有数の膨大なコレクションを誇る消しゴムコレクターとして有名。著書に『消しゴム図鑑』(光琳社)がある。公式サイトにて、コレクションの一部を公開中。

グッドデザイン賞
【グッドデザインしょう】

公益財団法人日本デザイン振興会が主催の総合的デザイン賞。1957年に通商産業省が創設した「グッドデザイン商品選定制度」を前身としている。受賞した製品などにはGマークを表示することができる。

首チョンパ
【くびチョンパ】

トンボ鉛筆のMONO1ダースにおまけとして
付けられた玩具。軟質樹脂でつくられたロケッ
トのような円筒状の本体に当時人気だった
ザ・ドリフターズのメンバー（いかりや長介、
加藤茶、仲本工事、高木ブー、荒井注）の頭
部を模った人形をはめて、本体を握ると頭部
が勢いよく飛ぶ。大変な人気になったが、教
育上問題があるとの批判も多かった。

雲形定規
【くもがたじょうぎ】

さまざまな曲線で構成された曲線を描くため
の定規。描きたい曲線にちょうど合う部分を
探して使う。

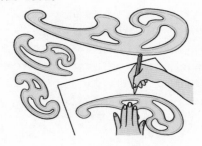

クラウドファンディング
【クラウドファンディング】

ものやサービスの企画・アイデアに対し不特
定多数の人がインターネット経由で少額出資
する資金調達方法。出資が企画実現に必要な
最低額に達した場合成立し起業者に資金が渡
る。あくまで出資のため企画が完成しないと

いうリスクもある。文房具などの製品の企画
の場合、出資の見返りとしてその製品が充て
られることが多く、早期受注生産に近い状況
になりがちである。

暮しの手帖
【くらしのてちょう】

暮しの手帖社が発行する1948年創刊の生活
総合誌。創刊時は『美しい暮しの手帖』。
1956年から開始された独自の基準で行われ
る徹底した商品テストによる日用品の評価記
事で有名（商品テスト記事は2007年に終了）。
ボールペン、消しゴムなど多くの文房具もテ
ストの対象となった。

グラシン紙
【グラシンし】

高度に叩解したパルプを抄いてつくった紙を
加熱・加圧ローラー（スーパーカレンダー）
に通すことで繊維間の空隙を無くした光沢の
ある半透明の高密度の薄紙。透過性があるの
で窓付封筒に使われたり、耐湿性や耐油性が
あるので、食品や薬品をはじめさまざまな包
装用途に使われる。これにパラフィンを塗布
するとパラフィン紙となりさらに物理的特性
が向上する。

クラフトテープ
【クラフトテープ】

クラフト紙を基材とする幅広の粘着テープ。
主にダンボール箱の封かんなどに使用される。
ガムテープ（→p54）と呼ばれることも多い
が本来は別物。一般
的には表面がラミネ
ート加工されていて、
重ね貼りや表面への
筆記には適さないが、
昨今は改良されたタ
イプもある。

クラフトパンチ
【クラフトパンチ】

手芸、工作などの装飾用途に使われる紙用の穿孔工具。多くは紙用で、一度に画用紙1枚程度の穿孔能力（→p101）だが、個体ごとに固有の形状の穴をあけられる。一度に複数の穴からなる複雑な図案の穴をあけるものや、ガイドに合わせて位置を移動しながら穿孔することで連続した形状に加工ができるものなど多種。

グラフ用紙
【グラフようし】

多数の数値からなる情報を二次元平面上に配置してその変化や比較などを視覚的に表現するための専用罫を備えた用紙。目の細かい方眼罫のものを指すことが多いが、表現したい情報に応じて対数や極座標などさまざまな座標の罫が用意されている。パーソナルコンピューターの普及により需要が激減した。

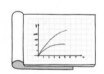

クリアファイル
【クリアファイル】

丈夫な表紙の中に透明な薄いポケット状のページを多数持つ冊子状のファイル。書類に穴をあけずに収納・整理でき、書類を保護したまま閲覧できる。「クリア（クリアー・クリヤ・クリヤー）ブック」「クリアポケットホ

ルダー」など、各社表記が異なる。一般用語としては単葉のクリアホルダーを指す場合も多い。

クリアホルダー
【クリアホルダー】

透明な樹脂シートを二つ折りにし、折り目と接する1辺を溶着した形の書類ケース。「クリア（クリアー・クリヤ・クリヤー）ホルダー」「クリヤーフォルダー」など、各社表記が異なる。着色や印刷が可能で、キャラクターグッズやノベルティなどにも多用される。本来冊子状のファイルを指す呼称「クリアファイル」と呼ばれることも多い。

グリーティングカード
【グリーティングカード】

クリスマスや新年、誕生日など記念日や時候の挨拶、感謝などを表現するために贈るメッセージが添えられたカード。単純なカードから、立体的な仕掛けや、音や光が出る仕組みまで多種多様。語義としては年賀状も含むが、年賀状はこれとは別のジャンルとして含まないことが多い。

グリーン購入法
【グリーンこうにゅうほう】

「国等による環境物品等の調達の推進等に関する法律」の略称。国、独立行政法人らおよ

び地方公共団体に、環境負荷の低減に配慮した製品やサービスを優先的に購入すること（グリーン購入）を義務づける法律。特定調達品目ごとに適合基準が設けられ、適合商品情報を公開することで、一般企業などにも広くグリーン購入を促し、持続的発展可能な社会の構築を目指している。多くの事務用文房具がこの特定調達品目に該当するため、適合基準を満たす開発が重要視されている。

繰出鉛筆
【くりだしえんぴつ】

広義ではシャープペンシルと同義だが、主に回転操出式のものを指す。

クリップ
【クリップ】

①重ねた複数枚の紙を素材の弾性を利用して挟み込み、穴をあけたり折ったりすることなく一時的に留めておく小さな器具。保持する紙の枚数や用途によってさまざまな種類がある。

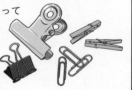

②筆記具などが衣服のポケットから滑り落ちることを防ぐために取り付けられた挟んで留める固定具。

グリップ
【グリップ】

道具の手で握る部分。特に筆記具において指で把持することを前提に疲労軽減や操作性向上のために設計された他の軸部分とは異なる形状や材質の部位を指す。

クリップボード
【クリップボード】

机上のような安定的な平面が用意できない場所で用紙への記入を円滑に行うため、書類を平らな状態で支持することを目的とした、支持したい用紙よりもひとまわり大きな硬質の板に用紙を固定するためのクリップなどを取り付けたもの。「用箋ばさみ」とも。

クルトガ
【クルトガ】

三菱鉛筆が2008年に発売したシャープペンシル。接地のたびに筆圧を利用して芯を回転させる機構「クルトガエンジン」を内蔵。芯先を常に均等に摩耗させることで、描線は細く保たれ、芯先は折れにくくなる。芯そのものに作用するという画期的な発想は以降のシャープペンシル開発に大きな影響を与えた。

クレールフォンテーヌ
【クレールフォンテーヌ】

フランスの紙製品メーカー。1858年に製紙工場として創業。1951年からノートの製造に着手。自社で製造するなめらかでインクがにじみにくい筆記用紙「ベラム紙」（→p158）を使ったノートで有名。1997年にロディア（→p188）を製造するヴェリヤック兄弟社を買収した。

クレ556
【クレごーごーろく】

呉工業が販売する防錆潤滑剤。防錆剤を含む鉱物油が浸透力の強い溶剤で金属の隙間に入り込み、金属表面に薄い皮膜をつくり潤滑・防錆効果を発揮する。古い機械などの可動部やネジに固着した油脂を溶かす効果があり、動かなくなった古いステープラーやパンチ、タイプライターや計算機などの事務機械類の整備には必携。長期にわたって潤滑の必要な部分には粘度の高いグリースなどが必要。

クレパス
【クレパス】

1925年に櫻商会（現在の株式会社サクラクレパス）の佐々木昌興が、画家の山本鼎と共に、クレヨンの簡便性とパステルの表現力を備えた描画材として世界ではじめて開発したオイルパステル。クレヨンよりも顔料を多く含み、固形ワックスの他に液体の油脂を使うことでやわらかく重ね塗りできる。「クレパス」はサクラクレパスの商標で、一般名称としては「オイルパステル」。単に「パス」と呼ばれることも多い。

クレヨラ
【クレヨラ】

アメリカに本社を構えるクレヨン・画材メーカー。1864年にジョセフ・ビニーが顔料メーカーとして設立（ピークスキル ケミカルワークス）。1885年にエドウィン・ビニーとC.ハロルド・スミスが引き継ぐ（ビニー&スミス）。1903年に発売した「クレヨラ　クレ

ヨン」は、現在も世界的に普及しているクレヨンとして有名。

クレヨン
【クレヨン】

元来の広義には鉛筆やコンテなどを含む棒状の画材の総称だが、日本では一般的にパラフィン・木蝋などと顔料を混ぜて固めた画材を指す。19世紀末頃フランスで発明されたもので、パステルに比べ硬質だが、定着剤が不要で扱いが簡単なので、児童画や初等教育に使われる。日本には1915年頃に丸善と五車堂がアメリカからクレヨラを輸入。大正時代に山本鼎らが提唱した自由画教育と共に全国に普及した。その後櫻商会が開発したクレパス以降、オイルパステルが普及し現在は主流の座を譲る。

クロス
【クロス】

アメリカに本社を構える筆記具メーカー。1846年にリチャード・クロスが創業。息子のアロンゾ・タウンゼント・クロスが「スタイログラフィックペン」など多くの発明を残す。創業100周年を記念して1946年に発売された「センチュリー」などで有名。

グロス
【グロス】

①ものの個数の単位。144個。12進法で12ダース（→p106）。なぜか今でも鉛筆だけは

12進法で数えられることが多い。②全体、まるごとの意。③光沢、艶、反意語はマット（つや消し）。

黒田善太郎
【くろだぜんたろう】

(1879-1966) コクヨの創業者。1905年に小林表紙店から独立し、和式帳簿の表紙を製造する「黒田表紙店」を開業。1913年から洋式帳簿の製造をはじめ、既製紙製品全般へと事業を拡大。1917年には「国（越中国）の誉れとなるように」との思いから「国誉」の商標を定め、現在のコクヨの礎を築いた。

クロッキー帳
【クロッキーちょう】

鉛筆、木炭、コンテなどを使って短時間で素早く描画するクロッキー（速写画）用の画帳。一般的なスケッチブックと比べると、耐水性のない薄手で、鉛筆などの乗りがよい肌理を持った専用紙が使われ、安価で頁数が多いのが普通。アイデアスケッチや構想のメモなど、さまざまな用途の雑記帳としても使われる。

罫
【けい】

ノートや便箋など筆記を目的とした用紙に、文字を揃えて書くためにあらかじめ引かれた線。罫線。

蛍光
【けいこう】

紫外線や短波長の可視光線が照射されるとそのエネルギーを吸収して電子が励起し、それが基底状態に戻る際に余分なエネルギーを光として放出する発光現象。この現象を起こす色素は、蛍光マーカーや、紙の蛍光増白剤、ブラックライト照射中のみ発光して読める不可視インクなどに使用される。

蛍光ペン
【けいこうペン】

蛍光色素を含有した透明色インクを使用したハイライター（→p136）。蛍光色素を配合することで塗布された部分が明るく強調されるのが特長だが、蛍光色素を含まず、色彩のみによって強調するものも慣習的に「蛍光ペン」と呼ばれる場合がある。蛍光インクを使ったマーキングペンとしては、1963年にカーターズ・インク・カンパニーが発売した「グロー・カラー・マーカー」が最初だが、蛍光インクを用いたハイライターとしてはドイツのスワンスタビロ社（→p96）が1971年に発売した「スタビロ・ボス」（→p92）が最初。

計算機
【けいさんき】

計算を機械的・自動的に行う装置の総称。コンピューターも含む。算盤（→p103）のような人が行う演算を補助する器具は「計算器」として区別する。

計算尺
【けいさんじゃく】

対数を利用したアナログ計算機。加算、減算はできないが、乗算、除算の他、対数、三角関数、平方根などの計算ができる。関数電卓以前の計算機は主に四則演算しかできなかったため、1970年代まで理工系の分野で広く実用された。他にも航空、写真、医療などさまざまな目的に合わせた特殊な目盛りを持つものが多数存在する。日本の逸見製作所（現在のヘンミ計算尺株式会社）が製作した孟宗竹のものは世界的に評価が高く、1960年代には世界シェアの大半を占めたといわれている。

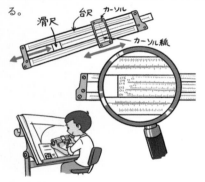

罫引き
【けいびき】

ノートなどの罫線を引くための機械。回転軸に任意の間隔で固定した薄い金属製の円盤の周縁部にインクをつけて、紙の上を転がして罫線を印刷する。印刷は平行線のみで、方眼罫を印刷する場合は一度印刷した紙を90度回転させてもう一度機械にかけて印刷する。水性インクを使用するため、現在主流のオフセット印刷（→p44、油性インク使用）とは異なり、万年筆のインクを弾かないのが特長。

消しゴム
【けしゴム】

主に鉛筆やシャープペンシルで筆記した描線に擦りつけ、黒鉛を吸着して消去するために使う天然ゴムまたは軟質プラスチックを原料とする塊（→p87「字消し」参照）。最古の記録は1770年にイギリスのジョゼフ・プリーストリー（→p87）が、文具商エドワード・ネアンから購入したゴムが鉛筆で書いた文字を消し去ることについて記述しており、その消字（rub out）能力から、ラバー（rubber）と名付けたといわれている。現在主流のプラスチック消しゴムは、1952年に日本の堀口乾蔵が塩化ビニルによる字消しの製造法を特許出願しており、1956年には日本国内の複数のメーカーから発売されている。

消しゴムはんこ
【けしゴムはんこ】

プラスチック消しゴムを原版とする凸版画表現。消しゴムを使った版画としては1985年から2002年まで活動したナンシー関が有名だが、ヒノデワシが彼女に消しゴムを提供したのをきっかけに1995年に消しゴム版画専用の字消し「はんけしくん」を発売。木版画などに比べて彫刻が容易で手軽にはじめられることから、2000年代に入ってから主婦層を中心に人気となり、多くの人気作家が登場。「消しゴムはんこ」としてハンドクラフトホビーの1ジャンルを形成するに至った。

決裁箱
【けっさいばこ】

未決裁の書類を一時的に収納、保管する箱。
書類よりも一回り大きな身蓋の平らな箱で、
単に書類の収納保管や分類な
どにも使われる。

ゲルインク
【ゲルインク】

ボールペンのインクの一種。リフィルの筒内
ではゲル（固体状）のインクがボールの回転
による剪断力を受けて液体状になり紙に転
写・浸透し、その後再び固体状に戻ることで
素早く定着する。油性・水性に比べ流動性が
制御しやすく、極細ボールペンを可能にし、
また筒内のインクが流動しないので、顔料の
沈殿が起こらず、下地が透けない鮮やかな発
色やラメ入りなど、ボールペンの多色化が可
能となった。1984年にサクラクレパスが発
売したボールサイン280が世界初。

原稿用紙
【げんこうようし】

１文字ごとに記入するためのマス目が区切ら
れている罫紙。20文字×10行を左右に配置
した400文字が標準的。中央の空行に魚尾と
呼ばれる記号があるのは、中央で外折りにす
る和綴じ製本の名残り。様式の起源には諸説
あるが、1681年に黄檗宗の禅僧、鉄眼道光
が大蔵経を翻刻した『黄檗版鉄眼一切経』に
由来するといわれる。古くは漢文の筆記や板
刻のための用紙（続けて書くかな文字には不
向き）、江戸中期の服部南郭による「寐隠弁」
にすでに使用されている。明治に入って漢字
訓読体の文章の筆記に使用されるようになり、
明治中期以降は活版印刷の普及に伴い、原稿
の文字数を把握することが必要になったため、
記者、作家を中心に、活版印刷の草稿を書く
現在の原稿用紙が普及した。洋紙製の原稿用

紙は浅草の相馬屋が尾崎紅
葉に提案されてつくったの
が最初といわれている。

原産国表示
【げんさんこくひょうじ】

製品を製造した国。日本では景品表示法によ
り「商品の内容について実質的な変更をもた
らす行為が行われた国」と定義されている。
つまりその製品にとって最も重要な加工が行
われた国のこと。たとえば外国製の材料や部
品を使っても日本で重要な加工や組み立てを
行えば日本製（Made in Japan）となる。製
造が国外でも設計やデザインが日本であるこ
とを誇示したい場合は（Designed in Japan）
などの表記をする場合もある。

限定品
【げんていひん】

生産数量、販路、販売期間など何らかの販売
条件を意図的に限定した商品。多くは購買欲
の刺激、ブランド価値の向上、流通へのイン
センティブなど戦略的な目的による。文房具
でもイベント限定や店舗限定など近年の文房
具ブームにおける
消費刺激策として
常套化している。

ケント紙
【ケントし】

化学パルプを原料とした、純白で硬く締まっ
た上質の図画用紙。マットな表面は鉛筆やシ
ャープペンシルとの相性がよく、比較的厚手
でインクがにじまず、消しゴムをかけても毛
羽立たないため、製図や漫画の原稿用紙など
に適している。イギリスのケント地方発祥と
言われている。

小池卯八郎
【こいけうはちろう】

(生没年不詳)1873年にウィーン万国博覧会に伝修生として派遣された井口直樹(→p31)と藤山種廣(→p148)から鉛筆の製法を伝授され、1874年に鉛筆工場を興した。時期を前後して鉛筆の製法を独自に開発した河原徳右衛門(→p56)と並んで日本ではじめて鉛筆製造を工業化した1人。

誤飲防止
【ごいんぼうし】

乳幼児の誤飲事故を防ぐために、筆記具のキャップなどには、万が一呑み込んでしまっても気道が確保できるよう通気孔を設けるなどの設計の他、口に入れたときに強烈な苦みをあたえて呑み込ませないという方法もある。使われるのは世界一苦い成分として知られるデナトニウムベンゾエートという物質で、毒性はないが、ごく微量でも不快な苦みを感じるため、乳幼児向けの玩具や文房具などに塗布するなどして使われる。

交換日記
【こうかんにっき】

1冊の日記帳を恋人、友人、家族など2人またはそれ以上で共有し、交互・順番に記録していく記帳方法、またそのためにつくられた日記帳。学校などに持ち出して手渡す必要があるため、第三者に盗み見られることを防ぐための錠前付きのものもある。

抗菌
【こうきん】

製品表面の細菌の増殖を抑制するように加工されている製品を抗菌加工製品といい、JIS(→p80)では、加工されていない製品の表面と比較し、細菌の増殖割合が100分の1以下である場合、その製品に抗菌効果があると規定している。医療現場や公共の場で不特定多数の使用を想定した筆記具などに抗菌加工を施したものがあるが、あくまで表面の細菌の増殖を抑制するものであって、細菌を殺す「殺菌」や取り除く「除菌」、ほぼ全てを殺すまたは除去する「滅菌」とは区別される。

航空法
【こうくうほう】

航空法第86条には「爆発性又は易燃性を有する物件その他人に危害を与え、又は他の物件を損傷するおそれのある物件で国土交通省令で定めるものは、航空機で輸送してはならない。」とあり、航空機の客室内への文房具の持ち込みは主に凶器と判断される刃物類について制限される。国土交通省のガイドラインでは、はさみの場合「先端が尖っていないもので刃体6cm以下であれば持込可能」とされているため、多くの携帯はさみはこの基準を満たしているが、形状、重量その他の事情により凶器であることを疑うに足りる相当な理由がある場合は、持ち込みを拒絶することができるとされているため、現場の判断で拒絶される可能性は否定できない。

工作用紙
【こうさくようし】

主に学童の造形教育用素材として使用するこ

とを目的としたボール紙。目的の寸法に加工
しやすいよう、裏面には目安となる方眼が印
刷されているものが多い。

硬度
【こうど】

硬さのこと。鉛筆の芯の硬度はH（hard）と
B（black）で表示され、数字が大きいほどH
はより硬く、Bはやわらかくなる。HとBの
間にHBを置き、HBとHの間にF（firm＝堅く
引き締まった）が置かれている。ニコラ・ジ
ャック・コンテ（→p129）が考案した製法
によって、黒鉛と粘土の混合比率を変えるこ
とで硬度を調節できるようになり（粘土が多
いほど硬い）、コンテは鉛筆に硬さを示す数
字を付けた。現在使われているHとBの基準
をはじめて採用したのはロンドンの鉛筆メー
カー、ブルックマン。日本のJIS（→p80、
日本産業規格）では6Bから9Hまでの17硬度
が規定されているが、三菱鉛筆は10B〜10H
の22硬度、ステッドラー社は12B〜10Hの24
硬度を販売している。

硬筆
【こうひつ】

毛筆（軟筆）に対し、鉛筆、万年筆、フェル
トペン、ボールペンなど、毛筆以外の筆記具
（毛筆に比べると先端が硬い）を総称する書
写書道用語。

小売店
【こうりてん】

メーカーや卸売業者から仕入れた商品を消費
者に直接販売する店。

コーネル式
【コーネルしき】

ノートを3つの領域
にあらかじめ分けて
記録することを特徴としたノート術。主な記
録領域の左にキーワード、下に要約を記入す
る。アメリカのコーネル大学教授ウォルタ
ー・パークが、学生が授業のノートを取りな
がら理解するための方法として開発し、著書
『How To Study In College』で発表したもの。
日本では学研ステイフルがこのメソッドを応
用したノートを販売している。

黒鉛
【こくえん】

炭素の同素体の1つで、鉛筆の芯の主成分。
古代より描画材として使われたが、1560年
代にイギリスのボローデールで良質の鉱床が
発見され、工業的に利用されるようになった。
金属光沢のある黒色の六角板状結晶が層状に
重なったもので、層と層の間の結合力が弱く
容易に剥離する性質があり、何かに擦りつけ
ると黒い痕跡を残すため、発見当初から筆記
材として使用された。安定性が高く導電性、
耐熱性、潤滑性に優れ、さまざまな用途で使
用される。元素について理解が進むまでは鉛
を含むと思われていた。「グラファイト」「石
墨」とも。

黒板
【こくばん】

チョークで文字などを書くための黒または暗緑色に塗装された板。チョークの筆跡を黒板消しなどで拭き取ることで繰り返し使用できる。日本では1872年にアメリカから大学南校（現在の東京大学の前身の１つ）に導入されたのがはじめとされる。

コクヨ
【コクヨ】

大阪に本社を構える文具・事務機器、オフィス家具メーカー。1905年に黒田善太郎（→p65）が和式帳簿の表紙製造メーカーとして創業（黒田表紙店）。既製紙製品から事務機器、オフィス家具へと事業を拡大し日本を代表する総合メーカーへ。キャンパスノート（→p58）などで有名。連結子会社に2000年創業の通信販売会社カウネット（→p49）がある。

5×3カード
【ごさんカード】

約５×３インチの寸法の情報カード。アメリカの図書館学者で十進分類法を考案したメルヴィル・デューイが図書目録用のカードとして1877年に米国図書館協議会に提唱し採択された規格で、実際には３×５インチではなく7.5×12.25cm。扱いやすい大きさでさまざまな用途の情報カードとして利用されるだけでなく、ジョッター（→p87）に入れて携帯するメモ用としても普及している。

腰リール
【こしリール】

キーホルダーやIDカードホルダーなどに使われる伸縮リールに、単語カードやメモ帳と着脱可能な小型筆記具を取り付けて自作するメモ用具。腰（ベルトなど）に固定しておき、いつでもすぐに引き出してメモをとることができる。製品として販売されているものではなく個人レベルで実践するメモの工夫として広まった。

個人情報保護スタンプ
【こじんじょうほうほごスタンプ】

郵便物や書類などに印刷された文字情報を読めなくするために、読まれたくない文字列の上に捺すスタンプ。スタンプ自体は一般的な浸透印（→p88）タイプが多いが、文字列を隠蔽するための特殊なパターンが刻まれているのが特徴。個人情報保護法の施行以降、主に個人情報の流出を防ぐためにシュレッダー（→p85）の簡易な代用品として発売され普及した。

個人情報保護法
【こじんじょうほうほごほう】

2003年に成立し2005年に全面施行された「個人情報の保護に関する法律」の略称。高度情報通信社会の進展に伴って拡大する個人情報の利用の有用性を認めた上で、個人の権利利益を保護するため、個人情報（特定の個人を識別することができる情報）を所持し事業に用いている事業者に対し遵守すべき義務と罰則を定めたもの。この法律の施行によって事業者は勿論、個人にまで個人情報の流出や悪用などの危険性に注目が集まり、シュレッダー（→p85）などの情報保護機器市場が大きく広がった。

骨董市
【こっとういち】

主に骨董を扱う古物の露天市。休日に寺社仏閣、公園などで行われることが多いが、近年は見本市会場などを使って大規模に開催されるものもある。古い文房具・事務用品や、文房具に関連する古い資料なども出品されていることが多く、アンティーク文具ファンにとっては貴重な品を入手する機会の1つ。

コットンペーパー
【コットンペーパー】

ぼろ布からつくられた紙を起源としていて、木綿繊維を原料としたやわらかく嵩高な洋紙を指したが、現在は化学パルプを原料とするものも含まれる。一般に表面が粗でで手ざわりがやわらかく嵩があり、書籍用や筆記用に使われる。

古典インク
【こてんインク】

空気に触れて鉄の化合物が酸化する反応を利用し、時間経過と共に青から黒に変色し、耐水性・耐候性を持つ万年筆用のインク。没食子（→p175）などから得られる。タンニン酸と硫化鉄（II）を混合することでインク内に生成される、没食子酸鉄（II）（無色で水によく溶ける）が、空気に触れて酸化すると没食子酸鉄（III）（水に溶けない真っ黒の安定した化合物）に変化する。しかしこれでは筆記するときに透明で文字が書きづらいので、青い染料を加え、筆記時には青く、時間経過と共に黒く変化するインクとした。これがブルーブラックと呼ばれる所以である。ただし、このインクは、インク瓶やペンの中にあっても徐々に酸化が進むので、沈殿したりペン内部に固着するなどの危険性があり、また遊離した硫酸が強い酸性を示すため、金属を腐食しやすいなど、扱いにくい特徴がある。このため、現在は、一部の製品を除いて、ブルーブラックという色名でも暗青色の染料インクであることが多く、これと区別するために「古典インク」「古典ブルーブラック」と呼ばれるようになった。

ご当地インク
【ごとうちインク】

小売店や観光地などが発売する特色の万年筆インク。販売地域や店舗を限定したり地域の名所や歴史にちなんだ配色や色名が採用されることが多く、コレクターズアイテムとして人気の銘柄も多い。中でも神戸のナガサワ文具センター（→p126）が神戸の風景をテーマに発売する「Kobe INK物語」はすでに70色を超え、同店の看板商品の1つとなっている。

ご当地文具
【ごとうちぶんぐ】

観光地などで販売される地域限定仕様の文房具。観光名所などをモチーフにしたデザインのものが多い。小ロットで地域性を出しやすいことから紙製品やマスキングテープ（→p169）などが多いが、レーザー加工技術などにより手の込んだ装飾を施したものも増えた。

→ボールペン

五倍子
【ごばいし】

ウルシ科ヌルデ属の葉の付け根にヌルデシロアブラムシが寄生した刺激により防御反応として組織が肥大化して生じた虫こぶ。その主成分はタンニンで、古典インク（→p71）の原料や布の染料、革をなめす際タンパク質を除去する薬品として使われる。日本ではお歯黒の原料としても使われた。「ふし」「ヌルデミミフシ」とも。

コピック
【コピック】

1987年にトゥーマーカープロダクツが発売したアルコール系カラーマーカー。当初はPPC（→p143）コピーのトナーを溶かさないデザイナー向けカラーマーカーとして展開された

が、その後コミック・イラスト用途での需要の増加に合わせてラインアップを拡張。発色がよく速乾性で扱いやすい。358色（2019年現在）にも及ぶインク色は、色相や彩度の等分割ではなくそれぞれ想定される用途に適した色からなる独自のカラーシステムを持ち、特にコミック・イラスト用途では圧倒的な人気を誇る。

コヒノール
【コヒノール】

チェコに本社を構える文房具メーカー。正しくは「コヒノール ハードマス」。1790年にジョセフ・ハードマスがオーストリアに陶器工場として創業（ハードマス）。その後鉛筆製造をはじめ、1889年の万国博覧会で17硬度を揃えた黄色い鉛筆「コヒノール1500」を発表。その品質の高さと塗装の美しさは高く評価され、上質な鉛筆の象徴的な色として多くのメーカーが鉛筆に黄色を採用するようになったといわれている。色鉛筆や芯ホルダーなどが有名。

ゴルフ鉛筆
【ゴルフえんぴつ】

ゴルフのスコアを書き留めるためにゴルフ場が配布する鉛筆。かつては短い鉛筆にゴルフ場の名入れをしたものだったが、現在はほとんどペグシル（→p157）に置き換わったため、これを指すことが多い。

コレクター
【コレクター】

収集家。あらゆる分野に収集家は存在するがもちろん文房具を収集するコレクターも数多く存在する。入手経路は店頭や骨董市だけでなくオークションサイトや個人売買サイトにも広がり、収集の対象やその範囲、収集の動機などは千差万別だが、非常に製品などの多いジャンルなので、時代、メーカー、品種の限定など独自のルールを設けたり独自の体系化がなされていることが多い。万年筆など同種のコレクターが一定数いるジャンルでは情報・物品の交換などを行う会が開催されることもある。

コロリアージュ
【コロリアージュ】

フランス語で彩色を意味する言葉で、塗り絵の意だが、キャラクターなどの絵を塗るものではなく、幾何学模様や植物などをモチーフにした緻密な文様を塗り分ける大人向けのものを指す。2013年にイギリスのイラストレーター、ジョハンナ・バスフォードが発表した『Secret Garden』が世界で2千万部以上売り上げる人気となったのをきっかけにストレス解消に効果のある大人向けの趣味としてフランスで流行、日本にも紹介されて、手軽にはじめられるホビーの1ジャンルとして人気となっている。

コンテ
【コンテ】

顔料に粘土を混ぜて主に角柱や円柱型に焼成した描画材で、デッサンやクロッキーに使われる。顔料は黒鉛の他、酸化チタン（白）や酸化鉄（茶）などがある。ニコラ・ジャック・コンテ（→p129）が発明。鉛筆の粘土芯（→p132）と同源で、描画用途に発展したもの。固着剤が含まれないので、保存するためには描画後に定着液（フィクサチーフ）を噴霧して固定する必要がある。

コンバーター
【コンバーター】

万年筆のインクカートリッジの代わりに装着することで、インクを吸入して保持するインク吸入容器。任意のインクを吸入して筆記することができる。

コンパス
【コンパス】

①ツマミを持つ支持部から伸びた開閉自在な2本の脚の一方に針、もう一方に筆記具を備え、針の先端を突き立てた点を中心に回転させて円を描くことのできる製図用具。コンピューターの普及により製図用具としてはほとんど使われなくなったが、小学校の中学年で学習する算数で必須のため、学童文具としては未だ大きな市場を形成している。数学的には一次及び二次方程式で表現される問題は定規とコンパスのみで作図可能。「ぶんまわし」「円規」とも。②方位磁針のこと。

「定規」と「ものさし」は違うもの?

　本来、「定規」と「ものさし」は、用途目的の異なる道具を表す言葉で、意味が異なります。「定規」は、正しい形の原形・見本で、「ものさし」は長さを測る基準です。ものさしは「尺」とも呼ばれます。

　英語で言えば定規は「ruler」、ものさしは「measure」や「scale」となります。

　たとえば、三角定規や雲形定規は形が重要で、目盛りはなくても定規として成立する一方、巻き尺は柔らかく形が定まらないのは問題ありませんが、目盛りは必須です。

　「定規」が示す直線や直角などの形は、時代や文化を超えて普遍的ですが、「ものさし」は、よりどころにしている物や文化によって、目盛りの幅が変わります。メートルやインチ、鯨尺、どれも基準が異なりますが、使う人々の合意によって成立しています。だから絶対的な正解があるわけではなく、統一するのはじつは難しい。

　このように「定規」と「ものさし」は、言葉上は明確な違いがありますが、普段私達が最もよく目にする直定規の多くに目盛りが印刷されていて、「定規」と「ものさし」の両方の機能を併せ持っているために、その違いがわかりにくくなっているのだと思います。あえて区別するなら、鉛筆を滑らせて直線を作図しているときはその道具を「定規」として使っていて、物に当てて目盛りを読み、長さを測っているときは「ものさし」として使っているということになります。

　話や考え方がかみあわない時に「ものさしが違う」などといいますが、それは、目盛りが違う、ということであって、尺度や基準が違うという比喩なんですね。

トビラ雑学 **3** › ステープラーの針のサイズ

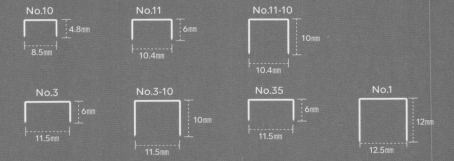

No.10 4.8mm 8.5mm

No.11 6mm 10.4mm

No.11-10 10mm 10.4mm

No.3 6mm 11.5mm

No.3-10 10mm 11.5mm

No.35 6mm 11.5mm

No.1 12mm 12.5mm

ステープラーの針の名称とサイズ

名称	肩幅（内寸）mm	足長さ（外寸）mm	綴じ枚数（枚）	対応機種
No.10	8.4	4.8	2枚〜32枚	
No.11	10.4	6	2枚〜40枚	バイモ11シリーズ
No.11-10mm	10.4	10	2枚〜80枚	バイモ80
No.3	11.5	6	2枚〜30枚	
No.3-10mm	11.5	10	30枚〜75枚	
No.35	11.5	6	2枚〜30枚	
1210FA-H	11.5	10	30枚〜70枚	
1213FA-H	11.5	13	50枚〜110枚	
1217FA-H	11.5	17	110枚〜170枚	
1224FA-H	11.5	24	150枚〜200枚	
No.1	12.5	12		
2115 1/4L	10.5	6.3		プライヤータイプホッチキス（HP-50）
2115 5/16L	10.5	7.9		プライヤータイプホッチキス（HP-50）
2115 3/8L	10.5	9.5		プライヤータイプホッチキス（HP-50）

あ ア
か カ
さ サ
た タ
な ナ
は ハ
ま マ
や ヤ
ら ラ
わ ワ

サーモクロミック
【サーモクロミック】

加熱や冷却など温度変化の刺激によって色が可逆的に変化する性質を持つことをサーモクロミズムといい、この性質を持つ材料をサーモクロミック材料（示温材）と呼ぶ。パイロットのフリクションシリーズに代表されるような温度によって変色するインクはサーモクロミックインク（示温インク）と呼ばれる。

再生材料
【さいせいざいりょう】

使用済み製品または製造工程から出る廃棄物を回収し、新しい製品の材料として利用するものをいい、前者をポストコンシューマー材、後者をプレコンシューマー材と呼ぶ。特にプラスチック製品におけるポストコンシューマー材は成分のバラツキや不純物などの問題があり、ごく一部を除き、文房具・雑貨などの日用品は、より高い純度を要求される光学部品や医療機器などの製造工程から出るプレコンシューマー材を利用することが多い。対義語として原料から新たに生成された未使用の材料をバージン材料と呼ぶ。

再生率
【さいせいりつ】

文房具では主に紙とプラスチックについて、製品に使われている材料に含まれる再生材料の重量比。 エコマークやグリーン購入法（→p62）などの適合認定において製品の環境負荷の参考指標の１つとして利用される。

裁断機
【さいだんき】

紙などを所定の形に切る道具。「裁断」には、決められた形に裁ち切ることという意味があり、１枚の紙を正確に所定の寸法に切り出す目的の道具を指すことが多い（→p111「断裁機」参照）。

財閥三菱と何等関係ありません
【ざいばつみつびしとなんらかんけいありません】

戦後GHQが指示した財閥解体によって財閥三菱に対しロゴマークと商標の使用停止を迫ったのに対し、同じ商標を使用しながら財閥とは無関係な三菱鉛筆が商標を使い続けるため、財閥とは無関係であることを示す目的でに商品や広告に表記した文言。他に「NON財閥」「非財閥」などの表示も見られた。

サイン帳
【サインちょう】

サインやメッセージなどを収集するためのリーフバインダー式の小型ノート。学校の卒業時などに同窓生や先生にサインを書いてもらう用途で1980年代に流行した。その後、より詳細な記入項目が用意されたプロフ帳（→p154）に人気は移行した。

サインペン
【サインペン】

1963年に大日本文具（現在のぺんてる株式会社）が発売した細字の水性マーキングペン（→p168）。発売当初日本での売れ行きはよくなかったが、アメリカの見本市で配布したものがアメリカの大統領リンドン・ジョンソ

ンの手に渡り、24ダースもの注文を受けたことで注目された。重力に影響されない筆記具として1965〜1966年にはアメリカの有人宇宙飛行計画で、ジェミニ6号・7号の装備に採用され、宇宙に行ったペンとして国内でも大ヒットした。現在は同種の筆記具を指す一般名称化している。

サクラクレパス
【サクラクレパス】

大阪に本社を構える筆記具・画材・文房具メーカー。1921年に佐武林蔵が佐々木昌興と共同で創業（日本クレイヨン商会）、1925年にクレヨンとパステルの長所を持ち合わせた世界初のオイルパステル「クレパス」（→p64）を発売。1984年には世界初のゲルインクボールペン「ボールサイン280」を発売。全芯色鉛筆「クーピーペンシル」（→p60）などでも有名。

雑誌の付録
【ざっしのふろく】

一部の雑誌において、添付される付録はいまや売上を大きく左右する重要な競争要素。文房具も比較的採用されやすいがその品質は年々向上しており、充分実用的な万年筆が採用されたりすると文房具ファンの間でも話題に上る。景品表示法の規制をうけるため1000円未満の雑誌に添付できる上限は原価200円だが、多くは広告を伴って提供される非売品のため、実質的にはより高価で、雑誌の価格の割にとても魅力的。

三角定規
【さんかくじょうぎ】

製図に用いられる2枚1組の直角三角形の定規。一方が30°・60°・90°の角を持つ直角三角形で、もう一方が45°・45°・90°の角を持つ直角二等辺三角形。通常、前者の長隣辺と後者の斜辺の長さが等しい。等角投影法や斜投影法で頻繁に使用される30°・45°・60°・90°を含み、2枚を組み合わせて滑らせることで平行線を引くことができる。

三角スケール
【さんかくスケール】

地図や建築図面など縮尺図面上で使用するためのものさし。断面が三角形で、各面の両側にそれぞれ異なる縮尺の目盛りがあるので計6種類の縮尺に対応できる。採用される縮尺は業種や用途によって異なるので購入の際には注意が必要。「サンスケ」とも。

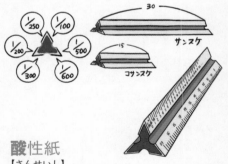

酸性紙
【さんせいし】

酸性の紙。19世紀中頃から20世紀中頃までの木材を原料とした洋紙のほとんどに採用されたサイズ剤（インクのにじみ止め）として使われた、ロジン（松脂）は、定着剤として硫酸バンド（硫酸アルミニウム）を必要とし、これによって紙が酸性になった。硫酸バンドは空気中の水分と反応して紙を酸加水分解してしまうため、紙が劣化しやすく保存性が悪い。

サンフォード
【サンフォード】

1857年創業のアメリカに拠点を置く世界最大の筆記具メーカー。ニューウェルブランズの子会社で、多くのメーカーを吸収。シャーピー、ペーパーメイト、プリズマカラーの他、ウォーターマン、パーカー、ロットリング、リキッドペーパー、ベロール、ローロデックス、ダイモなど多くのブランドを持つ。北アメリカでの三菱鉛筆の専属代理店も務める。

サンリオ
【サンリオ】

東京に本社を構えるギフト雑貨、文房具、カードなどの商品の企画・販売からキャラクターコンテンツの開発、版権許諾、テーマパークの運営まで幅広い事業を行う企業。1960年に辻信太郎が設立（山梨シルクセンター）。ハローキティをはじめオリジナルキャラクター群を数多く生み出し、1980年代のファンシー文具（→p146）ブームを牽引。現在でも同社のコンテンツは日本を代表するkawaiiキャラクターとして世界中で愛されている。

ジアゾコピー
【ジアゾコピー】

芳香族ジアゾニウム塩の光分解反応を利用する複写技法、青写真（→p28）とは逆で白地に線が青い（ポジ）表現。原稿と感光紙を重ねて露光し複写するため等倍精度が高く大判紙も複写可能なことから機械図面や建築図面の複写に多用された。「青焼き」とも。

シード
【シード】

大阪に本社を構える消しゴム・修正テープメーカー。1915年に三木康作が創業（三木康作ゴム製造所）。1958年にプラスチック消しゴムを世界に先駆けて生産開始したメーカーの1社で、1968年に発売したレーダーが、1970年『暮しの手帖』（→p61）で高く評価されたのをきっかけに人気となった。1984年に世界初となる修正テープの特許を出願、1989年に発売した。

シーリングスタンプ
【シーリングスタンプ】

封筒や手紙、容器などの封を留めると共に、未開封であることを証明するための封蝋（→p147）に差出人を証明する印を施すために捺す印章。印面は金属製で、溶かした封蝋を封筒などに垂らした上から押し当ててその刻印を写す。「印璽」とも。

シーリングワックス
【シーリングワックス】

封蝋（→p147）のこと。

シール
【シール】

装飾・表示・封かんなどに使われる、あらかじめ裏面に粘着剤が塗布された紙片の総称。元来は文書の発行者を証明する印章類（封蝋を含む）を指したが封蝋に封印の機能があることから封印の意味も持ち、印章でなくても封かん用の糊付き紙片も含むようになり、さらに転じて糊付きの紙片全般にも使われる。現在はステッカーやラベルとほぼ同義に使われている。

ジェットストリーム
【ジェットストリーム】

三菱鉛筆が2004年に発売した油性ボールペン（北アメリカ・ヨーロッパでキャップ式を発売。日本発売は2006年のノック式が初）。従来品よりも明らかに粘度の低いインクを開発し、油性ボールペンでありながら軽く流れるような書き心地で多くの人を驚かせ「低粘度油性ボールペン」という新しいジャンルを確立した。その粘度や書き心地のバランスは絶妙で、発売以来10年以上経過してなお日本のボールペン市場で圧倒的な人気を誇る。

栞
【しおり】

読書を中断する際に読みかけている頁に挟んで再開の目印とするもの。短冊状の紙片やそれに紐が付いたものが多いが、他の素材を使ったものや、今開いているページに自動的に追従する工夫がなされたものなど付加価値・付加機能を持つ製品も多い。同様の目的で手帳や日記帳の背の上部にあらかじめ取り付け

られた紐（→p94「スピン」参照）も栞と呼ばれる。

シカゴ・タイプライター
【シカゴ・タイプライター】

アメリカのジョン・T・トンプソンが立ち上げたオート・オードナンス社が1919年に開発した短機関銃「トンプソンサブマシンガン」を指す。断続的な銃声がタイプライターの操作音に似ていることからついた俗称。禁酒法時代のシカゴでマフィアが抗争に使用したことで有名になった。

紙器
【しき】

紙を加工してつくった容器の総称。文房具関連では、ギフトボックスや収納ケースなど商品やその付随品としての紙製容器を指す場合もあるが、商品の出荷箱や紙製の店頭什器（→p83）などを指す場合にも使われる。

色紙
【しきし】

和歌、俳句、書画などを書くための四角形の厚紙だが、有名人のサイン、力士の手型の他、送別・卒業・引退などでコミュニティを離れる人に贈る寄せ書きなどに使用されることが多い。一般的な寸法は、大が6寸4分×5寸6分（19.4×17cm）、小は6寸×5寸3分（18.2×16cm）の2種とされるが、寄せ書き用のものについては近年寸法も形状もこれに拘らず、自由な形式のものが多数発売されている。

字消し
【じけし】

消しゴム（→p66）のうち、軟質プラスチック製のものを、天然ゴム製の消し"ゴム"と区別するために用いる語。

字消し板
【じけしばん】

消しゴムで図面などの細部を消す際に、消したい部分以外を消してしまわないよう保護する、穴のあいた金属製の薄い板。消したい部分の形状に合わせてさまざまな形の穴が用意されている。

自在定規
【じざいじょうぎ】

鉛やアルミニウムなどのやわらかい金属の芯を軟質樹脂等で覆った製図用定規で、手で自由に曲げることができる。曲線をなめらかに作図する際に使用する。

指示棒
【しじぼう】

壁面に図表や資料などを掲示・投影して行う講義、説明の際に、講演者が特定の位置を指し示すために使用する棒。携帯しやすい伸縮可能な金属製の多段式のものが多く、先端部を取り外すとボールペンが収納されているものもある。「指し棒」とも。

JIS
【ジス】

「日本産業規格（Japanese Industrial Standards）」の略。産業標準化法に基づき制定される国家標準で、日本の工業製品の寸法や性能などさまざまな事項を統一、単純化するために、それらの標準や測定法などが定められている。文房具についても多くの規格が存在する。

自炊
【じすい】

書籍などを所有者本人がスキャナーなどを利

用して電子化することの俗称。電子化を効率的に行うために冊子を断裁機で枚葉に分解して連続給紙型スキャナーにかけるなどのさまざまな工夫が共有され、これらの行為を積極的に行う人たちを「自炊派」と呼ぶ。著作権などの問題があるため、あくまで書籍の所有者本人が個人的に行う行為であり、作成した電子データの閲覧、利用は本人に限定される。

システム手帳
【システムてちょう】

リングバインダー式で本文（リフィル）の差し替え可能な手帳の総称。1984年にイギリスのファイロファックスが日本で販売を開始してからブームとなり、まだ携帯電話やノートPCなどが登場・普及する以前の1980〜1990年代には個人向け情報管理ツールとして一気に広まった。最も普及しているサイズは、95×171mmのバイブルサイズ（→p136）と呼ばれる6穴タイプだが、大はA5サイズから、小はミニ6穴、マイクロ5まで、いくつかの共通規格があり、複数のメーカーが販売するリフィルを組み合わせるなど、使い方

の自由度は高い。

下敷き
【したじき】

ノートなどに筆記する際、筆記の安定性を高め、裏面の文字などが次の頁に写ったり筆圧で紙に凹凸がつくことを防ぐために、ページの下に差し入れて使用する平滑な表面を持つ薄板。一般的には硬質で筆記の摩擦感を低減するものが多いが、硬筆書写やボールペンでの筆記など、滑りすぎるとかえって扱いにくい場合に使う適度な摩擦感を生む軟質の素材のものもある。

試筆
【しひつ】

新年に初めて毛筆で文字を書くこと、書き初めのこと。最近では試し書き（→p110）の意味でも使われることが多いが、本来は誤用。

澁澤榮一
【しぶさわえいいち】

（1840-1931）実業家。2024年から発行される新一万円札の肖像。大蔵省官吏を経て第一国立銀行の設立の他、明治期の日本の多くの企業の立ち上げに関わり、設立育成した企業の数は約500社にものぼる。その中には、明治初期に洋紙の製造を開始し、その後日本最大の製紙会社となる王子製紙（抄紙會社）も含まれている。

シャー芯
【シャーしん】

シャープペンシル用芯（→p82）のこと。

シャープペンシル
【シャープペンシル】

主に黒鉛を主成分とする棒状の
固形芯（シャープペンシル用芯）
を消耗品として内蔵し、先端か
ら芯を突出させて紙に摩擦して
転写する筆記具のうち、芯のみ
を筆記に適当な長さ分だけ押し
出して固定する機構を有するも
の。現存する最古のものは1791年に沈没した
フリゲート艦HMSパンドラから発見されたも
のとされているが（芯を押し出す機構を持っ
ていたかは筆者には確認できなかった）、特
許上は1822年イギリスのジョン・アイザッ
ク・ホーキンスとサンプソン・モーダンが最初。

シャープペンシル禁止
【シャープペンシルきんし】

主に小学校などの初等教育の現場において、
児童・生徒に鉛筆の使用を義務づけ、シャー
プペンシルの使用を禁止する状況がしばしば
見られる。この理由については、適切な筆圧
をかけられないから、正しい持ち方が身につ
かないから、分解組み立てに夢中になって授
業に集中できないから、盗難やいじめの原因
になりうるから、貧富の格差に対する配慮な
ど諸説あるが、真意は定かではない。ただ、
学校側としては禁止しておいた方が無難とい
う点においては概ね一致している。

シャープペンシル用芯
【シャープペンシルようしん】

シャープペンシルに用いる芯。主に黒のポリ
マー芯だが、粘土芯や色芯もある。0.3、0.5、
0.7、0.9、2mmについてはJIS S 6005に規定
されているが、特に直径は、製品が普及した
後に規格の方が実情に合わせて制定されたの
で、呼び寸法と実際の寸法にずれが生じてい
る（たとえば、呼び寸法0.5mmの芯の実際の

直径は0.55〜0.58mm）。
長さは60mmが一般的。

シャーボ
【シャーボ】

1977年にゼブラが発売した軸の回転によっ
てシャープペンシルとボールペンを使い分け
られる複合筆記具。「右に回すとシャープペ
ンシル、左に回すとボールペン」というコピ
ーのテレビCMで同社を代表する人気商品に。
ラインアップにはAppleのデザイナーとして
有名なジョナサン・アイブが学生時代にロン
ドンのデザイン事務所RWGのインターン中
にデザインしたモデル（TX-2 1988年）も含
まれる。現在はシャーボXシリーズなどさま
ざまなモデルに発展。

写経
【しゃきょう】

主に仏教の経典を筆写することを指し、西洋
の写本などとは区別される。印刷技術が普及
する以前は布教に必要な経典を写本する行為
であったが、筆写する行為そのものを信仰や
供養の実践の1つとして行うようになった。
現在では、信仰の有無にかかわらず学習や修
練として行われることも多い。この場合は般
若心経が採用されることが多い。

シヤチハタ
【シヤチハタ】

愛知県に本社を構える印章・スタンプを中心
とする文房具メーカー。1925年に舟橋金造と

弟の高次が「万年スタンプ台」を開発し創業（舟橋商會）。1965年に独自開発の製法による多孔質ゴムを印面に使用した浸透印「Xスタンパー」を発売。1968年には認め印に応用した「シヤチハタ・ネーム」を発売。社名の「シヤチハタ」が浸透印式認め印の代名詞となる。

JANコード
【ジャンコード】

個々の商品がどの国のどのメーカーのどの製品かを機械的に識別するためにバーコードで表示される、国際的な共通商品コードEAN（European article number）の日本での呼称（Japanese article number）の略。アメリカ・カナダのUPC（Universal Product Code）とも互換がある。コードは13桁または8桁の数列で、事業者コードと商品アイテムコード、チェックデジットから構成されており、日本の事業者コードは一般財団法人 流通システム開発センター が管理している。商品の販売・受発注・物流・在庫管理などの重要な基礎情報として利用されている。

修悦体
【しゅうえつたい】

警備員の佐藤修悦が2003年から工事中のJR新宿駅の仮設壁面に布テープ（→p130）を使用して書いた案内表示をはじめとする佐藤

氏オリジナルの字体。布テープ（→p130）を使った極太の線の角を丸く切り整えた独特な力強い文字がSNSなどで話題となった。

什器
【じゅうき】

商品などを陳列するための器材の総称。店舗に設置されるラックやショーケースなどの「店舗什器」から、特定の商品を効果的に陳列するためにPOPを兼ねた「販促什器」、その他、汎用の陳列用の器具機材全般を含む。特に「ゴンドラ」と呼ばれる金属製の棚位置を自由に設定できるラックは、多くの小売店、量販店などで使用されていて、店舗什器の基準となっている。文房具を扱う店舗では3尺と呼ばれる900mm幅が一般的で、内寸が880mm程度なので、販促什器の多くは横幅が880mm以内で設計されることが多い。

自由研究
【じゆうけんきゅう】

主に初等・中等教育において、長期休暇や総合的学習の時間に、児童・生徒に与えられる、テーマや研究方法を本人が自由に設定できる研究課題。工作などの創作活動が含まれる場合もある。自主性や自由な探究心、創造性などを伸ばすことが期待されるが実際には何をしていいかわからず苦慮する子供も少なくなく、テーマや方法に関する参考書や、研究・工作キットなども多数販売されている。

重心位置
【じゅうしんいち】

筆記具などにおける、前後の重量の釣り合いがとれる位置。筆記具の扱いやすさの指標の1つとして捉えられることが多く、中央寄りやや前寄りの方が扱いやすいといわれるが、好みには個人差がある。また同じ重心位置でも、質量の分布によって慣性質量は異なり、取り回しのしやすさは異なる。

修正液
【しゅうせいえき】

書類等の誤字修正のため、誤字の上から紙面に塗布して隠蔽する、白色顔料を含む塗料。1951年にアメリカのベティ・ネスミス・グラハムが、タイプライターの誤字を修正する目的で考案、1956年に「ミステイクアウト」（後に「リキッドペーパー」）として販売したのが最初。当初は筆で塗布するものだったが1983年にぺんてるが先端にペンタイプのノズルを持つ目薬型を発売。以降ペンタイプへと発展する。

修正テープ
【しゅうせいテープ】

書類などの誤字修正のため、隠蔽力の高い白色顔料と粘着剤が塗布されたセパレーターを紙面に押しつけながら巻き取り、紙面に顔料を転写して誤字を隠蔽する道具。世界に先駆けて1984年にシードが考案し特許出願したが、

商品としては1989年にペリカン社が発売した「Rollfix」が世界初。同年シードが「ケシワード」を発表し、発売は翌年。

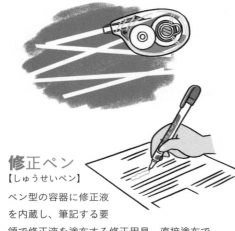

修正ペン
【しゅうせいペン】

ペン型の容器に修正液を内蔵し、筆記する要領で修正液を塗布する修正用具。直接塗布できるペンチップを備えた修正液はぺんてるが1983年に発売した目薬型の「ぺんてる修正液」が世界初で、その後完全なペン型ボディやボールペンタイプのペンチップなどへ改良される。

自由帳
【じゆうちょう】

主に学習帳のうち無罫のものを指す。一般的には学習帳の1品種として同一フォーマットの表紙を持つ。学校において用途を制限されない雑記帳として、漫画を描くなど教科外の使用をされることも多い。幼児向けの天糊製本の無罫雑記帳を指すこともある。

樹脂芯
【じゅししん】

ポリマー芯（→p164）のこと。

樹脂玉
【じゅしだま】

主にゲルインクのノック式ボールペンや、その替芯において、製造から使いはじめるまでの間に、インクが空気に触れて劣化したり、インクが流出したりすることを防ぐためにペン先を覆って密閉するように付けられた樹脂。最初の使用時に爪先などで取り除く。

出荷単位
【しゅっかたんい】

商品の中間流通段階での最小単位。発注ロットとも。小売店などはこの数の倍数でしか発注できない。文房具は、一部の高額品を除き、小売店への出荷単位が3〜20程度のものが多く、客がこれを下回る個数で注文を希望しても対応できない場合がある。

手動計算機
【しゅどうけいさんき】

歯車などの機械要素を用いて演算を行う機械式デジタル計算機で、手動のもの。1623年にドイツのヴィルヘルム・シッカートの発明が最初といわれ、現存する最古のものは1642年にフランスのブレーズ・パスカルが作成したもの。日本では、1901年に矢頭良一が制作したものが最初だが、大本寅次郎がつくったタ

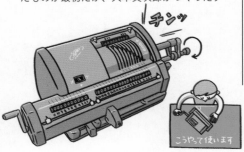

イガー計算機は極めて信頼性が高く、最も普及した製品として有名。電子卓上計算機が普及する1970年代まで実用品として使われた。

朱肉
【しゅにく】

印章（→p34）を捺すために用いる印肉のうち、朱色のもの。「印泥」とも。古くは辰砂（硫化水銀の鉱石）からつくられる朱色の顔料と植物油をヨモギなどの植物繊維に染み込ませ練り合わせたものだったが、水銀を含むことから、近年では他の顔料に置き換わっている。現在はスポンジなどに顔料を含ませて代用される簡便なものが多い。

趣味の文具箱
【しゅみのぶんぐばこ】

枻出版が定期刊行するムック。万年筆を中心とした高級筆記具を主に扱う。

シュレッダー
【シュレッダー】

投入した紙を細片にまで断裁することで、書類を復元不能にする装置。情報漏洩を防ぐなどの目的で使用される。紙片が細かいほど復元の難易度は高く、紙片の寸法による7段階のセキュリティレベルがドイツ工業規格（DIN）で規定されている。個人情報保護法（→p71）施行以降、企業の必需品として急激に普及して認知度が上がり、個人情報漏洩への関心から一般家庭にも小型の個人用機が普及した。紙だけでなく光学メディアや磁気メディアなども破砕できる機種もある。

シュレッダーはさみ
【シュレッダーはさみ】

書類を細かく断裁することによって情報漏洩を防止することに特化したはさみ。複数の刃を同時に開閉するなど裁断効率を高める工夫がなされている。パーソナルシュレッダーの代用品。

瞬間接着剤
【しゅんかんせっちゃくざい】

シアノアクリレートを主成分とする接着剤。対象物の間に挟んで圧接すると、表面積が広がり、周囲のわずかな水分に反応してモノマー状態のシアノアクリレートが瞬間的に重合することで硬化する。アメリカのハリー・クーヴァーが発明し1958年に発売された「イーストマン#910」が世界初。

小学一年生入学準備号
【しょうがくいちねんせいにゅうがくじゅんびごう】

小学館が発刊する小学1年生の児童を対象にする総合雑誌。特に入学前の入学準備号には保護者向けの情報が整理された別冊「入学がわかる本」が付属。ここに掲載される一覧を参考に文房具を購入する家庭も多く、学童文具業界には影響力が大きい。

定規
【じょうぎ】

直線や曲線、または特定の角度や形状の原形となる道具の総称で、それをなぞることで、必要な場所にその図形や角度などを写し取る。「ルーラー」とも。文房具としては、直線を引くための直定規、角度が決められた三角定規（→p77）、さまざまな曲線を持つ雲形定規（→p61）、テンプレート（→p119）など、主に製図などに使用するためのものを指す。

状差し
【じょうさし】

①先端が尖った金属棒を垂直に固定した基部を机上または壁面に設置し、処理中の伝票などの紙片を突き刺して一時的に保持するもの。
②主に郵便物など書状を差し入れておくために壁面や柱に設置するポケット状の入れ物。「レターラック」とも。

消字率
【しょうじりつ】

字消しの文字を消す能力を数値化したもの。100に近いほど消字能力が高い。JIS S 6050に規定された所定の手順によって、HBの鉛筆で着色した上質紙の表面に試料となる字消しを圧接して摩擦し、着色部の濃度Cと摩消部の濃度Mの比から、消字率 $E = (1 - M/C) \times 100$ として表される。

商標
【しょうひょう】

事業者が、自己の商品・サービスを他人のものと区別するために使用する、文字・図形・記号またはその組み合わせからなるマークのことで、登録すると他者の使用を排除する商標権が生じる。1997年に立体的な形状からなる商標、2015年に色彩のみからなる商標が追加された。

情報カード
【じょうほうカード】

情報を記録、整理するために用いる、厚紙でできた定型の紙片。用途に応じてさまざまな寸法や罫のものがある。並べ替え可能な図書などの目録として発達し（→p70「5×3カード」参照）、簡単なデータベースとして研究等のさまざまな用途に使用される（→p58「京大式情報カード」参照）。

書見台
【しょけんだい】

書物を読みやすくするための傾斜台。可搬性のある折り畳み式のものが多いが図書館などに設けられた資料閲覧専用の傾斜机も含まれる。

ジョゼフ・プリーストリー
【ジョゼフ・プリーストリー】

（1733-1804）イギリスの自然哲学者。1774年に脱フロギストン空気（酸素）の単離に成功。炭酸水の発明者としても有名。1770年に天然ゴムが黒鉛の鉛筆で書いた文字を紙から消し去る目的に使えることをはじめて記述。文字を消し去る（rub out）ことから「rubber＝消しゴム」の名を付けたといわれている。消しゴム発見者といわれることが多いが、その記述には文具商エドワード・ネアンが黒鉛を消す商品としてすでに販売していたものを購入したことが書かれており、消字能力の発見者ではない。

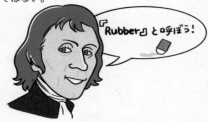

「Rubber♪と呼ぼう！」

食刻
【しょっこく】

対象物表面の不要部分を化学的または電気化学的に溶解させて除去する加工法。非加工部に防錆処理を施した金属素材を腐蝕液に浸すことで刻印装飾を施したり印刷版などをつくることができる。写真と類似した手法で防錆被膜を形成できるので複雑なパターンの加工が可能。「エッチング」とも。

ジョッター
【ジョッター】

表面に紙片を差し入れて固定し、未記入の筆記面を露出した状態で携帯するメモカード入れの一種。多くはポケットに入り手のひらに収まるほどの大きさの革製の板で、ポケットから取り出してすぐに安定した筆記が可能。5×3カード（→p70）に対応したものが多い。

あ
ア
か
カ

さ
サ

た
タ
な
ナ
は
ハ
ま
マ
や
ヤ
ら
ラ
わ
ワ

書道
【しょどう】

主に毛筆を使って文字を書く東洋美術の1様式。日本では特に芸道として発達した独自の体系を指す。他に文字の書き方を習う意の「習字」「書き方」「手習い」、文字を書き写す意の「書写」があるが、現在の学校教育では文字を美しく書く修練としてほぼ同義に使われることが多い。

芯
【しん】

ものの中心にあるものの総称で、文房具では主に鉛筆やシャープペンシル等の筆記具に内蔵される固形描画材やボールペンのリフィル等を指すことが多い。

芯研器
【しんけんき】

鉛筆や芯ホルダーの芯のみを尖らせるために研削する製図用具。平板状のヤスリに手で芯を擦りつけて研ぐものや、らせん状の刃の周りに芯ホルダーを回転させて芯を円錐状に削るものなどがある。

真鍮
【しんちゅう】

銅と亜鉛の合金で「黄銅」「ブラス」とも呼ばれる。強度、加工性、価格のバランスがよく扱いやすいため、昔は精密機械などの部品に多用された。文房具ではシャープペンシルのチャック（→p112）などに使われる。比重が8.5前後と、鉄（7.9前後）よりもさらに

重く、表面が酸化して黒ずんだ色に変色するのが欠点だが、「ずっしりと重量感があって高級感がある」「手に馴染んで味が出てきた」などとポジティブに捉えられることが多いため、近年特に趣味性の高い中高級文房具の外観素材として人気。

浸透印
【しんとういん】

印面に多孔質のゴム素材を使い、これにインクを浸透、保持させることで、朱肉やスタンプパッドなどを必要とせず連続押印できる印章（→p34）。認め印や頻繁に使用する業務スタンプなどに多用される。認め印としては広く普及しているが、印面が軟質で変形するため、ゴム印と同様、印鑑用の印章としては使用できない。

芯ホルダー
【しんホルダー】

主に黒鉛を主成分とする棒状の固形芯を消耗品として内蔵し、先端から芯を突出させて紙に摩擦して転写する筆記具のうち、芯を押し出す機構を持たないもの。

図案
【ずあん】

一般的には「デザイン」の意味だが、マルマンが発売するスケッチブックのシリーズ名として有名。図案シリーズは、1958年より量産開始され、現在でも販売され続けるロングセラー。特徴的な表紙のデザインはもはや日本を代表するスケッチブックとして誰もが知る。

水彩色鉛筆
【すいさいいろえんぴつ】

水を含ませた筆でなぞることで水彩画のようににじませたりぼかしたりすることができる色鉛筆の一種。親水性のない芯に乳化剤を添加することで水溶性を持たせている。

水彩紙
【すいさいし】

水彩絵の具など水分量の多い画材での描画に適した厚手の画紙の総称。一般の画用紙よりも表面に強めのにじみ止め処理が施されていて、吸水しにくく顔料が繊維内に入り込みにくいため、絵の具の発色がよく、絵の具を置いた後でもぼかしや重ね塗りなどの技法が使えるといった特徴がある。

水性
【すいせい】

液状物質の溶媒の主成分が水であること、または固体物質が水溶性であること。筆記具や画材はもちろん、接着剤などについても当てはまられる。

水滴
【すいてき】

墨を磨る際、硯に適量の水を滴下するのに用いる容器。水さし。

吸取紙
【すいとりがみ】

つけペンや万年筆で筆記した紙面に押し当てて乾いていない余剰のインクを吸い取り、乾燥を早めることで、書類の汚れや、隣ページへのインク写りを防ぐために用いる吸水性の高い紙片。枚葉としてノートや手帳に挟み込んで使う他、机上ではブロッター（→p153）に装着して使用する。

スーパーカー消しゴム
【スーパーカーけしゴム】

1975年連載開始の『サーキットの狼』に触発されたスーパーカーブームを受け、1977年からカプセルトイの景品として複数のメーカーから発売され大流行した塩化ビニル製のミニチュアカー。「カーケシ」とも。消字能力はほとんどないが、子供たちはあくまで消しゴムであると主張し学校に持ち込み、さまざまな遊びを生みだした。三菱鉛筆のボールペン「BOXY」（→p161）が弾いて走らせるのによく使われた。

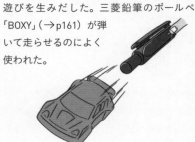

図画工作
【ずがこうさく】

文部科学省が小学校の学習指導要領に定める教科の1つ。略して「図工」。表現及び鑑賞の活動を通して造形的創造活動の基礎能力と豊かな情操を養うことを目的としている。さまざまな画材や工作用具に触れたり買い揃えるきっかけでもある。

透かし
【すかし】

部分的に薄く漉いた紙を光に透かして見たときに現れる模様。「ウォーターマーク」とも。紙の品質保証や、偽造防止、ブランドを誇示するなどの目的で製紙メーカー名や品名、ブランドロゴなどを漉き込んだもの。日本の紙幣に使われている透かしは「黒透かし」と呼ばれ、部分的に厚く漉く特殊な技法で「すき入紙製造取締法」により許可なくつくることが禁じられている。切符などの偽造防止目的で肉眼では認識しづらい特殊なインクを使って情報を印刷したものや、電子文書に組み込まれる改ざん防止情報なども、「透かし」と呼ばれる場合がある。

隙間ゲージ
【すきまゲージ】

機械部品などの隙間に差し入れて隙間の広さを測定する薄い金属板。段階的に異なる厚さの板が用意されている。本来は測定の為の器具だが、非常に薄く丈夫で、さまざまな厚さが用意されているため、万年筆のスリットの隙間の調整に転用される。

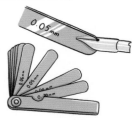

スクラップブッキング
【スクラップブッキング】

アルバムや台紙に写真などを配置して、ペーパークラフトの各種技法を駆使して飾るアート・ホビーの一種。

スクラップブック
【スクラップブック】

主に新聞・雑誌などから切り抜いた紙片を貼り付ける台紙を綴じた冊子。丈夫でコシのあるクラフト紙が使われることが多い。紙を貼り付けてページが分厚くなるのが前提なので、背幅に余裕がある製本が特徴。漫画家みうらじゅんが愛用していることでも有名。

スクリーントーン
【スクリーントーン】

裏面に粘着性のある透明フィルムに、網点やカケアミ、連続柄などのパターンが印刷され

たもの。モノクロの漫画やイラストレーションなどの原稿を作成する際に、必要な形に切り抜いて貼り付ける。手書きでは難しい均質な階調表現や手間のかかる背景などに使う。

スケジュール帳
【スケジュールちょう】

カレンダーを備え、予定管理機能を持つ帳面の総称。「手帳」（→p117）とほぼ同義で使われる。

スケッチブック
【スケッチブック】

主に厚手の画用紙や水彩紙、ケント紙などを綴じた画帳の総称。リング綴じで硬い厚手の表紙を持つものが多いが、天糊製本のものもある。

スケブ
【スケブ】

①スケッチブックの略称。②同人誌即売会などにスケッチブックを持参し、出店している作家に記念にイラストを書いてもらうこと。

すごい文房具
【すごいぶんぼうぐ】

2010年にKKベストセラーズより発行された文房具情報に特化したムック。ムックとしては異例のヒットとなり、以降の文房具ブームの先駆けとなった。

スコッチテープ
【スコッチテープ】

1930年代にアメリカのスリーエム社が開発したマスキング用テープの商品名として使われた商標だが、今は同社の粘着テープ及び接着剤全体のブランド名として使われている。アメリカでは、セロハンテープの一般名称としても使われる。

硯
【すずり】

固形墨を磨って水に溶かし筆記用の墨液をつくるための、主に石でつくられた道具。文房四宝（→p155）の1つ。堆積岩に含まれる石英・雲母・長石など硬度の高い粒子がつくる表面の細かな突起（峰芒（ほうぼう））が均一に細かく分布しているものが墨を速く均一に溶かす（おろす）ことができるよい硯とされる。材料は主に中国産で、広東省にある端渓（たんけい）で採れた石を使用した硯が最も有名。墨を磨る場所を「陸（おか）」、墨を流し込んで貯める場所を「海（うみ）」と呼ぶ。現在の学校教育では固形墨を使わずに墨液を使うことも多く、磨る機能に重点を置かないプラスチック製のものも見られる。

スタイラス
【スタイラス】

①蝋板（→p187）に筆記するために使う、先端が尖った青銅製の細い棒状の筆記具。②電子機器の入力に使用する専用の筆記具。

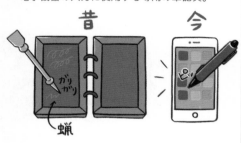

スタディプランナー
【スタディプランナー】

主に中高生に向けた、学習計画を立て進捗を記録するための手帳。今日学習する目標を具体的に書き、勉強した時間をグラフ化して記入するフォーマットが多い。画像投稿型SNSによる学習状況共有の流行（→p158「勉強垢」参照）に影響されて注目され、多くの製品が登場。計画だけでなく写真映えを意識している点が特徴。

スタビロ・ボス
【スタビロ・ボス】

ドイツのスワンスタビロ（→p96）が1971年に発売した世界初の蛍光ペン（→p65）。チーゼル型チップと平たいボディデザインが特徴。

スタンプ
【スタンプ】

広義には印章全般を指すが、個人や団体を証明するものを除く、主に情報を複製、表示する目的の印、特にゴム印や浸透印などを指すことが多い。

スタンプパッド
【スタンプパッド】

主にゴム印などを捺すためのインクを染み込ませたものを蓋付きのケースに納めたもの。

スティック糊
【スティックのり】

回転操出式容器に入った棒状の固形接着剤。円筒が多いが、楕円や三角、四角柱のものもある。水分量が少ないため、早く乾き、紙にシワが寄りにくい。1969年にドイツのヘンケルが発売した「プリットスティック」が最初。

ステープラー
【ステープラー】

金属製のコの字型の針（ステープル）の両端を紙に貫通させて折り曲げることで、紙を綴

じ合わせる事務機械。日本では「ホチキス」（→p163）とも。18世紀にフランスのルイ15世の求めで黄金のステープラーがつくられたという説があるが定かではなく、実質的には19世紀後半に発明・改良された。それ以前からピンやクリップで紙を留めることは行われていたが、1866年にジョージ・W・マギルが、割ピンに近い形状の金具を通す穴をあけ、金具を外に広げる道具を発明。1868年にはA・J・クレッツカーがコの字型の針を紙に貫通させてから内側に折り畳む道具を発明。そして1877年に、ヘンリー・R・ヘイルによって、針の貫通と折り曲げを同時に行うものが発明され、1879年、前述のマギルが現在のステープラーに近い構造の単発式ステープラーを完成させた。

ステショ
【ステショ】

ステーショナリーの略。学用文房具全般を指す。

ステッドラー
【ステッドラー】

ドイツに本社を構える筆記具・製図用品メーカー。1662年にフリードリッヒ・ステッドラーが鉛筆の製造を開始。1835年にヨハン・セバスチャン・ステッドラーが、J・S・ステッドラーを登記。1900年に商標登録された軍神マルスのマークと真っ青な軸の鉛筆「ルモグラフ」などで有名。

ステノパッド
【ステノパッド】

速記用のリングノート。硬い裏表紙を持つ、縦型・短辺綴じで、横罫の本文の中央に縦罫が1本引かれているもの。短く改行することで速い記録が可能なことからこのようなレイアウトになっている。「ステノノート」「ステノブック」とも。

砂消しゴム
【すなけしゴム】

硅石粉などの研磨剤を含む天然ゴム系の字消し。ボールペンなどのインクで書かれた文字を研磨剤で紙の表面ごと削り取って消字する。

簀の目
【すのめ】

和紙を漉く際に使用した簀の痕跡が紙の厚みの変化として残ったもので、光に透かすと、紙目（→p54）に対して直角に緻密に並んだ縞模様（簀目）と、平行で間隔のあいた線（糸目）が見える。洋紙では「レイド」（→p185）と呼ばれる。

和紙

スパイメモ
【スパイメモ】

1969年にサンスター文具が発売した子供用手帳玩具シリーズ。スパイについての豆知識や暗号の書き方などの情報と共に、水に溶けるメモや変装シールなどの付録が入っている。1967年に放送開始のテレビドラマ「スパイ大作戦」に影響された子供たちに爆発的な人気となった。「スパイ手帳」と呼ばれることが多い。

スパイラルノート
【スパイラルノート】

等間隔に穴のあいた紙をらせん状の針金で綴じたノート。ダブルリング（→p110）に対し、「シングルリング」と呼ばれることもある。

スピログラフ
【スピログラフ】

プラスチック製の板にあけられた内歯車付の穴に、付属の小さな歯車を内接させ、この歯車にあけられた小さな穴に筆記具を挿して回転させることで、紙面に幾何学模様（内トロコイド曲線）を描く玩具。歯車の大きさやペンを挿す穴の位置によって描かれる模様が変化する。1965年にイギリスのデニス・フィッシャーが考案し、爆発的ヒット商品となる（数学的には既知であり、1820年代以降さまざまな方式の作図器具が考案されている）。日本では1967年に発売された。発売当時は高価なデザイン玩具だったが、その後安価な子供用モデルや模造品なども多数販売された。

スピン
【スピン】

本や手帳などの背の上部に取り付けられた、栞（→p79）の役割をはたす紐。しおりひも。

スペースペン
【スペースペン】

アメリカのフィッシャースペースペンが販売する加圧式ボールペン。ポール・C・フィッシャーが1966年に特許を取得し、NASAに提案したモデルAnti-Gravity 7（#AG 7）が1968年のアポロ7号計画に採用されたことで有名になった（当初の特許内容は加圧カートリッジ式ではなくピストンによるノック加圧式。現在はインクタンクに封入された窒素

ガスによりインク隔壁を押す常時加圧カートリッジ式）。無重力下でも問題なく筆記が可能。なお、加圧式ボールペンの特許はそれ以前から多数存在する。また、この製品はフィッシャーが独自に開発したもので、NASAからの開発依頼や援助があったわけではない。

スポット商品
【スポットしょうひん】

商品が継続的に供給される定番品（→p115）に対し、当初から生産数や期間が限定されている売り切り商品。通常は在庫がなくなり次第、販売終了となる。文房具の場合はファンシー・キャラクター商品や季節品など、商品やデザインのライフサイクルが短いものに多い。

スマステーション!!
【スマステーション!!】

「SmaSTATION!!」。テレビ朝日系列で2001～2017年に放送された、香取慎吾がメイン司会を務める教養・情報バラエティ番組。文房具が特集される回は毎回大きな反響があり、紹介された商品の問い合わせが殺到し品切れが続出するなど、文房具業界への影響も大きかった。

スマッシュ
【スマッシュ】

ぺんてるが1986年から販売するシャープペンシル。製図用の「グラフ1000」をベースにつくられた一般筆記用で、長めのガイドパイプと円錐形の口金を併せ持つ。口金先端から継ぎ目のないグリップに内側から大きく突出したラバーが特徴で個性的な握り心地はファンも多い。2014年にYouTuberはじめしゃちょーが紹介したことで注目され中高生を中

心に爆発的人気となった。

墨
【すみ】

主に植物性の油を燃焼して得た煤と膠（→p128）を練り合わせて乾燥させた固形の顔料で、硯（→p91）で磨って水に溶かし、毛筆で筆記する。文房四宝（→p155）の１つ。菜種油などの植物油を原料とする「油煙墨（ゆえんぼく）」と松脂を多く含む松の木片を燃焼した煤から成る「松煙墨（しょうえんぼく）」に大別される。簡易に使用するため水に溶かした液状で販売される墨汁（液体墨）もある。印刷用語では黒色を意味する。

スリーエム
【スリーエム】

アメリカに本社を構える化学・素材メーカー。1902年に、鉱石の採掘会社として設立された（ミネソタ・マイニング・アンド・マニュファクチュアリング・カンパニー）。鉱石の採掘では失敗するが、その後サンドペーパーからはじまり、各種接着技術によって多くの製品や素材を生み出して成長し、世界的巨大複合企業となった。「ポスト・イット」や「スコッチテープ」などで有名。

3Dペン
【スリーディーペン】

筆記具状の本体内に熱源を備え、熱可塑性樹脂を加熱、溶融して吐出する造形道具。樹脂は吐出直後に自然冷却されて硬化するので、取り扱いに習熟すれば、あたかも空間上に線を引くように造形できる。この他、紫外線硬化樹脂を吐出しながらブラックライトを照射して硬化させるタイプもある。

スリーブ
【スリーブ】

袖の意で、広く筒状のものを指す。①一本差しの筒状ペンケースや、手帳やペンケースのペンを1本差し入れる部分。②消しゴムの巻き紙。消しゴムの汚れを防止すると共に、プラスチック消しゴムに含まれる可塑剤がペンケースや引き出しなどの樹脂に移行して溶かしてしまうのを防止する。③スライドしてかぶせる筒状の外箱、筆記具のギフト箱などによく使われる。

スワンスタビロ
【スワンスタビロ】

ドイツのヘロルツベルクに本拠を構える筆記具ブランド。1855年にグスタフ・アダム・シュヴァンハウザーがニュルンベルクに鉛筆製造会社として創業。鉛筆、色鉛筆の他、1971年に発売した世界初の蛍光ペン「スタビロ・ボス」(→p92) でも有名。

寸法表示
【すんぽうひょうじ】

一般的に商品寸法は、W（Width＝幅）、H（Hight＝高さ）、D（Depth＝奥行）で表示されるが、ノートやファイルなど薄いものの場合、W、H、T（Thickness＝厚さ）で、また、ペンなどの円筒状のものでは、H、Φ（Φは工学で直径を表す）で表示される。

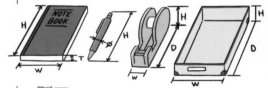

製図ペン
【せいずペン】

主に設計製図に使用する筆記具で、均一な太さの線を描くことができる中空パイプ状のペン先を持つ筆記具。複数の異なる太さのペン先が用意されていて、描線の太さごとに使い分ける。パイプの中に細い針状の部品があり、その針で弁を開閉し、針とパイプの内壁の間の隙間に毛細管現象でインクが流れる仕組み（→p188「ロットリング」参照）。

製図用シャープペンシル
【せいずようシャープペンシル】

主に設計製図に用いることを前提に設計されたシャープペンシル。普通、定規に当てて正確な線を引くために、長く平行なガイドパイプを持ち、3種以上の線幅（一般に図面上で意味が異なる）に対応した芯径を用意している。また、均一な太さの線を引くためにペン先を回転させやすくする細い円形断面のグリップや、投入した芯の硬度を表示する窓、邪魔な場合は取り外し可能なクリップなどの共通点がある。PCによる製図が普及した現在は、製図よりも一般筆記や描画用に使われることが多い。

静電式複写
【せいでんしきふくしゃ】

帯電したトナー粒子を誘導して紙に転写する複写方法の総称で、現在最も一般的な普通紙コピー機に採用されている「乾式間接静電複写」もこれに含まれる（→p143「PPC」参照）。

生分解性プラスチック
【せいぶんかいせいプラスチック】

自然環境の中で微生物によって分解される高分子材料。微生物の分泌する分解酵素によって低分子量化し（一次分解過程）、微生物が体内に取り込んでエネルギー生産に用いることで炭酸ガスに変換される（完全分解過程）。環境中に廃棄された際の環境負荷を低減する効果が期待されている。文房具そのものやパッケージなどに使われることもある。外観か

らはほとんど区別できないが、自然に分解されるため、劣化の進行が早い場合がある。

青墨
【せいぼく】

松煙墨の別名。墨色がわずかに青みを帯びており、古くなるほどその青みが強くなるといわれる。

製本テープ
【せいほんテープ】

①書類をステープラーで綴じた簡易製本の背を補強するための丈夫な紙製の粘着テープ。②契約書などを綴じ合わせるのに使う白い紙製の粘着テープ。契約書などが複数枚にわたる場合にそれらをステープラーで製本し、背をこのテープで綴針ごとくるみ、テープと書類にまたがるように契印を捺すことで、改ざんや差し替えのできない1通の書類と見なす。

セーラー万年筆
【セーラーまんねんひつ】

東京に本社を構える筆記具・機械メーカー。阪田久五郎が兄の斎次郎と共に国産金ペン先を開発した後、1911年に独立して広島県呉市に創業（阪田製作所）。軍港呉にちなんでセーラー万年筆を商標とした。万年筆「プロフィット」や、「長刀研ぎ」をはじめとする独特のペン先で有名。万年筆の部品成形自動化のために培った技術を用いて産業用ロボットの生産も行っている。

97

世界堂
【せかいどう】

東京都新宿区に本店を構える1940年創業の画材・デザイン用品・文房具・額縁・絵画の専門店。圧倒的に豊富な品揃えに加え、ほとんどの商品が常時低価格で、会員カードに加入するとさらに割引される。至る所に掲示されている、「モナリザもアッと驚くこの品揃え！　この価格」というキャッチコピーと共に描かれた口を開けて驚いたモナリザで有名。

赤道
【せきどう】

地球の南北両極から最も遠い大圏。緯度０度。年間を通じた日射量が最も大きく概して高温のため、海上輸送で文房具（特に糊、マーカーペンなど揮発しやすい液体を含むものやクレヨンなど融点が低いもの）を輸送する際に赤道付近を通る経路を避けられない場合（たとえばインドから日本など）は熱による悪影響が無視できず、これが原因で輸入できない文房具もある。

石盤
【せきばん】

粘板岩などを薄い板状に加工したものに木の枠をつけたもの。石筆（蝋石）で筆記し、布や海綿（→p49）などでつくった石盤拭きで消去する。正確な起源は不明だが14世紀頃

の記述にはすでにあり、18世紀末から20世紀まで主に教育用として普及した。日本には明治初期に低学年の学童用の学用品として導入され、明治から大正にかけて広く用いられた。

背クロス
【せクロス】

書籍やノート、手帳などの、表紙と裏表紙が分離している型の製本（背継ぎ表紙・切りつけ表紙）において、表紙と裏表紙を繋ぎ合わせ補強するために貼り付けられる帯状の布または丈夫な紙。

セスキ炭酸ソーダ
【セスキたんさんソーダ】

炭酸ナトリウムと重曹の複塩。この水溶液が家庭の掃除用クリーナーとして注目されている。弱アルカリ性で手垢やヤニ汚れなどがよく落ち、拭き取った後べたつかないので、汚れた文房具の簡単なクリーニングに重宝する（汚れの種類や表面素材によっては使用できない場合もある）。

接着剤
【せっちゃくざい】

接合したい物と物の間に入ってそれらを貼り合わせる物質の総称。接着のメカニズムはさまざまだが一般的には液状またはそれに近い流動性を持つ状態で被着面を濡らした後、乾燥や化学反応など化学的な変化によって硬化するものを指し、接合前後で物質が化学的に変化しない粘着剤（→p131）と区別する。

セパレーター
【セパレーター】

①未使用の粘着テープや粘着シールの粘着面を覆って保護し、使用時には剥がして捨てる紙やフィルム。粘着面と接する面は粘着材が容易に剥離するようシリコーン樹脂などによる剥離剤でコーティングが施されている場合が多い。②前述の紙やフィルム、ロール状の粘着テープなどの、粘着面と接する面にコーティングされた剥離剤の層。

セピア
【セピア】

イカ墨を原料とするインク及びその色。暗い灰茶褐色。経年劣化したモノクロ写真の色がこの色に近く、古い写真の色を表す色名として定着したため、しばしばこの色名自体が懐古的なイメージで使われる。

ゼブラ
【ゼブラ】

東京に本社を構える筆記具メーカー。1896年に石川徳松が「石川ペン先製作所」として創業。日本初の鋼製のペン先を開発。「見える・見える」（→p171）のCMで人気となった「クリスタルS-4100」や、両頭油性マーカーの「マッキー」、「シャーボ」「サラサクリップ」「デルガード」などが有名。現在でも漫画用のつけペン先の製造も行っている。

セミB5
【セミビーご】

179×252mm。主にノートに使われる規格寸法で、JIS S 5504では6号（または学用3号）と呼称される。日本でB5ノートというと現在はほぼこの寸法。B5正寸（182×257mm）よりも縦横共に若干小さい。これはB列本判（765×1085）から9丁取りできるギリギリの寸法で、かつて行っていたB5正寸［四六判（788×1091mm）から8丁取り］よりも、生産の都合がよいため、1965年より、B5ノートに限り、正寸ではなくこの寸法が標準として規格化されている。

本来のB5
セミB5

ノートといえばこのサイズ

国語

3-4 土果王

Campus

あ ア
か カ
さ サ
た タ
な ナ
は ハ
ま マ
や ヤ
ら ラ
わ ワ

ゼムクリップ
【ゼムクリップ】

スチール製の針金でできた2重に巻かれた長円形のクリップ。特許は出願されておらず起源は不明だが1899年にアメリカのウィリアム・ミドルブックがこの形のクリップを自動製造する機械の特許を出願しており、1890年頃には存在していたと思われる。ゼム（gem）という呼称はこのクリップの販売で成功したイギリスのクシュマン＆デニソン社が1892年より使用したブランド名に由来している。

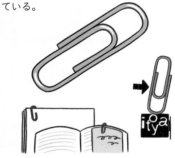

セメダイン
【セメダイン】

日本の東京に本社を構える接着剤メーカー。また、その接着剤のブランド名。1923年に今村善治郎が、合成接着剤を開発。「セメダイン」と命名し、接着剤の製造販売業として創業。その後この商品名が社名となる。命名の由来は現在公式には接合材であるセメント（CEMENT）と力の単位を表すダイン（DYNE）との造成語で、「強い接合・接着」という意味とされるが、開発当時輸入されていたイギリス製の接着剤「メンダイン」を市場から「攻め出す」という意味だったともいわれている。1938年に発売された汎用接着剤セメダインCなどで有名。

セラミック
【セラミック】

非金属の無機材料を高温で焼き固めたもの。一般的な陶磁器も含まれるが、文房具の素材用語として使用される場合は、工業的に製造工程を精密に制御して製造されるファインセラミックを指すことが多い。一般的に金属と比べて硬く、軽く、錆びない長所を持つ。中でも靭性の高いジルコニア系セラミックは、一部のはさみや1枚切りナイフの刃など、耐摩耗性を要するものに使われる。

セルロイド
【セルロイド】

ニトロセルロースと樟脳（しょうのう）などから合成される合成樹脂で、人工のものとしては最古の熱可塑性樹脂。成型が容易で、ペンケースや万年筆などの文房具の他、多くの日用品に使われたが、発火性が強く危険（第5類危険物に分類される）なため、ほとんどは他のプラスチックに置き換えられた。独特の風合いから、現在も一部の筆記具などに使用される。

メガネフレーム
アコーディオン
ギターピックなど

セルロース・ナノファイバー
【セルロース・ナノファイバー】

木材から得られる繊維をさらにほぐして繊維幅が数ナノメートルにまで微細化した繊維。三菱鉛筆の「ユニボール シグノ307」のゲルインクの増粘剤に採用された。新素材として期待されているが用途は開発途上。

セレクトショップ
【セレクトショップ】

本来はブランドショップの対義語で、特定のブランドを販売する店舗ではなく、店舗の選択によって品揃えされた店舗を指し、その意味ではほとんどの文具店が該当するが、中でもその商品選定のコンセプトやセンスの独自性を強く押し出した店舗を指す場合が多い。

セレンディピティ
【セレンディピティ】

偶然の意外な出来事に出合った人が、聡明さによって、もともと探していなかった別の価値のあるものを発見する幸運。イギリスの小説家ホレス・ウォルポールが、『セレンディップの3人の王子』という童話にちなんで生みだした造語。この説明に、当初の目的とは異なる簡単に剥がれてしまう接着剤の発見から「ポスト・イット」を生みだしたスリーエム社（→p95）の事例が頻繁に引用される。

セロテープアート
【セロテープアート】

作家の瀬畑亮が2008年に発表したセロテープを造形素材とした芸術作品。

セロハンテープ
【セロハンテープ】

セロファンの基材に、ゴム系の粘着剤を塗布した粘着テープの1つ。その用途の広さから最も普及している粘着テープ。普通はやや黄みがかった透明。経年劣化するので長期の保存には向かない。1930年にアメリカのスリーエム社（→p95）のリチャード・ドルーが開発。日本では、戦後アメリカ進駐軍の要請によりニチバン（日絆工業）が製造したのがはじまりで、「セロテープ」という呼称はニチバンの商標。

穿孔能力
【せんこうのうりょく】

パンチが穴をあけられる能力の目安。一度の作業で穴をあけられるコピー用紙の枚数で表現される。

先行販売
【せんこうはんばい】

メーカーが公示する発売日よりも前に一部の限られた店舗などで商品を販売すること。市場の反応を事前に知るための試験販売や、小売店へのインセンティブなど、理由はさまざま。マニアにとっては、話題の新製品を他人より早く入手できる機会として見逃せない。

ゼンタングル
【ゼンタングル】

2004年にアメリカのリック・ロバーツとマリア・トーマスが提唱した、簡単なパターンの連続で面を埋め尽くしていくアート表現の技法。禅とTangle（絡まる）を合わせた造語で、リラクゼーションの方法としての意味合いが強い。

線幅
【せんはば】

筆記具などで書いた線の太さ。製図などでは
線幅の違いに意味を持たせるため、製図ペン
（→p96）では表記されている場合が多い。
ボールペンなどで表示されているボール径と
は異なる。

染料
【せんりょう】

描画や着色に使う、溶媒に溶ける有色の物質。

染料系
【せんりょうけい】

色材として染料を用いたインク、またそれを
使った筆記具など。均質で流動性が高いため
トラブルが少なく書き心地のよい筆記具をつ
くりやすいが、溶媒が水の場合は一般に耐水
性がなく、また顔料に比べて隠蔽力や耐光性
に劣るなどの弱点がある。

象が踏んでも壊れない
【ぞうがふんでもこわれない】

1967年にサンスター文具が放送した「アー
ム筆入」（→p28）のテレビCMのキャッチコ
ピー。

蔵書票
【ぞうしょひょう】

本の所有者を示すために見返しに貼る小さな
紙片。活版印刷によって本が普及しはじめた
15世紀のドイツが発祥。持ち主の趣向を凝
らした図案やさまざまな技法の精緻な版画で

つくられた蔵書票はそれ自体美術品として扱
われることも多い。「エクスリブリス」とも。

ソーター
【ソーター】

①多数の書類を順番通りにならべるために使
う道具。長さが少しずつ違う帯状のシートの
一端を固定し他端に見出しを設けたもので、
整理したい書類を該当するシートの下に差し
入れる動作を繰り返すと、書類がアルファベ
ット順や数字順などに重なっていく。②多く
の棚板を持つ書類整理棚。

ゾーリンゲン
【ゾーリンゲン】

ドイツ西部の都市。中世より刃物の町として
知られ、舶来高級刃物の産地として知られる。
ツヴィリング・J.A.・ヘンケルスなどのメー
カーが有名。

測量野帳
【そくりょうやちょう】

コクヨが1959年から販売する測量業務に特
化した野外記録用ノート。ポケットに入れや
すい縦長薄型のハードカバーで、立ったまま
でも記入しやすい。垂直方向の測量を記録す
る「レベル」、水平測量の「トランジット」、

3mm方眼で汎用の「スケッチ」の3種類がある。特にスケッチは測量以外のフィールドワークや普段のメモ用としても使われ、近年はデザイン性の高いノートとして人気で、限定柄が発売されたり、デコレーションや改造を施す人も。

育つ
【そだつ】

長期間使用することによる製品の経年変化を愛着を持って語る表現。特に革製品に対して使う。（例）「トラベラーズノートがいい感じに育ってきた。」

そのときロシアは鉛筆を使った
【そのときロシアはえんぴつをつかった】

アメリカとロシアによる宇宙開発競争時代、アメリカが無重力空間で使える加圧式ボールペンの開発に莫大な予算をつぎ込んだのに対し、ロシアは鉛筆で済ませたという小話だが、事実とは無関係。

ソルベント
【ソルベント】

福岡工業が販売するペーパーセメント（→p156）専用の溶剤。本来はペーパーセメントで貼ったものを剥がしたり、ペーパーセメントの濃度を調整するものだが、印刷やほとんどの筆記具のインクを溶かすことなく、多くの粘着材を溶かして剥がすことができるため、シールやテープの剥離剤として大変便利。揮発性が高く火気厳禁。

算盤
【そろばん】

複数の細い串に通した上下に移動可能な珠の位置で数を表す計算補助器具。それぞれの串は桁を表し、珠の位置がその桁の数を表し、四則演算の途中経過を保持する短期記憶装置として計算を補助する。演算そのものは人が行うため、算盤自体は計算機ではない。また、電子的な装置ではないことからアナログと誤解されがちだが、表現できる数は整数と小数で、数を離散的に扱うため、デジタルな計算器といえる。

Stationery
column

三角定規の穴の理由

定規の話でよく話題になることの一つに、三角定規の穴の理由があり、「温度や湿度の変化による膨張や収縮を吸収するため」とか「空気を逃がすため」とか、様々な説が語られていますが、そのほとんどは間違いです。

たとえば、温度による膨張収縮については、アクリルは1℃の温度変化で約0.007%伸縮し、仮に室温の差が20℃あったとして、10cmの三角定規の端から端の伸縮は0.14mmしかありません。しかも測定される物自体もその温度変化で伸縮するわけですから温度変化に対する定規の正確性を論じることには意味がありません。また、空気を逃がすという点においても、同様にほとんど効果が見られないうえに、定規はいったん紙面に置いてから滑らせて移動させるもので、持ち上げる際にも、空気

云々以前に薄くて指でつまむのが難しく、普通は机やノートの端からはみ出させて持ち上げるので、意味はありません。

ではなぜ穴があいているのか？筆者が定規メーカーの方から聞いた話では、「その方が定規らしいから」だそう。かつて木製の三角定規が帯状の木片を3本組み合わせて作られたために中央に外形と相似な穴があったのを模してプラスチックのものにも三角の穴（加工の都合カドは丸い）をあけていたが、コストがかさむために、多くは丸穴で代用するようになったとのこと。効果は紙の上を滑らせたり押さえたりする際に指をかけやすい程度で、特に小型の物にはなくても困らないが、あったほうがそれらしい。ということで今でも穴があいてるものが多いんだとか。

た
行

トビラ雑学 **4**> ノートの罫の種類

一般的なノートの罫

呼称	罫幅
UL罫	10mm
U罫	8mm
A罫	7mm
B罫	6mm
C罫	5mm

その他の罫

方眼罫
ドット方眼罫
縦罫
原稿罫
英習罫
音楽罫
国語方眼罫（十字リーダー入）

方眼罫

ドット方眼罫

縦罫

原稿罫

英習罫

音楽罫

国語方眼罫

UL罫（10mm）

あいうえお

サシスセソ

U罫（8mm）

あいうえお

サシスセソ

A罫（7mm）

あいうえお

サシスセソ

B罫（6mm）

あいうえお

サシスセソ

C罫（5mm）

あいうえお

サシスセソ

ダース
【ダース】

ものの個数の単位。12個。「打」と表記されることもある（dozenに由来）。文房具に関して、現在は鉛筆のみ習慣的にこの単位で販売されることが多く、統計上も12進法で表記されることが多い。12ダースが1グロス（→p64）。

ダーマトグラフ
【ダーマトグラフ】

ワックスを多く含み、紙だけでなくガラス・金属・プラスチックなどにも筆記できる紙巻き色鉛筆。温度変化による芯の膨張収縮でも芯が抜けないよう、紙巻き軸を採用している。三菱鉛筆の登録商標で、「Dermato」は皮膚を意味する接頭辞で元々は手術の際、皮膚に直接マーキングするための筆記具として使用されたが、現在は用途から皮膚は除かれている。「ダーマト」「デルマトグラフ」「デルマ」とも。

大学ノート
【だいがくノート】

両面にペン筆記可能な洋紙に横罫を印刷した筆記用紙を綴じ合わせた洋装丁ソフトカバー

ノート。1884年に東京大学赤門前の文具・洋書店松屋が洋行帰りの大学教授に勧められてつくったのが最初というのが定説だが、「大学ノート」という名称がいつ誰によって付けられたのかは不明。

ダイカスト
【ダイカスト】

耐熱鋼でできた精密な金型に、比較的低融点の非鉄金属を溶かして機械で圧入する鋳造方法。精密で複雑な形状の金属部品が短時間で量産できる。文房具では複雑な形状のコンパスの脚や鉛筆削器内部の部品、一部のカッターナイフのボディなどに使われる。「ダイキャスト」とも。

ダイカット
【ダイカット】

平面的な素材に複雑な形状の刃物でできた型を押しつけて打ち抜く加工方法の総称。型抜き。メモ帳や下敷、消しゴム、ステッカーなどの外形をキャラクターの形に切り抜いた製

品を、四角い断裁製品と区別するために「ダイカット○○」と呼ぶことがある。

耐水紙
【たいすいし】

水を通さない、あるいは水に濡れても変質しない紙の意だが、ユポ（→p179）に代表される紙ではなく樹脂でできた薄いシートを指すことが多い。紙の表面に水を通さない樹脂をコーティングしたものや、水を弾く撥水加工をしたもの、油脂を浸透させたものなどを指すこともあり、目的や耐水性能により各種ある。

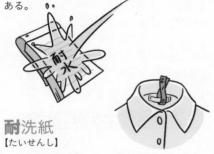

耐洗紙
【たいせんし】

水に濡れても破れにくい特殊紙。水・熱に強く、色落ちしないため、衣類のクリーニングの管理タグに使われている他、一部の耐水メモなどに使われている。樹脂シートのユポ（→p179）に比べて普通の紙に近い表面は、ほとんどの筆記具で筆記が可能。

大福帳
【だいふくちょう】

江戸時代から大正時代まで日本の商家で使われた会計帳簿で、売買金額を書き入れる元帳。売掛の状況を把握するための最も重要な帳簿の1つ。「本帳」「大帳」とも呼ばれ、明治から使用されはじめた洋式帳簿が普及するまで一般的に使用された。

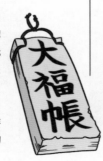

タイプライター
【タイプライター】

鍵盤と紙送り機構と鋳造活字一式を備え、鍵盤を押すとそれに対応した文字の活字を、インクを染み込ませたリボンの上から紙に打ち付けて印字する文書作成機械。1714年にイギリスのヘンリー・ミルが特許を得ているが詳細は不明。日本には1901年に黒澤貞治郎が輸入したのが最初で、その後カナ用や和文用なども開発された。1980年代から急激に普及したワードプロセッサー（→p188）に取って代わられた。

タイムレコーダー
【タイムレコーダー】

主に勤怠管理などに使う時刻を記録する装置。専用の記録紙「タイムカード」を挿入すると、時計と連動したスタンプによりその時刻を記録紙上に打刻する。

ダイモ
【ダイモ】

1958年にアメリカのダイモ社が発売した、硬質なプラスチック製の粘着テープに文字をエンボス刻印する手動装置。ダイヤルを回して文字を選択し、ハンドルを握ると、文字刻印がテープを挟んで圧接され、凸加工されると同時に変形部が白くなる。

高畑正幸
【たかばたけまさゆき】

テレビ東京の番組「TVチャンピオン」の、1999、2001、2005年に行われた「全国文房具通選手権」で優勝し「文具王」を自称。サンスター文具の企画開発を経て2012年に独立。文房具の開発から、解説、評論、撮影、実演販売までさまざまな活動を行う。本書の著者。他に『究極の文房具カタログ』(河出書房新社) など。

多機能筆入
【たきのうふでいれ】

1970年代中頃から80年代はじめまで流行し

た学童用筆入れで、ボタンを押すことで鉛筆がせり上がったり、消しゴムや鉛筆削器、ルーペ、温度計、メモ帳などが飛びだしたり、書見台になるものなど、さまざまな仕掛けが内蔵されているものの総称。メーカー間の開発競争により過度に複雑化し、学校やPTAではしばしば問題視された。家庭用ゲーム機の普及により終息。

竹尺
【たけじゃく】

竹製のものさし。乾燥した竹を割って目盛りを刻んだもの。まっすぐで強い繊維を持つ竹は直線状に加工しやすく、歪みや狂いが少ないため、ものさしの材料に適しており、古くから使われている。また滑りがよいため和裁などの縫製には未だに使われている。

多穴パンチ
【たけつパンチ】

日本では主にJIS Z 8303に規定された、中心間隔が9.5mmのいわゆるルーズリーフの穴をあけるパンチを指す。カール事務器の「ゲージパンチ」など。1/3ピッチや3穴、4穴、6穴などを含める場合もある。

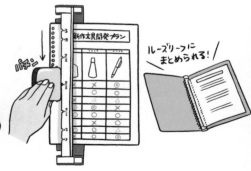

タックシール
【タックシール】

主にラベルや目印として文字などを印刷または記入して貼る事務用シールの総称。多くは紙製・無地で、同じ形のシールが台紙に整列しており、各種プリンターなどの出力にも対応している。郵便物の宛名印刷やファイルの見出しなどに使われる。

立つペンケース
【たつペンケース】

開いたまま机上に立てて置くことが可能な仕組みを持つペンケース。机上での占有面積が小さく、開いたままペンスタンドのように使用することができるため、外出先でも邪魔になりにくく、デスクに近い作業性を確保できる特徴を持つ。2015年頃から人気が上昇し、一つのジャンルを形成するに至った。

開けると

舘神龍彦
【たてがみたつひこ】

日本のライター、手帳評論家。各種メディアでの手帳の紹介や使い方の提案にとどまらず、歴史や文化などの側面からも解説。手帳の開発にも関わる。手帳の種類を問わない手帳ユーザーの集まりとして、「手帳オフ」を2007年よりいち早く開催している。著書に『手帳と日本人』（NHK出版）、『凄いiPhone手帳術』（エイ出版社）など。手帳活用の基本をまとめた「手帳音頭」の作詞作曲も務める。

田中経人
【たなかのりひと】

（1905-1992）リヒトラブの創業者。1938年に福井商店（現在の株式会社ライオン事務器）から独立し、事務用品の卸業として創業（田中経人商会）。その後事務用品メーカーへと移行し、現在のリヒトラブの礎を築いた。文房具全般に関する興味と造詣が深く、著書『文具の歴史』（リヒト産業）は、文房具の歴史を知る上で貴重な名著。

ダブルクリップ
【ダブルクリップ】

閉口するコの字型の板バネの口端に針金を曲げたハンドルを取り付けたクリップ。ハンドルを背の方に倒しテコとして開口させ、紙を綴じた後は反転させて閉じる。1915年にアメリカのルイス・エドウイン・バルツレーが発明。保持枚数が多く、把持力がとても強いのにかさばらず安価なため、枚数の多い書類を綴じるクリップとしては最も普及している。「バインダークリップ」とも。

ぱた

ダブルリングノート
【ダブルリングノート】

本文の縁に等間隔に開けられた四角い穴に、櫛歯状に曲げた針金を通して丸め、一列に並んだリング状に綴じたノート。どのページも自由に開き、360度裏に回しても平らに使える。針金がらせん状のシングルリングに比べ、折り返してもページがずれず、丈夫で安定して開きやすい。1934年イギリスのジェームス・バーンが発明。その1/3インチ（8.47mm）ピッチが国際標準だが、日本には多穴パンチと同じ9.5mmピッチのものも併存する。

玉紐
【たまひも】

厚紙や樹脂でできた硬貨ほどの大きさの円盤2枚を一組とし、互いを紐で括り留める封筒の簡易封かん具。2枚の円盤は、封筒のベロと胴それぞれに、鳩目などで取り付け、一方には紐を取り付けてある。封かんの際は、紐を交互に円盤にかけ回して括る。封筒の他、スケッチブックや手帳などにも使われる。鳩目を使わず粘着テープで簡単に取り付けられるものもある。

タミヤ瓶
【タミヤびん】

タミヤが販売するプラモデル用塗料の保存用ガラス瓶「カラースペアボトルミニ（角ビン）」を指す。安価で容量が手頃（10mL）かつ密閉性が高いので、万年筆

のインクを小分けにするのに便利で、インク交換の容器の事実上の定番となっている。この瓶に入れてインクを分けることを「タミヤする」とも。

試し書き
【ためしがき】

購入前の筆記具を実際に筆記して確認する行為。「試し書きコレクター」の寺井広樹（→p118）によると、試し書きの目的や書かれる内容は国や地域によって異なり、途上国ではその個体が不良品でないことを確認するために行うが、先進国ではその品種の書き心地や線幅、インクの色あいなどを知るために行うという違いがある。筆記具売り場には専用の試筆用紙が用意されていることが多い。万年筆の場合は専用のカウンターでペン先にインクをつけてもらって試す。

ダルマ画鋲
【ダルマがびょう】

くびれた円筒状のつまみを持つ画鋲。「プッシュピン」（→p149）とも。

タングステンカーバイド
【タングステンカーバイド】

「炭化タングステン」。タングステンと炭素からなる非常に硬い化合物。この粉末をコバルトを結合材として加圧成形し焼結したものを「超硬合金」と呼ぶ。硬度が高く耐摩耗性に優れるため、切削工具の刃先などの他、ボールペンのボールにも使用される。

単語カード
【たんごカード】

手の中にすっぽり収まる程の小さな短冊状の厚紙を、金属製の開閉できるリングで綴じたもの。表に問い、裏に答えを書いておき、表を見て答えを考え、裏をめくって確認する。

外国語の単語や歴史年号、公式や化学式など、短いフレーズの暗記学習に多用される。

単語帳
【たんごちょう】

主に語学学習に使う、外国語と自国語を対照できるように左右にふりわけて記録するノート。単語とその意味の他、品詞などを記入する欄が用意されている。多くは幅の狭い小型のリングノートで、片側のページを裏に回すと、暗記できているかを確認する簡易テストにもなる。

断裁機
【だんさいき】

紙などを断ち切る道具。厚みのある紙束の不要部分を直線的に切り落とす道具を指すことが多い。一般の家庭や事務所ではあまり使わ

れないものだが、ドキュメントスキャナーの普及で書籍をスキャンする準備として背を切り落とす目的で個人でも小型断裁機が使われることが増えた（→p76「裁断機」参照）。

チームデミ
【チームデミ】

プラスが1984年に発売した小型文具セット。手のひらに載るサイズのプラスチックケースに型抜きしたウレタンを敷き詰め、ステープラー、はさみ、糊など、7種の文具が収まる。ミニチュアのような見た目だが個々の文具が実用できる完成度であり、働く女性を中心に爆発的ヒットとなり、ギフトやノベルティにも使われた。あまりの人気から模造品も多く出回った。

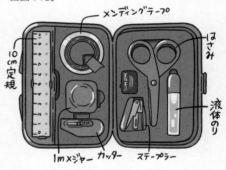

メンディングテープ
10cm定規
1m×ジャー
カッター
ステープラー
液体のり
はさみ

チェックライター
【チェックライター】

小切手や手型など、記入式の有価証券に、金額を印字する専用の事務機械。改ざん防止のため、数字や記号は、金属製の刻印を圧接して押印と同時に紙に細かな凹凸を刻む。

チキソトロピー
【チキソトロピー】

攪拌したり振盪したりして力を加えることによって粘度が下がり、その状態が時間経過に伴って変化する現象。非常に粘度が高い固体状のゲルに力を加え続けると粘性の低い液体状のゾルに変化し、静止するとまたゲルに戻っていく。これを応用したのがゲルインクで、リフィルの筒内では固体状のインクがボールの回転による剪断力を受けて液体状になり紙に転写・浸透し、その後再び固体状に戻ることで素早く定着する。

チタンコート
【チタンコート】

鋼やチタン合金、アルミなどの表面特性を向上させるために、非常に硬い窒化チタン（TiN）や、窒化チタンアルミ（TiAlN）の薄い被膜を施すコーティング。耐摩耗性や硬度、耐熱性、耐酸性が高い。文房具では、はさみやナイフなどの刃の耐久性を向上させるために加工する。

チャック
【チャック】

工具や材料を掴んで固定する機構部分の総称だが、文房具では主にシャープペンシルや芯ホルダーの芯を掴む機構部分のことで、ノックによって開閉し、芯を二方または三方から締め付けて固定する。金属製から量産性の高い樹脂製に置き換えられたものも多いが、金属製にこだわるファンは多い。

中性紙
【ちゅうせいし】

中性から弱アルカリ性の紙。図書や公文書の保管において、19世紀以降につくられた洋紙（酸性紙）の劣化が無視できなくなったことから、20世紀半ば頃に中性のサイズ剤（にじみ止め）を使うなどによって開発された。現在はほとんどの洋紙が中性紙になっている。手漉き和紙はもともと中性紙で、1000年以上の保存が実証されている。

彫刻刀
【ちょうこくとう】

彫刻や版画などの細工に用いる、主に手の力だけで押して切削する小型の刃物。用途に応じてさまざまな形状の刃先のものがある。

調整
【ちょうせい】

万年筆の書き心地をよくする、あるいは好みや書き癖に合わせるためにペン先などに手を加えること。

「超」整理法
【ちょうせいりほう】

野口悠紀雄が1993年に同名の著書で提唱した、

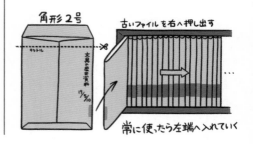

角形2号封筒を使った袋ファイリングシステムを中核とする実践的な個人向け書類整理法。書類を分類せず、新しく作成したり使用したものを左端に差し込んで他を右に押し出すことで、使用頻度の高いファイルが自動的に左に集まり、探索時間を短縮できるというもの（→p178「山根式袋ファイリング」参照）。

帳簿
【ちょうぼ】

主に金銭に関わる取引を記録するための帳面。

チョーク
【チョーク】

硫酸カルシウム（石膏）または、炭酸カルシウム（石灰）を固めた棒状の筆記材で、主に黒板などに筆記するのに使われる。前者は柔らかく、後者は硬く粉が飛散しにくい。現在は後者が主流で、廃棄されたホタテの貝殻や卵の殻などから再生される。「白墨」とも。

千代紙
【ちよがみ】

①さまざまな模様を木板で色刷りした和紙。手芸の材料の他、折り紙や包装紙としても使われる。②模様が印刷された折り紙。

貯金箱
【ちょきんばこ】

主に硬貨の貯蓄を目的としたスリット状の硬貨投入口を持つ収納容器。ゆうちょ銀行（郵便貯金）が1975年から開催している「ゆうちょアイデア貯金箱コンクール」を、全国1万校以上の小学校が夏休みの宿題として採用しているため、夏休みの工作の定番課題となっている。

直営店
【ちょくえいてん】

①メーカーが直接経営して商品を販売する店舗（メーカーから仕入れて販売する店舗は「代理店」）。コクヨのthink of thingsなど。②小売業の本部が直接運営している店舗（オーナーは別で商号商標やノウハウの提供を受ける店舗は「加盟店」）。東急ハンズの場合、名古屋店とANNEX店が加盟店で、それらを除く店。

直液式
【ちょくえきしき】

マーキングペンや水性ボールペンのうち、液体のインクを軸内のタンクに直接保持するもの。インクを使い切るまで潤沢な吐出量を維持できる反面、インク漏れの防止や、キャップ開閉やインク流出に伴う筆記具内外の気圧コントロールが難しく、設計・製造に高度な技術を要する。「生インク式」とも。

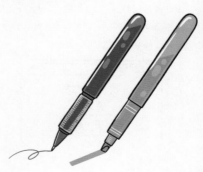

つけペン
【つけペン】

ペン先以外にインクを保持する装置を持たないインクペンの総称。狭義では金属製のペン先を軸に差し込んで使うものを指すことが多いが、広義では羽根ペンやガラスペンなども含まれる。インクを内蔵しないため、インクを頻繁に変更したり、特殊なインクを使ったり、また消耗品としてペン先を扱うことで、力強い表現が可能となり、漫画など一部の用途には未だに使われている。

土橋正
【つちはしただし】

土橋正事務所代表。ステーショナリーディレクター。文房具コラムの執筆や商品企画、メーカーに対するコンサルティングなどを行う。著書に『文具の流儀　ロングセラーとなりえた哲学』(東京書籍)、『暮らしの文房具』(玄光社)など。

綴り紐
【つづりひも】

パンチで穴をあけた書類を綴じるための紐。多くの場合は硬い表紙を当てて、書類の追加や差し替えができるよう、蝶結びで綴じる。端を穴に通しやすいよう、両端は補強されていて細く硬い。和紙を縒ってつくったものは紙縒と呼ばれる。

ツバメノート
【ツバメノート】

ツバメノートが1947年から製造販売しているノート。グレーの毛入り表紙に黒のクロス、糸綴じされた本文はツバメの透かし模様が入った吸水性のよいフールス紙(→p147)に、今やほとんど使われなくなった罫引き(→p66)による水性インクで引かれた罫線のため、万年筆などで筆記した際にインクの浸透が速く、罫にも弾かれない。未だほとんど製法を変えずつくり続けられる大学ノートの原型的存在。

坪量
【つぼりょう】

1㎡あたりの紙の重量。単位はg/㎡。正確には「メートル坪量」、つまり1辺1mの正方形あたりの重量の意味で、「米坪量」とも呼ばれる。紙の厚みの目安として使われる。

低粘度油性ボールペン
【ていねんどゆせいボールペン】

油性ボールペンのインクの粘度を大きく下げることでなめらかな書き味を実現したボールペン。2006年(海外向けは2004年)に三菱鉛筆が発売した「ジェットストリーム」によって確立され、以降多くのメーカーが開発。油性ボールペンのラインアップに加えている。

ディバイダー
【ディバイダー】

コンパスの一種で、両脚とも先端に針を持つ。開脚で二点間の距離を記録し別の場所に移すことができ、また、左右の脚を交互に支点としながら直線上を移動すれば、直線を等間隔に分割したり、整数倍の距離を示すことが可能。

どっちも針

定番品
【ていばんひん】

商品が継続的に生産、供給される商品。メーカーの在庫がなくなれば基本的には同じ仕様の製品が追加生産される（→p95「スポット商品」参照）。

テイボー
【テイボー】

静岡県に本社を置くマーキングペンのペン先製造メーカー。前身は1896年創業の高級フェルト帽製造メーカー「帝国製帽」。アメリカ視察から帰った内田洋行（→p36）の内田憲民からペン先の試作を要請され、寺西化学工業の「マジックインキ」（→p169）に採用された。その後フェルト帽の製造を中止し、社名を「テイボー」に改めペン先製造に特化。現在は年間約50億本のペン先を製造する（日本のマーキングペン生産数は約7億本）。

テープ
【テープ】

幅の狭い帯状のものの総称。文房具でこの語が単独で使われる場合は粘着テープを指す。

テープディスペンサー
【テープディスペンサー】

粘着テープを必要な長さだけ自在に引き出して切断するための器具。机上に置いて使うものは、テープを引き出すときに動かない充分な自重を備えるか、吸盤やその他の器具で机上に固定される。近年刃に工夫がされ、切り口が直線状になるものが増えた。「テープカッター」とも。

ビー

テープ糊
【テープのり】

粘着剤が塗布されたセパレーター（→p99）を紙面に押しつけながら巻き取り、紙面に粘着剤のみを転写する道具。1988年にペリカン社が発売した「Rollfix」が世界初。しわにならず乾燥を待たなくてよい事務用糊として普及が進んでいる。

デコる
【デコる】

ノートやペンケースなどの持ち物に着色や加工を施して装飾すること。

デザインナイフ
【デザインナイフ】

ペンのような棒状の軸の先端に、交換式の小さな刃を固定するチャック（→p112）を備えたカッターナイフ。指先で刃の進行方向を変えることができ、筆記具のような細かな動作が可能なため、繊細な切断が可能。デザインや手芸、消しゴムはんこなどさまざまな用途に使用される。

デザインフィル
【デザインフィル】

日本の東京に本社を構えるデザイン文具メーカー。1950年に便箋などの紙製品メーカーとして創設（みどり商会）。紙製品を中心としつつ小型の文房具まで企画開発するデザイン文具メーカーへと発展。デザイン文具ブラ

ンド「ミドリ」や「トラベラーズノート」（→p122）などで有名。手帳用に開発した筆記用紙「MD用紙」には定評がある。

手提げ金庫
【てさげきんこ】

現金や有価証券など貴重品を収蔵するための錠前を備えた丈夫な容器のうち、上部に取っ手を備えた小型可搬式のもの。局所的に発生する金銭のやり取りや一時保管を行う際に使用される。

デジタルペン
【デジタルペン】

筆記した内容をデジタルデータとして記録し、PCやスマートフォンなどのデジタル機器で

取り扱えるようにする筆記具の総称。さまざまな方式があり、それぞれに利点や欠点、用紙の制限や書き心地の違いなどがあり、未だ発展途上にある。

デスクオーガナイザー
【デスクオーガナイザー】

机上で必要な文房具などの道具類を1か所に集めてすぐに取り出せるよう整理収納するための容器。必要な道具類に応じてさまざまな形態がある。

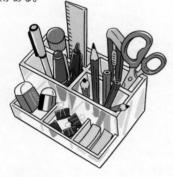

デスクペン
【デスクペン】

机上で使うことを前提につくられたつけペンや万年筆、ボールペンなどの総称。携帯を想定せず、台にペンキャップを固定したペンスタンドの使用が前提なので、クリップはなく、尻軸が細長く伸びたつけペンのようなデザインが多く、キャップを尻軸にはめるようになっていない。また、ペンスタンドに抜き差しして使うため、キャップはネジになっていない。

こちらにサインをお願いします。

手帳
【てちょう】

①携帯用の小型の帳面の総称。カレンダーを備え、予定管理機能を持つものを指すことが多い。日本に紹介されたのは福沢諭吉が1862年にフランスから持ち帰った無地の手帳が最初といわれている。日付が印刷されたものは、大蔵省印刷局が1879年に発行した「懐中日記」が最初（→p129「日記帳」参照）。②所持者の身分や経歴情報を記録・証明する目的で発行される冊子。警察手帳・年金手帳・おくすり手帳など。③用途に特化した参照情報をまとめた冊子。

デッドストック
【デッドストック】

長期にわたって売れ残り、すでに廃番となるなど本来の価値を失った状態で死蔵されていた状態の商品。売れ残り品のため、一般にはほとんど価値を持たないが、コレクターにとっては、未使用、未開封で部品や説明書等が完備されているなど、状態が良好な場合が多く、後に人気を得た品の場合は蒐集品として高額で取引される場合もある。

鉄筆
【てっぴつ】

①謄写版印刷の原紙に文字を刻むために用いる、金属製の尖った先端を持つ道具。ヤスリ板の上に原紙を置いて鉄筆で筆記することにより、原紙のパラフィンを削り落として製版する。謄写版がほとんど使われなくなった現在、紙に折り目を付けるなど別の用途に使われることもある。
②篆刻（→p119）に使う小刀、または篆刻。

鉄ペン
【てつペン】

金ペン（→p59）に対してスチール製のペン先及びそのペン先を持つペン。「白ペン」とも。

テプラ
【テプラ】

キングジムが1988年に発売した世界初のかな漢字ラベルライターシリーズ。入力した漢字を含む和文及び英数字を帯状の粘着テープに印字することができる。英数字やカナ文字しか印刷できないダイモ（→p108）に代わり、ファイルの見出しに限らずあらゆる表示に使われ、急激に普及した。

デモンストレーター
【デモンストレーター】

①商品を実演する人。②通常品は不透明な万年筆の内部の構造などが見えるように透明樹脂でつくった特別モデル。

寺井広樹
【てらいひろき】

たきびファクトリー代表。世界100カ国以上4万枚を超える文房具店の使用された試し書き用紙を所蔵するコレクター。「世界タメシガキ博覧会」などを開催。試し書きから、人々と文房具の関わりやお国柄などさまざまな事情を読み解く。著書に『「試し書き」から見えた世界』（ごま書房新社）などがある。

テレフォンリスト
【テレフォンリスト】

携帯電話やメモリー機能のある固定電話が普及する以前、よく使う電話番号を記録・検索するために使用された帳面。五十音順などで検索しやすいように見出しがずれた特殊な製本になっていたり、スライダーをセットしてボタンを押すとそのページが開く仕掛けがあるものなどもある。

篆刻
【てんこく】

石や木などに印章（→p34）を彫ること。主に秦以前の中国の古い篆書体で彫る。書道と同じく、文字による芸術表現のひとつ。

電子手帳
【でんしてちょう】

1980年代から1990年代に発売された、手帳機能に特化した情報電子機器の総称。情報の共有や機能の更新性に乏しく、PCとの接続や機能のインストールを前提とした万能型の携帯情報端末PDA（personal digital assistant）に取って代わられた。

電子文具
【でんしぶんぐ】

情報処理を行うための電子装置を内蔵する個人向け事務用小型機器の総称。単純な動作を機械化する電動文具は含まない。

電卓
【でんたく】

電子卓上計算機。電子回路で計算を行う計算機のうち、卓上に置いて使える大きさ以下のもの。1963年にイギリスのBell Punch and Sumlock-Comptometerが開発した重量16kgの「Anita」が最初といわれている。その後小型化が進み、1972年にカシオが携帯サイズの「カシオミニ」（→p50）を発売。その後も小型化、低価格化、多機能化を経て今に至る。

伝票
【でんぴょう】

金銭や物品の出入り・取引の日時・内容・条件・責任など、個々の取引と同時にその取引の証明として取引に関する情報を明記して当事者間で交される一定の様式を備えた紙片。取引や証明する事柄によって書式は異なる。

テンプレート
【テンプレート】

①製図などで頻繁に作図する基本的な図形や文字などの形を透明プラスチックの板にくり抜いたもの。製図用ペンやシャープペンシルなどで内側をなぞって図形を写す。筆記具のペン先の太さを考慮し、目的の形状よりも0.5mm程度大きくつくられている。②書式の雛形。

澱粉糊
【でんぷんのり】

植物からとれる澱粉を主成分とする接着剤。主に紙の接着に用いる。米をはじめ、用途によりさまざまな植物の澱粉が使用されるが、現在日本で普及している2大ブランドの「ヤマト糊」はタピオカ、「フエキ糊」はトウモロコシを原料としている。

ToDoリスト
【トゥードゥーリスト】

今すべきこと（タスク）を書き出す一覧表。今すべきことを書き出して視覚化し、項目が終了したらチェックマークを入れるなどして、作業の漏れを防ぎ、未完了の項目をこなしていく。

東急ハンズ
【とうきゅうハンズ】

1976年創業の、全国展開する都市型のホームセンター。1号店は神奈川県藤沢市（2006年閉店）。文具以外にも画材・材料・工具など幅広く扱い、機能性に特徴を持つ新製品の導入の早さには定評がある。小型のライフスタイルショップ店「ハンズ　ビー」も各地に展開。

礬水引き
【どうさびき】

書・日本画・版画などに使う和紙に、礬水（どうさ・ばんすい・陶砂）と呼ばれる膠とミョウバンを水に溶いたものを塗布することで、墨や顔料のにじみを防止する加工。礬水引きを施した紙を礬水紙と呼ぶ。

当社調べ
【とうしゃしらべ】

「世界初」「世界最小」「売上No.1」などと表記する際にその根拠となる情報を自社の調査によって得たということ。不当表示にならないためには、客観的な調査に基づいた調査結果が正確かつ適切に引用されていることが必要とされる。

謄写版
【とうしゃばん】

筆記と同様の手作業で製版できる簡易孔版印刷機。1887年にアメリカのトーマス・A・エジソンの特許を元にアルバート・B・ディックが発売（ミメオグラフ）。日本では堀井新治郎が1894年に謄写版と名付け発売した。

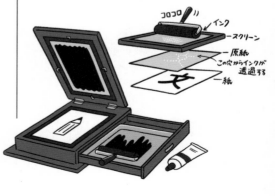

パラフィンなどを塗布した原紙を、ヤスリ板の上に載せ、鉄筆（→p117）で擦ることで、ヤスリ板の細かな凸によってパラフィンがはがれ原紙に微小な孔があけられる。これを枠に固定して紙に載せ、ローラーでインクを押しつけて印刷する。数十〜数百枚程度の少部数の印刷が低コストでできることから、普通紙複写機が普及するまで広く使われた。「ガリ版印刷」とも。

当社比
【とうしゃひ】

自社の従来品とくらべた比率。従来品からの向上を数値でわかりやすく伝える表現。新製品のカタログや広告などで使われることが多い。

胴糊
【どうのり】

袋や封筒の封かん用の糊が、蓋（フラップ）ではなく胴側に付いているもの。蓋に糊が付いていないので、商品の出し入れの際に粘着剤が商品にくっつくことがない。ルーズリーフの袋などでは必須。

フタに糊が付いてると…
あぁっ

研ぎ出し
【とぎだし】

材料を研磨によって目的の形状にする、あるいは平滑にし光沢のある表面を得る加工の総称。①目的や好みの筆記特性を得るために万年筆の先端を研磨して形状を変えること。②塗り重ねた漆や金銀箔の上にさらに漆を施し、研磨して仕上げる蒔絵の技法。

研ぎ直し
【とぎなおし】

万年筆のペンポイントが不適当な状態に摩耗したものを研磨して整えること。

ドキュメントファイル
【ドキュメントファイル】

小見出しのついた多数のポケットを蛇腹状に積層した書類入れ。あらかじめ決められた項目ごとに書類を分類・保管するのに使われる。

徳川家康
【とくがわいえやす】

（1543-1616）江戸幕府の初代将軍。日本に渡来した最初の鉛筆の所持者といわれている。その鉛筆は徳川時代初期に献上されたもので、現存する最古の鉛筆とされ、久能山東照宮宝物として保存されているが、伊達政宗（1567-1636）の副葬品からも異なる形式の鉛筆が発見されており、この2点が日本に現存する最も初期の鉛筆とされる。

ワシのえんぴつ

塗工紙
【とこうし】

抄紙された紙の表面に顔料を含む塗料を均一に塗布し、表面の凹凸を平らにすると共に印刷特性を向上させるなど機能性を付加した紙。

特許
【とっきょ】

知的財産権の中でも代表的な産業財産権（工業所有権）の1つ。自然法則を利用した技術的思想の創作「発明」について、特許庁の審査により、産業上の利用可能性があり、新規性や進歩性などが認められたものに対し与えられる権利。実用新案（物品の形状、構造、組み合わせに係る「考案」を保護する）よりも高度な要件を満たす必要がある。「パテント」とも。

ドット入り罫線
【ドットいりけいせん】

コクヨが2008年に発売したキャンパスノート（→p58）の特種罫。横罫をベースに、罫線上に罫幅と同じ間隔で小さな点が打たれていて、縦罫を引いたり文頭の縦位置を揃えたりしやすい他、方眼罫のような作図などにも使いやすくなっている。同時期に出版され話題となった『東大合格生のノートはかならず美しい』（文藝春秋）が解説本の役割を果たし、急激に認知されるようになった。

トモエリバー
【トモエリバー】

巴川製紙所が製造する超軽量印刷用紙のブランド名。元々はカタログなどの印刷物の送料を削減するための印刷紙として開発されたがそれをベースに手帳用に開発した「トモエリバー（手帳用）」は、薄く軽く柔軟だが筆記具のインクが裏抜けしにくい。以前よりレイメイ藤井のシステム手帳「ダ・ヴィンチ」シリーズに使われていたが、ほぼ日手帳（→p163）に採用され有名になり、書き心地のよさから筆記用紙としても人気に。

ドライアップ
【ドライアップ】

マーキングペンなどのペン先に含まれるインクの溶媒が気化して書けなくなること。

ドラフター
【ドラフター】

機械や建築の設計製図などに使われる製図機械（ほとんど一般名称化しているが、MUTOHホールディングスの商標）。L字型に直交する2本の定規が取り付けられたハンドルが、自在アーム（あるいはトラックと呼ばれるスライドする梁）に取り付けられていて、製図板上の自由な位置に平行移動でき、任意の位置に水平・垂直の線を引くことが可能。またハンドルは任意の角度に回転、固定でき、一定の角度を保ったまま平行移動可能なので、各種の投影図法にも対応できる。コンピューターによる製図が普及しほとんど使われなくなった。

トラベラーズノート
【トラベラーズノート】

デザインフィルが2006年から販売する、旅をコンセプトにデザインされたシステムノート。長方形の1枚革のカバーに、中とじ製本のリフィル（ノート）をゴムバンドでとめた

だけのシンプルな構造で、リフィルは交換可能。さまざまなリフィルやパーツなどが充実しており、カスタマイズが楽しめる。革のカバーは使い込むほどに表情が変化する。

トルコ折り
【トルコおり】

トルコ地図折り（Turkish Map Fold）として世界的に有名な折り方で、紙の面積を1/6まで小さくすることができ、両端を引き離すと全体が連動して展開する。また折り畳んだときに外になる面に表紙を付けると、表紙を開くだけで展開するので、観光地図などに多用される。手帳に印刷物などを貼り込むテクニックとしても便利。

手帳サイズにも
ピッタリ収まる

トレーシングペーパー
【トレーシングペーパー】

図面などに重ねて透視した図を筆記具でなぞり複写するために使う半透明の紙。硫酸紙やパラフィン紙、グラシン紙の他、シート状の樹脂のものもある。写真撮影の際ストロボなどの光を拡散するためのディフューザーとしても使われる。

トンボ鉛筆
【トンボえんぴつ】

日本の東京に本社を構える、鉛筆・消しゴムを中心に、筆記具・修正具・接着用品などを扱う文具メーカー。1913年に小川春之助（→p43）が文具商として創業（小川春之助商店）。1967年に高級鉛筆MONO100を発売。そのときダース箱の景品として付けた消しゴムがよく消えると人気になり、2年後に単独の商品としてMONO消しゴムを発売。日本を代表する消しゴムとなる。スリーブに印刷された3色の帯は誰もが知るところとなり、2017年には色彩のみからなる商標として登録された。

トンボユニオンズ
【トンボユニオンズ】

1955年、トンボ鉛筆はパシフィック・リーグの「高橋ユニオンズ」のスポンサーとなり、チーム名が「トンボユニオンズ」に改称された。出資は1年で終了し翌年は「高橋ユニオンズ」に戻った。戦績は42勝98敗1分。パ・リーグ最下位だったが、文具業界では唯一の球団保持であり、話題になった。

Stationery
column ④

「シャー芯」の直径は0.5㎜ではない?

シャープペンシルに記されている0.5㎜とか0.3㎜とかの表示ですが、これはいったい何を表しているかご存知でしょうか、普通に考えれば芯の直径だと思いますよね。これは半分正解で半分不正解です。正確にはこの数字は「表示直径」で、実際の直径とは異なります。JISやISOでは、表示直径0.5㎜の場合、 実寸法は0.55〜0.58㎜と規定されていて、実際に市販品を測定してみると0.57㎜前後になっています。さらに表示直径0.3㎜の場合は、実寸法0.37〜0.39㎜であり、さらに「呼び寸法」0.35㎜という実際に引ける線幅に近い数字も設定されており(海外の製図用シャープペンシルでは0.35㎜と表示されている場合がある)とても面倒なことになっています。これは、

JISやISOが制定されるよりも前に0.5㎜や0.3㎜という表示で商品が既に流通しており、規格がそれを追うように決まったことに由来しています。これに対し、製図ペンは図面のルールが先行するので、筆記される線幅を表示しています。同様にマーキングペンも線幅を表していますが、紙質や筆圧などによる変化が大きいので目安程度。また、ボールペンの場合は、チップ先端のボールの直径を表していて、線幅は油性や水性などインクの種別や粘性などによって大きく異なります。このように同じ0.5㎜と表示されている筆記具でも、測定している部分や規格ルールが異なるため、実際に書いてみるとずいぶん印象が違ってきます。

な行

トビラ雑学 **5** > 封筒のサイズ

角形3号
B5

角形2号
A4
クリアホルダー

角形1号
B4

封筒の名称とサイズ

呼称	横	縦	用途	郵便
角形1号	270	382	B4	定形外
角形2号	240	332	A4クリアホルダー	定形外
角形20号	229	324	A4	定形外
角形3号	216	227	B5	定形外
角形6号	162	229	A5、A4二つ折り	定形外
長形3号	120	235	A4三つ折り、定型では最大サイズ	定型
長形30号	90	235	A4四つ折り	定型
長形40号	90	225	A4四つ折り	定型
長形4号	90	205	B5三つ折り	定型
洋形2号	162	114	はがき、A4縦横四つ折り	定型
洋形4号	235	105	A4三つ折り	定型
洋形長3号	235	120	A4三つ折り、定型では最大サイズ	定型

長形3号
A4用紙
3つ折

長形4号
B5用紙
4つ折

洋形2号

郵便はがき

名入れ
【ないれ】

①ノベルティ（→p133）として配布する製品に、宣伝する企業名や商品名などを印刷、刻印すること。②小売店などが販売商品に対し、購入者が希望する名前（購入者本人の名前や、贈答品の場合は贈る相手の名前など）を印刷、刻印すること。

長形3号
【なががたさんごう】

封筒の定型寸法の1つ。幅120mm×高さ235mm。定形郵便物で送れる最大サイズで、A4用紙を3つ折りにしたものが入る。

ナガサワ文具センター
【ナガサワぶんぐセンター】

兵庫県神戸市に本店を構える文房具専門店。1882年に長澤力蔵が創業（長澤紙店）の老舗。オリジナル商品の開発にも意欲的で、震災復興を祈念して神戸の景色をテーマにつくられた万年筆用インク「Kobe INK物語」などが人気（→p71「ご当地インク」参照）。

中島重久堂
【なかじまじゅうきゅうどう】

1933年創業の大阪に本社を構えるプラスチック小型鉛筆削り専門メーカー。切れ味のよさに定評があり、国内文具メーカーの小型削器に内蔵されるユニットのOEM（→p41）製造では圧倒的なシェアを誇る。刃に「NJK」の刻印が目印。

中田俊一
【なかたしゅんいち】

（1902-1968）プラチナ万年筆（→p150）の創業者。1919年に岡山で万年筆販売を開始、1924年に上京し万年筆製造メーカー中屋製作所を設立。第二次大戦中には東京兵器の社長を務め、零戦の製造を手がけたが、その間も万年筆の開発を続けた。プラスチック成型機の導入やカートリッジインク開発など先進的な研究開発でプラチナ万年筆の礎を築いた。

中屋万年筆
【なかやまんねんひつ】

日本の東京に本拠を構える万年筆ブランド。1999年にプラチナ万年筆（→p150）から、同社の製造現場に長年勤務した職人がネット販売のセミオーダー万年筆メーカーとして発足。熟練の技術に裏付けられた、漆や蒔絵、彫金などさまざまな伝統工芸技術を取り入れた万年筆を好みの仕様で注文できる。

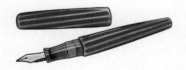

中綿式
【なかわたしき】

マーキングペンや水性ボールペンのうち、液体のインクを中綿（繊維状の貯蔵体）に染み込ませて保持するもの。インク漏れの防止や筆記具内外の気圧調整が容易な反面、粘度の高いインクには不向き、インク残量に応じて

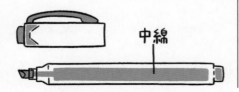

中綿

インク吐出量が変化してしまう、などの欠点がある。

泣き出し
【なきだし】

ボールペンの筆記時に、ボールの回転によって引き出されたインクのうち、紙面に転写されなかった余剰のインクがボール保持部によって掻き取られて徐々に集まり、インクの塊を形成すること。これが紙面に落ちると「ボテ」（→p163）となる。

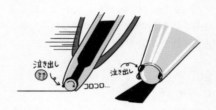

泣き出し　コロコロ…　泣き出し

長刀研ぎ
【なぎなたとぎ】

セーラー万年筆独自の万年筆のペン先の研ぎ方の１つ。ペンポイントを長刀の先端のように細長く研ぐことによって、ペン先の接地角度によって描線の太さを変化させることができる。使い慣れると、毛筆のトメ・ハネ・ハライなどが擬似的に表現できる。

ナショナルブランド
【ナショナルブランド】

商品の製造メーカー自らが企画・開発する自社ブランド。「NB」（→p150「プライベートブランド」参照）。

NAMIKI
【ナミキ】

パイロットコーポレーションの高級蒔絵万年筆ブランド。独自の漆技術ラッカナイトに、蒔絵の創作集団「國光會」が手がける芸術性の高い蒔絵が施された万年筆は世界で高く評価されている。

並木良輔
【なみきりょうすけ】

（1880-1954）パイロットコーポレーションの創始者。商船学校を卒業し日本郵船から三井物産で商船に乗り組んだ後、商船学校の教授となる。教鞭を執る傍ら発明した烏口（→p54）の改良から、摩耗しにくいペン先の研究へと進み、1916年に金ペン（→p59）にイリドスミン（→p33）を加工する技術を開発。1918年に和田正雄と共に並木製作所を設立した。2人が船乗りだったことから、商標は不沈を意味する浮き輪とし、ブランドは水先案内人を意味するパイロットとした。

ナンバリング
【ナンバリング】

書類や切符などに連番を押印するための事務機器。ハンドルを押し下げて押印するが、あらかじめ設定した回数ごとに数字が1繰り上がる仕組み。「ナンバリングスタンプ」「ナンバリングマシン」とも。

匂い玉
【においだま】

1980年代の女児を中心に流行した玩具。芳香剤を含む粒状の樹脂で、小さな瓶やプラスチックケースに入った状態で販売されることが多い。手紙などに香りをつけたり名札の裏やペンケースに入れたりして香りを楽しむ玩具だが、文房具店で販売されることが多く、学校に持ち込まれることも多かった。「香り玉」とも。

膠
【にかわ】

動物の骨、皮などから煮出した繊維状タンパク質（コラーゲン）で、純度の低いゼラチンのこと。加熱するとゲル（固体）からゾル（液体）に変化し、また戻る性質を利用して古代

より世界各地で接着剤として利用されてきた。また水中で保護コロイドの役割を果たすなど、さまざまな特性があり、木材などの接着から、描画材の顔料の固着剤、墨（→p95）づくり、礬水引き（→p120）など、その応用範囲は広い。

2穴パンチ
【にけつパンチ】

日本では最も普及しているファイル、バインダー用の綴じ穴の規格JIS S 6041に規定された、直径6mm、中心間隔が80mmの穴を穿孔する器具。

ニコラ・ジャック・コンテ
【ニコラ・ジャック・コンテ】

（1755-1805）フランスの科学者・画家。ナポレオン戦争で上質な黒鉛の塊の入手が困難になったことから戦争大臣ラザール・カルノーの命で鉛筆の開発に着手。粉状の黒鉛と粘土を混ぜて高温で焼き固める鉛筆芯の製法を発明。1795年に特許を取得した（→p132「粘土芯」参照）。その後コンテ社を設立し芸術家向けに「クレヨン・コンテ」の名で販売。画材のコンテはその1つの形態。

ニチバン
【ニチバン】

1918年に歌橋憲一が硬膏・軟膏を製造する製薬会社として創立（歌橋製薬所）。第二次大戦中の1944年に、戦時企業整備によって絆創膏メーカー24社が歌橋製薬所の下に統合され、社名を日絆工業株式会社と改めた（1961年からニチバン株式会社）。戦後1947年に国産初のセロハンテープを完成させ、GHQに納めた。1948年より発売されているセロテープで有名。

日記帳
【にっきちょう】

①日々の出来事を書き記す帳面。日記という記録自体は古代から行われているが、製品として日付が予め印刷された帳面は、1812年にイギリスのジョン・レッツがつくった「レッツ・ダイアリー」が最初で、日本では1879年大蔵省初代印刷局長の得能良輔がつくった1880年用の「懐中日記」が最初といわれる（→p117「手帳」参照）。②取引の概要を発生順に記録する帳簿。

ニブ
【ニブ】

筆記具のペン先（筆記媒体に触れる部品）の総称。特に万年筆やつけペン、マーキングペンのペン先を指すことが多い。

コレ

日本PTA全国協議会推薦
【にほんピーティーエーぜんこくきょうぎかいすいせん】

公益社団法人日本PTA全国協議会が、企業から推薦依頼のあった製品を審査し合格したもの。推薦を表す決まった様式はなく、パッケージなどへの表示マーク等は各企業が独自に作成し表示している。

日本文具大賞
【にほんぶんぐたいしょう】

リードエグジビションが主催するISOT（国際文具紙製品展）（→p28）において、機能・デザインに優れた文房具に与えられる賞。

にわか
【にわか】

古参のファンが、流行などに乗って急にファンを自称するようになった者に対して使う蔑称。入門者に対し、先行者の優位を誇示するために使われる場合もある。

人間工学
【にんげんこうがく】

人間を、物理的・身体的側面、生理的側面、心理学的側面から観察・測定して得た知見を、人間が扱うものや環境の設計に活かす学問。文房具の開発では、筋電図や脳波、使用時の体表温度分布などを測定して、使用時の負荷が小さいことをアピールすることが多い。

布テープ
【ぬのテープ】

合成繊維を基材とする幅広の梱包用の粘着テープ。紙を基材とするクラフトテープに比べ、粘着力が強く丈夫でありながら、手でまっすぐにちぎることができ、重ね貼りもできる。耐水性があり、油性マーキングペンで文字などを書くことが可能。さまざまな色のテープもあるなど、多くの面で使い勝手がよい反面、重く、価格が高い。

沼にはまる
【ぬまにはまる】

特定ジャンルの趣味や活動、収集などに対する熱中が度を超してしまい、もはや抜け出せないばかりかエスカレートしていく状況の比喩表現。多くの場合、時間や金銭などを過度につぎ込むのがやめられない状況を示す。マニアやファンの自虐的表現だが半ば自慢気味に使われる場合が多い。

ぬらぬら
【ぬらぬら】

主に万年筆の書き味について、インクフロー（→p34）がよくなめらかに筆記できるときに使われる擬態語。

塗り絵
【ぬりえ】

画材などを使って着色して楽しむための輪郭だけが書かれた絵、またはそれを綴じた冊子。

ネーム印
【ネームいん】

認め印として使われる、印面に個人の名前（苗字）を持つ小型の丸型印で、主に浸透印（→p88）のものを指す。

ネームペン
【ネームペン】

①ネーム印を内蔵したペン。②持ち物などに名前を書くための油性マーキングペン。

ねりけし
【ねりけし】

「練り消しゴム」。粘土のように自由に形を変えられるやわらかい字消し。擦るのではなく、筆跡に押しつけて黒鉛を吸着させて取り去る。実用品としてはデッサンなどの絵画用として使われるが、玩具的な面白さがあるため色や香りのついたものが学童に人気。「練りゴム」とも。

年玉手帳
【ねんぎょくてちょう】

企業や機関が誂え、年始に社員や取引先に無償配布する手帳。日本では1879年に大蔵省印刷局が発行した「懐中日記」がはじめとされる。

粘着剤
【ねんちゃくざい】

接着剤の一種だが、高粘度の液体やゲルで、貼り合わせの前後で状態が変わらず、貼り合わせるものに押しつけられると表面の凹凸に合わせて流動して隙間を埋め、分子間力が大きくなり貼り付くもの。「感圧接着剤」とも。

粘着テープ
【ねんちゃくテープ】

帯状の基剤の片面また
は両面に粘着剤を塗布
した接合材。圧接する
ことで貼り付けること
ができる。

粘着ピン
【ねんちゃくピン】

ポスターなどの掲示物を壁面に穴をあけずに
固定するために用いる粘着性のある小片。画
鋲の代用として使用される。

目立たず
壁も傷めず
はがせる

粘度
【ねんど】

物質の粘り具合。単位はPa·s（パスカル秒）。
粘度が低い液体ほど、流れる際の抵抗が少な
い。特にボールペンなど筆記具のインクの粘
度は、性能や書き心地に大きく影響する重要
な要素。

粘土
【ねんど】

①2〜5μm以下の鉱物からなる粒子で、僅
かな水分を加えると塑性（力を加えると容易
に変形し、その形でとどまる）を示し、高温
で加熱すると焼結しセラミック（→p100）
となる。鉛筆の芯の主要な構成要素の1つ。
②①の粘土、あるいはそれに類似する塑性を

示す造形材料の総称。

粘土芯
【ねんどしん】

主に鉛筆に内蔵される、粉末状の黒鉛と粘土
を混ぜて焼き固めた筆記用の固形芯。イギリ
ス産の純度の高い黒鉛鉱の代用品として、
1794年にフランスのニコラ・ジャック・コン
テ（→p129）が発明。黒鉛と粘土の混合
比率を変えることで硬度を変えることが可能
で、現在の鉛筆のほとんどに採用されている。
これに対し主にシャープペンシルに採用され
ているのは樹脂芯（→p85）である。

ノーカーボン紙
【ノーカーボンし】

顕色剤と反応して発色する無色の染料（発色
剤）と、顕色剤をあらかじめ別々に塗布した
紙を重ね、筆記の圧力によってそれらを反応
させて発色させる複写紙。上層の紙の裏面に
は、発色剤をカプセル状の皮膜に閉じこめた
ものを塗布し、下層の紙の表面には顕色剤が

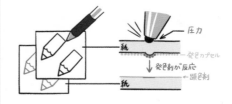

圧力
紙
発色カプセル
発色剤が反応
顕色剤
紙

塗布してあり、上層の表面にボールペンなど
で筆記すると、その圧力でカプセルが破壊さ
れ、染料が下層の顕色剤と反応し、上層の紙
に筆記された内容と同じものが下層に複写さ
れる。カーボン複写に比べて手や他の書類を
汚さない利点があるが、複写された筆跡が長
期保管に向かないなどの欠点がある。

ノート
【ノート】

主に洋紙を洋装丁で製本した帳面で文章や図
表などを記録することを目的としており、画
帳やメモとは区別される。多くは目的や記録
内容に合わせて罫線などが印刷されている。
ノートブック。

ノベルティ
【ノベルティ】

商品や企業などの宣伝を目的として、宣伝対
象の名称やロゴマークなどを表示して無料で
配布する記念品。文房具が使われることも多
い。市販品に名入れ（→p126）しただけの
ものから、宣伝対象に合わせて特別に製作さ
れるものまであり、中にはコレクションの対
象になり、マニアの間で高額で取引されるも
のも。

ノマドワーカー
【ノマドワーカー】

オフィスや自宅に常在せず、ノートパソコン
や携帯電話などの通信端末などを使って、コ
ワーキングスペースやカフェなどさまざまな
場所で仕事をする人を、遊牧民（ノマド）に
例えた表現。近年はノマドワーカー向けの文
具商品も多数登場している。

糊
【のり】

広義では接着・粘着剤の総称。狭義では水糊
やでんぷん糊など、主に紙を接着するための
水性の液状またはペースト状の接着剤を指す。

ノンドライ
【ノンドライ】

ペン先が長時間外気に触れていても筆記に支
障をきたさないインク及び構造の総称。ノッ
ク式ボールペンなどに採用されるリフィル
（→p183）や、マーキングペン（→p168）
のインクなど。マーキングペンのインクの場
合、多くは空気に触れると表面に薄い被膜を
形成して内部の溶媒が揮発するのを防ぐ。

ノンブル
【ノンブル】

本やノートなどに付されるページ番号。

コレ
↓

Stationery column ⑤

鉛筆の硬度とスマホの保護ガラス

　「硬さ」というのは、長さや重さなどと違って、実は定義するのがとても難しい性質です。実は絶対的な測定方法はなく、お互いに擦り合わせて傷が付いた方が柔らかいという方法か、硬いダイヤモンドを押しつけてできた凹みの大きさで判断する方法などがありますが、どれも相対的で、意味が異なります。文房具で硬さといえば、鉛筆の硬度表示ですが、これもJISによると「6Bから9Hに至るまでしんの硬さが増加し、9Hから6Bに至るまで線の濃さが増加していること」と「中心硬度をHBとする」というだけで、但し書きとして「科学的定義はまだ規定されていない」と書かれています。(HBの濃度についてのみ所定の測定方法で決められた数値範囲がある。)ですから各社の鉛筆の硬さや濃さが必ずしも揃っているわけではありません。

　また、JISで規定されている硬度は、HBとFを含む6Bから9Hまでの17硬度。その範囲外は自主的な基準となります。2008年には三菱鉛筆が10Bから10Hまでの22硬度を発売して、世界で最も硬度幅をもつ鉛筆を謳い話題となりましたが、2019年にはステッドラーが12B〜10Hの24硬度で更新しています。ところで鉛筆の硬度ですが、意外なところで硬さの基準として使われています。たとえば、スマートフォンの保護ガラスフィルムのパッケージに「硬度9H」などと表記されているものがありますが、実はこれ、9Hの尖った鉛筆で引っ掻いても傷が付かないということ。鉛筆が表面硬さの簡易指標として使われているのです。鉛筆の硬さは定義できないけど、鉛筆を使ってガラスの硬さは比べられる。不思議ですね。

134

は
行

トビラ雑学 **6** ＞ マークのいろいろ

※下に掲載しているマークは
イメージです。

JISマーク

工業標準化法に基づき、主
務大臣が定める鉱工業品の
種類・形状・寸法等に関す
る規格。経済産業省が認定。

STマーク

「Safety Toy」の頭文字を取
ったもので、日本玩具協会
の安全基準に合格した商品
に付けられた玩具のマーク。
玩具として扱われる文房具
には付けられる場合がある。

エコマーク

公益財団法人日本環境協会
が認定した、環境保全に役
立つ「環境保全型商品」に
表示。

再生紙使用（R）マーク

「ごみ減量化推進国民会議」
が定めた、古紙パルプの配
合率を表示したマーク。申
請や届出は不要。

グリーンマーク

公益財団法人古紙再生促進
センターが定めた、古紙を
原則として40％以上原料に
利用した製品に表示できる
マーク。表示には承認手続
きが必要。

FSCマーク

「Forest Stewardship Cou
ncil®（森林管理協議会）」
が認定する、環境や地域社
会に配慮して森林の管理や
伐採が行なわれている森林
から生産された木材（紙）
製品につけられるマーク。

ベルマーク

公益財団法人ベルマーク教
育助成財団が主催する運動。
ベルマークの付いたものを
購入、集めて送れば教育設
備品がもらえる。

クリーンマーク

日本字消工業会の安全管理
の自主規制に適合している
ことを示すマーク。番号は
日本字消工業会に所属する
製造業者を示している。

Gマーク（グッドデザイン賞）

経済産業省が工業製品のデザイ
ン工場省令のため実施している
グッドデザイン賞に選定された
商品に付けられる。

キッズデザイン
マーク
（キッズデザイン賞）

日本
文具大賞
マーク

パーカー
【パーカー】

イギリスに本拠を置く筆記具ブランド。1888年にジョージ・サッフォード・パーカーがアメリカで筆記具メーカーとして創業。1894年にインク漏れを軽減する仕組み「ラッキー・カーブ」を開発。1954年に発売したノック式ボールペン「ジョッター」や1921年発売の万年筆「デュオフォールド」などで有名。全てのラインアップに共通する矢羽根型のクリップが特徴。

バーチカル
【バーチカル】

手帳のフォーマットの1つ（→p25「手帳の種類」参照）。時間軸を縦に取り、詳細な時間の管理や配分がしやすい。

ハードカバー
【ハードカバー】

表紙に硬い素材を使った製本方法、またそれを採用した本やノート。

パイプ式ファイル
【パイプしきファイル】

筒状の綴じ金具を使用したファイル。一般に保持枚数が普通紙で300〜1000枚程度と大容量。パンチ穴よりも細い筒状の金具と、その

筒の内径よりも細い棒状の金具で紙を表裏から挟み込んで綴じる仕組みで、書類の差し替えを行う際、任意のページで前後に分けた書類のどちらにも金具に通した状態のまま扱える。片開きと両開きがある。

バイブルサイズ
【バイブルサイズ】

システム手帳の用紙の最も普及しているサイズ。171×95mmで6穴。聖書の大きさとは関係ない日本独自の呼称で、世界的には「パーソナル」と呼ばれる。

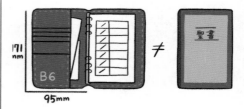

ハイマン・L・リップマン
【ハイマン・エル・リップマン】

（1817-1893）アメリカ人。1858年に、鉛筆の片側1/4に黒鉛芯の代わりに消しゴムを埋め込んだ「黒鉛芯と消しゴムの結合体」の特許を取得。両端を削って消しゴムを露出させて使用する。これが消しゴム付き鉛筆の元祖とされる。現在一般的な金属製の筒で固定する方式は1891年にエバーハード・ファーバーが特許を取得したものが最初。

ハイライター
【ハイライター】

文書上の文字列の一部を強調するために、その文字列の上に重ねて引く透過性のある明色の筆記具の総称。1963年にカーターズ・インク・カンパニーが発売した「リーディング・ハイライター」が最初。現在多くは蛍光色素を含む幅広のマーキングペンで、蛍光ペン（→p65）とほぼ同義で使われる。

パイロットコーポレーション
【パイロットコーポレーション】

日本の東京に本社を構える万年筆・筆記具を中心とする文具及び玩具メーカー。1918年に並木良輔（→p128）と和田正雄が万年筆メーカーとして設立（並木製作所）。カスタムシリーズを中心とする各種万年筆や、高級蒔絵万年筆のブランドNAMIKI（→p128）の他、人間工学を採り入れた筆記具ドクターグリップや、消せる筆記具フリクション（→p152）シリーズなどで有名。

バインダー
【バインダー】

綴じ穴のある用紙を自在に付け外しできる綴じ具を備えた表紙で、主に未記入の用紙（ルーズリーフ、帳簿など）を綴じて記録するもの（→p146「ファイル」参照）。

バインダークリップ
【バインダークリップ】

ダブルクリップ（→p109）のこと。

白銀比
【はくぎんひ】

白銀比と呼ばれる比率は2種類ある。一方は別名「第二貴金属比」と呼ばれる1：1＋$\sqrt{2}$（1：2.4142......）。もう一方は別名「大和比」と呼ばれる1：$\sqrt{2}$（1：1.4142.....）。文房具関係で白銀比というときは一般的に大和比の方を指し、長辺を半分に切ってできた長方形の長辺と短辺の比がもとの長方形と同じになる。A4を半分に切るとA5になるのはこの比率を採用しているため。

白色度
【はくしょくど】

JISで規定されている紙の白さを表す指標。紙の表面に光を当て、反射した光の比率（反射率）を数値化したもの。特に再生紙などにおいて一般に白色度を高くするための漂白や、蛍光増白剤などの使用は環境負荷が高くなる傾向があるため、各種の環境基準では白色度の上限が指定される場合が多い。

白墨
【はくぼく】

①チョーク（→p113）の別名。②胡粉（貝殻を焼いて粉末状にした炭酸カルシウムからなる白色の顔料）を練った白色の絵の具。

137

舶来品
【はくらいひん】

海外から輸入されたもの。主に江戸時代末期の開国から戦後日本製品の性能や品質が欧米に追いつくまで、欧米から入ってきた国産に比べて高性能で質の高い工業製品に対する憧れや敬意のニュアンスを含む場合が多い。

はさみ
【はさみ】

２枚の刃を向かい合わせて配置し、擦り合わせることで、刃の間に挟まれたものを切る道具。２枚の刃をU字型のバネ状の部材でつなぎあわせ、支点よりも前に力点があるU字はさみ（和ばさみ）と２枚の刃をX型に交差する形で重ねて中央を回転軸でとめ、力点と作用点の間に支点があるX字はさみ（洋ばさみ）に大別される。起源については諸説あるが前者は紀元前1000年頃には存在したといわれている。日本には４世紀頃に中国から渡来したと考えられる。

パステル
【パステル】

顔料を少量の粘結剤で固めた描画材。クレヨンに比べ、重ね塗りやぼかしなどの技法が使えるため、やわらかく重厚な表現ができるのが特長だが、固着剤が含まれていないので、

保存するためには描画後に定着液（フィクサチーフ）を噴霧して固定する必要がある。

肌色
【はだいろ】

かつてクレヨンや色鉛筆などの子供用画材を中心に使われていた色名。人種差別等に対する問題意識から、特定の色を肌の色と規定するのはおかしいとして、ビニー＆スミスカンパニー（現在のクレヨラ社）が1962年に自主的に肌の色を意味する「フレッシュ」を「ピーチ」に変更した。日本では桃色がピンクを表すため、「うすだいだい」や「ペールオレンジ」などに読み替えられた。

はっぱふみふみ
【はっぱふみふみ】

1969年に放送されたパイロットの万年筆「エリート」のCMにおいて大橋巨泉が即興で言い放った「みじかびの、きゃぶりきとれば、すぎちょびれ、すぎかきすらの、はっぱふみふみ」というフレーズが大流行。CMでは「わかるね？」と続くが、全く意味はない。

パテント
【パテント】

特許、特許権。カタログや商品パッケージ等には略号で表記されることが多い。「PAT.」は特許取得済み。「PAT.P」は特許出願中。

バトエン
【バトエン】

1993年にエニックス（現在の株式会社スクウェア・エニックス）が発売した、ゲーム用鉛筆。各面に勝負遊びに必要な情報が印刷された六角鉛筆。対戦者が互いにこの鉛筆を転がして上を向いた面に書かれた記号や数字、指示などによって勝敗を決める。

鳩目
【はとめ】

紐を通すために紙や布に開けた穴を補強する目的で施される環状の金具。呼称は金具の形状が鳩の目に似ていることに由来。荷札や綴じ込み表紙などに使われる。この金具を取り付けるための専用工具を鳩目パンチと呼ぶ。「アイレット」とも。

羽根ペン
【はねペン】

鳥の羽根の軸を斜めに切り落として整え、先端に切り割りを入れてつくるつけペン。先端が摩耗すると、摩耗した部分をナイフで削り落として整えて使う。鵞鳥(がちょう)の羽根が多く使われたことから鵞(が)ペンとも呼ばれる。7世紀

はじめから18世紀終わりまで主要な筆記具として長く使われた。

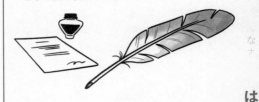

パピルス
【パピルス】

カヤツリグサ科の多年生植物カミガヤツリ（パピルス草）の地上茎の髄を剥がした薄片を並べたものを縦横に重ねて圧着したシート状の書写材料。紙を意味するPaperの語源だが、材料を繊維レベルまで分解していないので、分類上は紙ではない（→p53「紙」参照）。古代エジプトで紀元前3000年頃からつくられ、紙に取って代わられる13世紀頃までつくられた。その製法は一度失われたが、大プリニウスの著書『博物誌』をもとに研究が進められ20世紀に復元された。

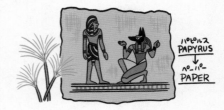

早川徳次
【はやかわとくじ】

（1893-1980）実業家・発明家。総合家電メーカーシャープの創業者。1915年「プラム製作所」の中田清三郎から依頼された繰出鉛筆の内部部品製造を機に、自ら操出鉛筆を改良し、同年「早川式操出鉛筆」の特許を申請。「早川兄弟商会金属文具製作所」を設立して販売を開始。事業を拡大したが、関東大震災で工場を焼失、早川兄弟商会を解散して事業を全て日本文具製造（後のプラトン文具）に譲渡。その後設立した「早川金属工業研究所」で、アメリカより輸入された鉱石ラジオの模倣による開発に成功。後に総合家電メーカーシャープへと発展させた。

早矢仕有的
【はやしゆうてき】

（1837-1901）医者・実業家。丸善雄松堂の創業者。1867年に福澤諭吉の私塾（後の慶應義塾）に入門し英学・経済を学び1869年

に「丸屋商社」を創業。日本初の会社設立趣意書といわれる『丸屋商社之記』を定め、その中で、世の急務である教育や医療にも洋書や薬品医療機器が乏しく不自由な状況なので、これらの品を売買するのを専業とするという主旨の宣言をし、書籍、医薬品、医療器具にとどまらずさまざまな西洋雑貨や文房具などの輸入販売を行った。早矢仕がつくった牛肉と野菜のごった煮がハヤシライスの起源とする説があり、現在も丸善に併設されたカフェのメニューにはハヤシライスがある。

針なしステープラー
【はりなしステープラー】

針などの結合部材を使わずに紙に切り込みを入れてかみ合わせたり、局部的に強い圧力をかけて紙同士の摩擦によって接合したりするなど物理的な加工を施すことで紙を綴じ合わせる事務機械。切り込み型は1909年にアメリカの、ジョージ・P・バンプが特許を出願したものが最初。圧着型はそれ以前の1903年には広告が存在しているから歴史は古い。日本には大正時代初期には輸入されており、当時は金属針を使用するステープラー同様に販売されたが、その後利便性の向上はステープラーが圧倒的で、市場は縮小した。しかし、食品異物混入事件などが社会問題となり安全意識が高まる中、2009年にコクヨが針なしステープラー（後のハリナックスシリーズ）を発売し、再び市場を挽回した。

パレット
【パレット】

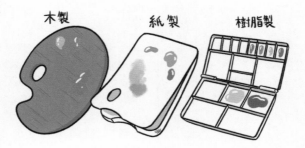
木製　紙製　樹脂製

絵の具を混色するための板。絵の具や溶剤に侵されない材料であればよく、さまざまな材料のものがあるが、学童が使う水彩絵の具用としては樹脂製が主流。紙製の使い捨てもある。

バレットジャーナル
【バレットジャーナル】

2003年にアメリカのライダー・キャロルが発表した手帳術。箇条書きの先頭に打つ「・」（バレットポイント）に由来。ノートにページ番号を振り、目次やカレンダーなど必要な項目を自分で書き加え、箇条書きと記号を活用してタスクやスケジュール、メモなどを管理するシンプルで自由度の高い手帳術。日本では自作手帳の一スタイルとして流行し、本来の目的を超えて手帳づくりを楽しむ人も多い。

パン
【パン】

天然ゴム製の消しゴムが普及する以前、黒鉛で書かれた描線の消去には硬くなったパンが使われた。現在でも木炭デッサンなどの美術用途では油分の少ないパンを使う場合がある。

バンカーズボックス
【バンカーズボックス】

アメリカのフェローズが販売するダンボール製の事務用書類収納箱。1917年にハリー・

フェローズが同社の前身となる「バンカーズ・ボックスカンパニー」を立ち上げて販売を開始。シンプルなオフィス収納の定番として人気。

＼ スッキリ ／

ハンギングフォルダー
【ハンギングフォルダー】

紙製のフォルダー（→p147）の小口側の両端辺に金属製の棒をわたし、端辺からはみ出した部分にフックを備えたもの。背を下にして専用の枠を備えたキャビネットやボックスファイルの縁などにフックをかけて収納する。フォルダーはフックによって開口部を上にして吊り下げられた状態になるので、書類を投げ込むだけで整理ができ、自重で曲がってしまうことがないのが特長。

半紙
【はんし】

和紙の最も普及した規格寸法。一般的には8寸×1尺1寸（242×333mm）を指し、元々は江戸時代に普及した杉原紙の寸延判（1尺1寸5分×1尺7寸）を全紙としそれを半分に切ったものが原形と考えられる。

パンチ
【パンチ】

紙に穴をあける道具の総称。主に用紙をファイルやバインダーに綴じるために用いるが、装飾や情報の記録や目印として穿孔するものも含まれる。

ハンドラベラー
【ハンドラベラー】

商品などに価格や日付などを印字したラベルシールを貼り付ける道具。本体内に印字装置とロール状のシールを内蔵し、ハンドルを握って印字したシールを、本体ごと対象物に押し当てて貼り付ける。

PL法
【ピーエルほう】

製造物責任法。PLは製造物責任（Product Liability）の略。製造物の欠陥によって損害が生じた場合に製造業者等が損害賠償責任を負うことを規定した1995年に施行された法律。文房具も例外ではなく、施行以来、安全性等に関する多くのガイドラインが策定され、改善が行われている。

Pカッター
【ピーカッター】

プラスチック板を切断する専用のカッター。鉤状になった先端で板の表面を掻き取って溝を彫る。何度も繰り返して、溝の深さが板厚の半分以上になったところで、板を割る。「プラスチックカッター」「アクリルカッター」とも。

パキッ

ギィー

B-TOOLマガジン
【ビーツールマガジン】

1988年4月から1992年1月までナツメ出版企画が発行した、文房具の情報に特化した月刊誌。毎号幅広いテーマを持った特集と新商品情報で当時の文房具人気を後押しした。充実した調査記事で、資料的価値も高い。

PPC
【ピーピーシー】

普通紙複写機（Plane Paper Copier）の略。特殊な専用紙を使わず普通紙に複写する機器の総称で、現在使われている多くのコピー機がこれにあたる。光を当てると電荷を発生する感光体を均一に帯電させた後、部分的に光を当てることで電荷の有無による像をつくり、帯電したトナー粒子を誘導して紙に転写、定着させる。1938年にアメリカのチェスター・F・カールソンが静電気による複写技術「ゼログラフィ」を発明。これをもとにアメリカのハロイド（現在のゼロックス社）が開発。1959年に世界初の普通紙複写機「Xerox914」を発売した。

肥後守
【ひごのかみ】

金属板を曲げてつくった柄に鋼材の刃を回転させて収納できるように取り付けた折り畳み式の携帯ナイフ。刃を固定する機構を持たず、チキリと呼ばれる突起で刃を繰り出し、親指で押さえることで固定する。起源については諸説あり定かではないが、明治時代の後半から、兵庫県三木市で生産されるようになり、後に多くの模造品も出回り、子供の必携品として全国的に普及した実用ナイフである。1960年の浅沼事件以降、急激に衰退した（→p40「鉛筆削器」参照）。

日玉
【ひだま】

手帳やカレンダーの日付を表す数字の部分。月や日を表す数字を「玉」と呼び、日の数字を「日玉」、月の数字を「月玉」と呼ぶ。手帳やカレンダーづくりでは絶対に間違いが許されない重要な情報。

左利き用
【ひだりききよう】

多くの文房具は右利きの人が右手で扱うことを前提に設計されているが、はさみなど一部の道具については、左手で扱うと人間工学上著しく不利であるために、一般のものとは鏡像の製品が左利き用としてつくられる場合がある。但し、左手で右利き用の道具を使うことに慣れてしまっている場合、左利き用の道具がかえって使いにくく感じられる場合もある。

筆圧
【ひつあつ】

筆記時に、筆記具の先端を紙に押しつける力。「筆圧」と呼ばれるが、圧力（面積あたりの力）ではなく単に力として使われている場合が多い。

ビック
【ビック】

フランスに本社を構える筆記具・ライター・剃刀メーカー。1945年にマルセル・ビックとエドゥワール・ビュッファールが筆記具の部品メーカーとして創業。ラズロ・ビロから特許を買い取り、1950年に透明軸の使い切りボールペン「ビック・クリスタル」を発売。1961年に発売したオレンジ色のボディに黒のキャップを持つ「オレンジ・ビック」と、同商品のキャンペーン用にレイモン・サヴィニャックによってデザインされたビックボーイなどで有名。

筆洗
【ひっせん】

水や溶媒を溜め置いて筆の穂先を洗浄する容器。

ヒノデワシ
【ヒノデワシ】

東京に本社を構える消しゴムメーカー。1919年にゴム製品メーカーとして創業（白髭護謨工業所）。昭和初期より消しゴムの製造を開始。1986年発売の、けしくずがまとまりやすい消しゴム「まとまるくん」や、消しゴムはんこ専用の消しゴム「はんけしくん」などで有名。

美文字
【びもじ】

主に日常生活における実用筆記の手書き文字において美しく見栄えのする文字を指す。書字に特別な技能を持たない人に使う啓発用語であり、伝統的な書道とは異なる文脈で使われる。

百均
【ひゃっきん】

百円均一ショップの略。全ての商品を原則100円の均一価格で販売する小売店。「100円ショップ」とも。当然、文房具も多く扱われていて、たいへん便利だが、品質や知的所有権などに問題がある製品も含まれるのは否定できず、注意が必要。一部の商品を倍数の価格（200円、300円など）で販売する店もある。

文房具年表

時期 ／ 内容

時期	内容
前15000年頃	フランスのラスコー洞窟に壁画が描かれる
前13000年頃	スペインのアルタミラ洞窟に壁画が描かれる
前4000年頃	東南アジアで樹皮紙「タパ」が使われる
前3500年頃	メソポタミアのシュメール人が粘土板に葦ペンで刻字する〈絵文字〉
前5000年頃～前3000年頃	中国の仰韶文化で、彩陶に描線を描くのに葦などの先端を削いだペン状のものと、それを叩きほぐしたものが使われた
前3000年頃～1年頃	メソポタミアで、粘土板に楔型と丸型の葦ペンで刻字する〈楔型文字〉
前3000年頃～13世紀頃	エジプトでパピルスが発明される。葦筆や葦ペンで筆記された
前2500年頃	エジプトで動物の皮に文字を書いた記録がある
前2100年頃	ペルーで樹皮紙「タパ」が使われた
前1600年頃	中国の殷王朝の初期かそれ以前には、煤を膠などで溶いた墨汁と毛筆が存在していた
前1500年頃	おそらくこの頃までにはさみが発明された
前1400年頃～前771年	中国の殷～周時代において、甲骨に文字が刻まれる
前1000年頃	ギリシアで、現存する最古のはさみ〈U字型ばさみ・握りばさみ・和ばさみ〉がつくられる
前7世紀頃	古代ローマで蝋板に尖筆が使われる
前5、4世紀頃～5、6世紀	中国で帛〈絹織物〉が筆記媒体として使われはじめる
前5、4世紀頃～8、9世紀	中国で木札〈木簡〉・竹簡が使われはじめる
前403～前221年	中国の戦国時代の墳丘から見つかった現存する最古の毛筆「長沙筆」がつくられた
前221～前206年	中国の秦代で、現存する最古の固形墨〈墨丸〉がつくられた
前220年頃	中国で紙がつくられはじめる
前2世紀	トルコのベルガモンで羊皮紙がつくられるようになる
前179～前142年頃	中国で、現存する最古の紙「放馬灘紙」がつくられた
前27年頃	ローマで、現存する最古の中間支点はさみ〈洋ばさみ・ローマはさみ〉がつくられた

BC 5000　BC 4000　BC 3000　BC 2000　BC 1600　BC 1500　BC 1400　BC 1300　BC 1200　BC 1100　BC 1000　BC 900　BC 800　BC 700　BC 600　BC 500　BC 400　BC 300　BC 200　BC 100　0

- **5世紀〜19世紀** — インドや東南アジアの一部で貝多羅（タリポット椰子などの葉）が使われた
- **6世紀頃〜19世紀頃** — ガチョウの羽根を使った羽ペンが使われる
- **610年** — 高句麗から渡来した曇徴が日本に製紙技術を伝えた
- **7世紀後半頃** — 中国で木板が使われはじめる
- **770年** — 刊行年代がわかる世界最古の印刷物『百万塔陀羅尼』が日本でつくられた
- **868年** — 現存する世界最古の印刷された書籍『金剛般若経』が中国で印刷された
- **953年** — エジプトのファーティマ朝のカリフ、ムイッズが万年筆の原型となる筆記具を発明
- **12世紀** — ヨーロッパでシルバーポイント（銀筆）が使用される
- **1560年代** — イギリスのカンバーランド山脈にあるボローデル渓谷で、カンバーランド黒鉛鉱山が発見される
- **1565年** — スイスの博物学者コンラート・ゲスナーの著書『とくに石と岩に含まれる化石の形とイメージについての本』に、鉛筆に関
- **16世紀後半** — イギリスのケスウィックの指物師が、黒鉛の棒を木材にはめ込んだ
- **1623年** — ドイツのヴィルヘルム・シッカートが機械式計算機「カリキュレーティング・クロック」を発明したが、火災により完成に至らず
- **1632年** — イギリスのウィリアム・オートレッドが計算尺を発明
- **1642年** — フランスのブレーズ・パスカルが機械式計算機「パスカリーヌ」を発明
- **17世紀中頃** — 起源は不明だが、この頃にはヨーロッパで画鋲が普及していた
- **1662年** — フリードリッヒ・ステッドラーがドイツで鉛筆の製造業（現在のステッドラー）を創業（1835年にステッドラー創立）
- **1663年** — 鳩居堂が京都で薬種商として創業
- **1714年** — イギリスのヘンリー・ミルが最初のタイプライターの特許を得ているが、詳細は不明
- **1740年頃** — イングランドのジェームズ・ワットマン（ターキー製紙場）が「網目紙（ウォーヴ・ペーパー）」を発明
- **1761年** — カスパー・ファーバーがドイツにファーバーカステルを創立
- **1770年** — イギリスのジョセフ・プリーストリーによる消しゴムに関する最古の記述
- **1780年頃** — イギリスのサミュエル・ハリソンが鉄ペン（金属板を丸めたペン先）を考案
- **1792年** — 初代今津屋小八郎が今津屋（現在の株式会社ライオン事務器）を創業
- **1794年** — フランスのニコラ・ジャック・コンテが黒鉛と粘土を混ぜて焼く芯の製法を発明（特許取得は1795年）
- **1798年** — フランスのルイ・ロベールが長網式抄紙機を発明

時系列年表（筆記具・文具の歴史）

上部年代軸：1800　1810　1820　1830　1840　1850　1860　1870　1880　1890　1900

- **1809年** イギリスのフレデリック・バーソロミュー・フォルシュが後部にバルブのある筆記具を発明。万年筆の特許としては最も古い
- **1809年** ジョゼフ・ブラマーが「複式泉筆（Compound Fountain Pen）」の特許を取得
- **1822年** イギリスのジョン・アイザック・ホーキンスとサンプソン・モーダンがシャープペンシルの特許を取得
- **1828年** 一貫斉国友藤兵衛が、インクを内蔵する筆「御懐中筆」を量産する
- **1830年代** イングランドのバーミンガムで金属製のつけペンが量産される
- **1832年** ドイツのカール・ホルネマンが絵の具の製造メーカーとしてペリカンを創立
- **1835年** ドイツでステッドラー設立（創業は1662年）
- **1840年** ドイツのフリードリヒ・ゴッドロープ・ケラーが木材からパルプをつくる製法を開発
- **1851年** ドイツのファーバーカステルのローター・フォン・ファーバーが、現在普及している鉛筆の長さ・太さの基準を示した
- **1855年** ゲオルグ・グロースベルガーとヘルマン・クルツがドイツの鉛筆製造メーカーとしてグロースベルガー・アンド・クルツ（現在のスワンスタビロ）を創業
- **1858年** アメリカのハイマン・L・リップマンが消しゴム付き鉛筆を発明
- **1862年** 福澤諭吉がフランスから手帳を持ち帰る（この西航手帳が日本に紹介された最初の手帳といわれる）
- **1866年** アメリカのジョージ・W・マギルが、紙に割ピンに近い形状の金具を通す穴をあけ、金具を外に広げる道具を発明
- **1868年** アメリカのアルバート・J・クレッツォが、コの字型の金具を紙に貫通させてから内側に折り畳む道具を発明
- **1869年** 福澤諭吉の門人、早矢仕有的が洋書・薬品・医療機器の輸入販売業として丸屋商社（現在の丸善雄松堂株式会社）を創立
- **1872年** 浅野長勲が日本初の洋式製紙会社として有恒社（現在の王子製紙株式会社）を創立（1874年より操業、1924年に王子製紙に吸収される）
- **1872年** 渋沢栄一が日本初の洋式製紙会社として抄紙会社（現在の王子製紙株式会社）を創立（1875年より操業）
- **1873年** ウィーンの万国博覧会で井口直樹と藤山種廣が鉛筆の製造方法を習得して帰国
- **1874年** 小池卯八郎が鉛筆製造工場を興す
- **1874年** 日本初の洋紙製造工場（有恒社）が操業を開始
- **1874年** イギリスのレミントン父子商会がクリストファー・レイサム・ショールズらの特許を元にタイプライターを製造、発売する
- **1877年** アメリカのヘンリー・R・ヘイルが針の貫通と折曲げを同時に行う紙綴じ器を発明
- **1879年** 大蔵省印刷局が「懐中日記」を発行（日本で発行された日付が印刷された最初の手帳）
- **1879年** アメリカのジョージ・W・マギルが、現在のステープラーに近い構造の単発式ステープラーを発明
- **1882年** 長澤力蔵が長澤紙店（現在の株式会社ナガサワ文具センター）を創業
- **1883年** アメリカのルイス・エドソン・ウォーターマンが毛細管現象を応用した万年筆を発明
- **1886年** 八代目足立市兵衛が足立商店（現在の不易糊工業株式会社）を創業
- **1887年** 眞崎仁六が眞崎鉛筆製造所（現在の三菱鉛筆株式会社）を創業
- **1887年** トーマス・A・エジソンの特許を元に、アルバート・B・ディックがアメリカで世界初の謄写版を発売（商標は「ミメオグラフ」）
- **1888年** アメリカのジョージ・サッフォード・パーカーがパーカーを創業
- **1888年** アメリカのジョン・ロードがボールペンを発明（実用に至らず）
- **1894年** 堀井新治郎が謄写版を発売
- **1896年** 石川徳松が石川ペン先製造所を創業（現在のゼブラ株式会社）
- **1898年** 田口精爾が墨汁を発明。田口商会を創業し「開明墨汁」を発売

年表（1930年〜1960年代）

- 1934年 アンリ・ヴェラヤックが紙製品メーカー（現在のロディア）をフランスに創立（翌年アンリの弟ロベールが加わり、ヴェリヤック兄弟社となる）
- 1938年 フランスでハンガリー人のラズロ・ビロがボールペンの製造を開始
- 1938年 アメリカのチェスター・F・カールソンが複写技術「ゼログラフィ」を発明
- 1942年 山田勝太郎が山田航空工業（現在のマックス株式会社）を創業し、零戦の尾翼の部品を製造する（1946年よりステープラーの製造を開始）
- 1943年 アルゼンチンでハンガリー人のラズロ・ビロが世界初のボールペン「birome」を発売
- 1945年 トンボ鉛筆が高級製図用鉛筆「No.8900」を発売
- 1945年 フランスでマルセル・ビックとエドゥワール・ビュッフアールが筆記具の部品メーカーとしてビックを創業
- 1946年 三菱鉛筆株式会社が高級製図用鉛筆「No.9800」を発売
- 1946年 日絆薬品工業（現在のニチバン株式会社）が「セロテープ」を発売
- 1948年 今泉商店と鈴木商店が合併し、事務用品卸として千代田文具（現在のプラス株式会社）を設立
- 1951年 堀口乾蔵が塩化ビニルによる消しゴムの製造方法を発明
- 1951年 アメリカのベティ・ネスミス・グラハムが修正液の特許を取得（1956年に「ミステイクアウト」として発売）
- 1952年 トンボ鉛筆が高級鉛筆「HOMO（ホモ）」を発売
- 1953年 寺西化学工業株式会社が「マジックインキ」を発売（当初は内田洋行の商品として発売された）
- 1956年 日本の複数のメーカーからプラスチック消しゴムが発売される
- 1956年 岡田良男が世界初の折刃式カッターナイフを発明
- 1958年 三菱鉛筆株式会社が高級鉛筆「uni（ユニ）」を発売
- 1958年 アメリカのイーストマン・コダックが世界初の瞬間接着剤「イーストマン#910」を発売（1951年にハリー・クーヴァーとフレッド・ジョイナーが発明）
- 1958年 アメリカのデビッド・ダイモが、硬質なプラスチック製の粘着テープに文字を刻印する装置「ダイモ」を発売
- 1959年 アメリカのハロイド（現在のゼロックス）が普通紙複写機「Xerox914」を開発
- 1960年 大日本文具（現在のぺんてる株式会社）が世界初のポリマー芯「ハイポリマー芯（0.9㎜）」とノック式シャープペンシル「ぺんてる鉛筆」を発売
- 1961年 イギリスのベルパンチ社が世界初の電子卓上計算機・サムロックアニータ」を発売
- 1962年 大日本文具（現在のぺんてる株式会社）が0.7㎜と0.5㎜のポリマー芯を発売
- 1963年 トンボ鉛筆が高級鉛筆「MONO（モノ）」を発売
- 1963年 大日本文具（現在のぺんてる株式会社）が「サインペン」を発売（1965〜1966年にはアメリカの有人宇宙飛行計画でジェミニ6号と7号の装備に採用された）
- 1963年 アメリカのカーターズ・インク・カンパニーが文字を強調する透明色インクのマーカー「リーディング・ハイライター」を発売
- 1963年 アメリカのカーターズ・インク・カンパニーが蛍光インクを使用したマーカー「グロー・カラー・マーカー」を発売
- 1963年 パイロット萬年筆（現在の株式会社パイロットコーポレーション）が世界初のキャップのない万年筆「キャップレス（回転操出式）」を発売（ノック式は1964年発売）

1970　　　　1980　　　　1990　　　　2000

- 1964年　オートが世界初の水性ボールペンを開発
- 1964年　アメリカのIBMが世界初のワードプロセッサー「MT/ST」を開発
- 1965年　サンスター文具株式会社がポリカーボネイト製ペンケース「アーム筆入」を発売（1967年から放送されたテレビCM「象が踏んでも壊れない」でヒット商品に）
- 1967年　大日本文具（現在のぺんてる株式会社）が水性ボールペン「ローリングライター」を発売
- 1968年　シードゴム工業（現在の株式会社シード）がプラスチック消しゴム「レーダー」を発売（1970年に『暮しの手帖』で高く評価され、人気に）
- 1969年　サンスター文具株式会社が、子供用手帳玩具「スパイメモ」を発売（水に溶けるメモや変装シールなどの付録でヒット）
- 1969年　大日本文具（現在のぺんてる株式会社）が0.3㎜のポリマー芯と世界初の0.3㎜シャープペンシル「ぺんてるメカニカ」を発売
- 1969年　ドイツのヘンケルが世界初のスティックのり「プリットスティック」を発売
- 1971年　ドイツのスワン鉛筆工場（現在のスワンスタビロ）が蛍光ペン「スタビロ・ボス」を発売
- 1972年　カシオ計算機株式会社が乾電池駆動の小型電卓「カシオミニ」を発売
- 1972年　セーラー万年筆株式会社が「ふでペン」を発売
- 1973年　大日本文具（現在のぺんてる株式会社）が0.2㎜のポリマー芯と世界初の0.2㎜シャープペンシル「スライド02」を発売
- 1977年　複数のメーカーからスーパーカー消しゴムが発売される（カプセルトイの景品として）
- 1978年　東芝が日本語ワードプロセッサー「JW-10」を発売
- 1980年　株式会社バンダイが漫画『キン肉マン』の登場キャラクターをかたどった「キン肉マン消しゴム」を発売
- 1983年　アメリカのスリーエムが再剥離可能な粘着剤を塗布した付箋「ポスト・イット」を発売
- 1984年　ファイロファックスが日本でシステム手帳の販売を開始
- 1984年　株式会社サクラクレパスが世界初のゲルインクボールペン「ボールサイン280」を発売
- 1984年　シードゴム工業（現在の株式会社シード）が修正テープを考案し、特許を出願（発売は1990年）
- 1984年　プラス株式会社が小型文具セット「チームデミ」を発売
- 1986年　ヒノデワシ株式会社が消しくずがまとまりやすい消しゴム「まとまるくん」を発売
- 1988年　ドイツのペリカンがテープ糊「Rollfix」を発売
- 1988年　株式会社キングジムがラベルライター「テプラTR-55」を発売
- 1989年　ドイツのペリカン社が修正テープ「Rollfix」を発売
- 1991年　パイロット（現在の株式会社パイロットコーポレーション）が人間工学をデザインに採用したボールペン「ドクターグリップ」を発売（シャープペンシルの発売は1992年）
- 1994年　パイロット（現在の株式会社パイロットコーポレーション）がボール径0.3㎜のボールペン「ハイテックC」を発売
- 1998年　イタリアのモド・アンド・モド（現在のモレスキン）が、19世紀後半にフランスでつくられた伝説のノートを再現した「モレスキン」を発売（創業は1997年）

2002年　糸井重里が代表を務める株式会社ほぼ日が、1日1ページの手帳「ほぼ日手帳」を発売

2003年　コクヨ株式会社が、「カドケシ」を発売

2003年　三菱鉛筆株式会社が低粘度油性ボールペン「ジェットストリーム」を発売

2005年　ドイツのロイヒトトゥルムが、ハードカバーノート「ロイヒトトゥルム1917ノートブック」を発売

2006年　三菱鉛筆株式会社が低粘度油性ボールペン「ジェットストリーム」を発売（日本国内）

2006年　三菱鉛筆株式会社が、「ジェットストリーム」を欧米向けに発売（日本での発売は2006年）

2006年　株式会社パイロットコーポレーションが温度変化で透明化するインクを使ったラインマーカー「フリクションライン」を発売

2006年　株式会社パイロットコーポレーションが温度変化で透明化するインクを使った消せるボールペン「フリクションボール」をフランスで発売（日本では2007年に発売）

2006年　ミドリ（現在の株式会社デザインフィル）が「トラベラーズノート」発売

2007年　コクヨS&T（現在のコクヨ株式会社）が、立つペンケース「ネオクリッツ」発売（「クリッツ」の発売は1999年）

2008年　カモ井加工紙株式会社が、意匠用途としてのマスキングテープ「mt」を発売

2008年　三菱鉛筆株式会社が、芯が回ってとがり続けるシャープペンシル「クルトガ」を発売

2008年　マックス株式会社が、40枚綴じ可能なハンディステープラー「バイモ11」を発売

2010年　株式会社キングジムがデジタルメモ「ポメラDM-10」を発売

2012年　ゼブラ株式会社がエマルジョンインクを応用した先端まで交差角が一定のはさみ「フィットカットカーブ」を発売

2013年　プラス株式会社が、対数螺旋を応用した先端まで交差角が一定のはさみ「フィットカットカーブ」を発売

2014年　株式会社パイロットコーポレーションが子供向けの万年筆「カクノ」を発売

2014年　ぺんてる株式会社が0.2mmの一般筆記用シャープペンシル「オレンズ」を発売

2015年　ゼブラ株式会社が独自機構で芯が折れないシャープペンシル「デルガード」を発売

2017年　コクヨ株式会社が、リングが柔らかいリングノート「ソフトリングノート」を発売

ぺんてる株式会社が、0.2mm、0.3mmでは初の自動芯出機構搭載のシャープペンシル「オレンズネロ」を発売

ビュバー
【ビュバー】

吸取紙（→p89）のこと。

ビリジアン
【ビリジアン】

元来はクロム化合物を含む緑色の顔料を指したが、現在はその色に由来する色名として広く使われる。深い青緑色。黄色と混色すると緑になるので、色数の少ない絵の具には緑ではなくビリジアンが採用されることが多い。

樋渡源吾
【ひわたりげんご】

（生没年不詳）鉛筆製造業者。1859年に創業、1877年に開催された第1回内国勧業博覧会に、小池卯八郎（→p68）と並んで鉛筆を出品し、鳳紋賞牌を受けた。創業は小池より15年も古く、記録に残る日本で最も古い鉛筆製造者。

ピンセル
【ピンセル】

収納容器を兼ねた安全画鋲抜取器。先端に向かって開口したスリットを持つ薄い金属板を、打ち付けられた画鋲の頭部の下に滑り込ませて、本体をテコにして引き抜く。引き抜いた

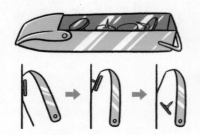

画鋲はそのまま本体内に格納され、可動式の蓋をひらいて再利用する。1957年に高野篤らが発明。

便箋
【びんせん】

手紙を書くための紙。罫線や模様などが印刷されているものも多い。「書簡箋」「用箋」とも。

ビンテージ
【ビンテージ】

古物のうち、年代を経ることによって、稀少性が上がったりあじわいが増すなど、価値が高まったもの。ビンテージに特化した文房具コレクターも多い。

品番
【ひんばん】

商品の種類や色柄などを区別して管理するための記号や番号。JANなどの共通規格とは異なり、メーカー各社の社内ルールに基づいて付与される。このため、メーカーにより単なる連番の場合もあれば、数字や記号に種別や価格などの意味を読み取れるものもある。特にコクヨの旧品番は、商品を表す2文字のカナで意味がわかりやすく、覚えやすかった。

びんぼう削り
【びんぼうけずり】

鉛筆を両側から削って使うことの俗称。「泥棒削り」とも。

ファーバーカステル
【ファーバーカステル】

ドイツに本社を構える鉛筆・筆記具メーカー。1761年にカスパー・ファーバーが創業。1851年にローター・フォン・ファーバーが、現在普及している鉛筆の長さ・太さを確立した。濃緑色に金文字の鉛筆「カステル9000番」や、キャップに削器を内蔵する「パーフェクトペンシル」などで有名。

ファイル
【ファイル】

主に印刷物や書類、伝票など、記録済みの文書を保持し、整理、保管する機能を持つ表紙（→p137「バインダー」参照）。

ファイロファックス
【ファイロファックス】

イギリスに本拠を構える手帳ブランド。1921年にウィリアム・ラウンスとポスィーン・ヒルが創業（ノーマンアンドヒル）。アメリカのエンジニア用マニュアルのファイル「LEFAX」を参考に、バインダー式のシステム手帳「fILOFAX」を開発。日本では1984年から販売され、システム手帳ブームを起こした。

ファンシー文具
【ファンシーぶんぐ】

女児に向けた、可愛らしい意匠や装飾を施した文具の総称。特に1970年代後半から80年代にブームを巻き起こした、メーカーのオリジナルキャラクターを採用した商品群やその系譜を指すことが多い。

封筒
【ふうとう】

手紙や書類の他、証券や写真などの紙片を入れて郵送したり、複数の書類などをひとまと

まりにして保管したりする際に用いる、主に紙製の平らな袋。角形、長型、洋型などの定型寸法の他、用途に合わせて種類は多岐にわたる。

フールス紙
【フールスし】

日本ではサイズ（にじみ止め）の効いた両面ペン書き可能な化学パルプからつくられた筆記用紙で、特に透かし模様の入ったものを指すが、世界的には13.5×17インチの紙を指す用紙寸法。15世紀半ばにイギリスで導入された道化の帽子（Fool's cap）型のすかしに由来する。「フールスキャップ」「フールスカップ」とも。

封蝋
【ふうろう】

封筒や手紙、容器などの封を留めると共に、未開封であることを証明するために、熱して溶かした蝋を垂らして固めたもの。またそれに使う蝋。「シーリングワックス」とも（→p78「シーリングスタンプ」参照）。

不易糊工業
【ふえきのりこうぎょう】

大阪に本社を構える糊・文具メーカー。1886年に八代目足立市兵衛が創業（足立商店）。

1895年に大阪府立商品陳列所（現在の大阪工業技術試験所）の藤井恒久の指導で腐らない糊を開発。荀子の「萬世不能易也」（永遠に変わることなし）に因んで不易と名付けられた。1975年には「フエキ糊どうぶつシリーズ」を発売。当初はウサギ・ゾウ・イヌの3種だったが、イヌ以外の人気がなかったためイヌだけが残り、現在のマスコットキャラクター「フエキくん」となった。

フェルトペン
【フェルトペン】

元来はペン先にフェルトを使用した筆記具を指したが、現在はマーキングペン（→p168）とほぼ同義。

フォトクロミック
【フォトクロミック】

光を当てることによって色が可逆的に変化する性質を持つことをフォトクロミズムといい、この性質を持つ材料をフォトクロミック材料と呼ぶ。コクヨの瞬間接着剤レッドテックはこのフォトクロミックを応用した製品で、塗布時は赤い色が光に晒されることで透明化する。

フォルダー
【フォルダー】

書類を挟み込んで保管するための厚紙を二つ折りにした簡易ファイル。

福澤諭吉
【ふくざわゆきち】

（1835-1901）日本の武士・蘭学者・著述家・啓蒙思想家・教育者。慶應義塾の創設や著書「学問のすすめ」などで有名。1862年の文久遣欧使節に同行した際に立ち寄ったパリで入手し、欧州滞在中の見聞を書き留めて持ち帰った「西航手帳」が日本にもたらされた手帳のはじまりとされ、1873年に出版した『帳合之法』で日本にはじめて西洋式（複式）簿記を伝えた人でもある。また門下生の早矢仕有的（→p140）が丸屋商社（現在の丸善雄松堂株式会社）創業にあたって強く影響を受けるなど、日本の文房具に与えた影響も大きい。

複写伝票
【ふくしゃでんぴょう】

カーボンまたはノーカーボン複写印刷が施された、複数枚で一組の帳合された伝票で、一番上の用紙にボールペンなどで記入すると、その筆圧により、下の用紙に同一の内容を複写する。

福袋
【ふくぶくろ】

年始の初売りなどで、原則として内容が明かされずに販売される多数の商品が封入された袋商品で、普通は販売価格よりも内容の合計価格の方が明らかに高い。在庫処分的な目的でつくられることも少なくないので、不人気商品や廃番品などが含まれることも多い。昨今は内容を明示して販売されるものもある。

藤山種廣
【ふじやまたねひろ】

（1838-1886）1873年に日本政府の伝修生として井口直樹（→p31）と共にウィーン万国博覧会に派遣され、「黒鉛と薬品の交合」を研究分野としてボヘミヤ州ハルトムート製造所で研修に努めて帰国。小池卯八郎（→p68）に技術を伝承した。国産の鉛筆開発の端緒を開いた。

付箋
【ふせん】

主に書籍や用紙に用件の付記や目印のために貼付する小型の紙片を指したが、1980年にアメリカのスリーエム社が発売した再剥離可能な粘着剤を施した「ポスト・イット」（→p162）以降、その用途は、さまざまなものに貼付可能なコミュニケーションツールとして、また、さまざまなメソッドと共に発想・思考を補助するツールとして発展した。現在は再剥離可能な糊が付けられた紙片であれば用途にかかわらず付箋と呼ばれることが多い。

蓋糊
【ふたのり】

袋か封筒の封かん用の糊が蓋（フラップ）側に付いているもの。商品の出し入れの際に粘着剤が商品にくっつく恐れがあるが、中身の大きさに合わせて蓋の折り返し深さを調節できるので、汎用の袋として使われる（→p121「胴糊」参照）。

ブックエンド
【ブックエンド】

並べて立てた本の端に置くことでその本が倒れることを防ぐもの。本立て。

ブックカバー
【ブックカバー】

主に、読書中の本の表紙にかぶせることで、汚れや傷みを防いだり表紙の内容を他人の目から隠すための保護カバー。

ブックダーツ
【ブックダーツ】

アメリカのブックダーツ社が製造販売する、薄い金属板を二つ折りにした、本のページの縁に挟んで固定する栞。一方の先端がペン先のような尖った形状になっていて、行単位で場所を指し示すことができる。

ブックマーク
【ブックマーク】

栞（→p79）のこと。

プッシュピン
【プッシュピン】

プラスチック製のくびれた円筒もしくはそれに類する形のつまみを持つ画鋲。1900年にアメリカのエドウィン・ムーアが発明。当初はつまみがガラス製だった。「ダルマ画鋲」（→p110）とも。

フッ素コート
【フッそコート】

フッ素樹脂で、金属などの表面を覆うことで、さまざまな汚れや粘着剤などの付着を防いだり、滑りをよくする効果を得る表面加工の総称。はさみの刃などに施される。フッ素樹脂は、1938年にアメリカのデュポン社の、ロイ・プランケットによって発見された、フッ素を含むオレフィンを重合して得られる合成樹脂で、非粘着性や耐摩耗性、滑り性が非常に高い。

あ
ア

か
カ

さ
サ

た
タ

な
ナ

は
ハ

ま
マ

や
ヤ

ら
ラ

わ
ワ

筆
【ふで】

主に先端を切りそろえていない動物の体毛を束ねた「穂」を竹や木の筒の先に差し込んだ筆記具。文房四宝（→p155）の１つ。穂に墨液を含ませて紙に筆記する。馬・鹿・狸・兎・いたち・猫・山羊などさまざまな動物の体毛が使われるが種類によって硬さやしなりなどが異なり、用途によって使い分けられる。動物以外には植物繊維や、最近はナイロンなどの樹脂を使ったものも。

筆ペン
【ふでペン】

毛筆の穂先を模した多孔質な樹脂や人造毛による柔軟性の高いペン先を持ち、毛筆で書いたような抑揚のある表現ができるマーキングペン。1972年にセーラー万年筆が発売した「ふでぺん」が最初（万年筆と同様の軸に毛筆のペン先を取り付けたものは1970年に開明が「開明万年毛筆」を発売している）。1976年にはぺんてるが人造毛を使った毛筆タイプの「ぺんてる筆」を発売。近年は絵手紙やブラッシュカリグラフィー用のペンとして色数の多い製品も増えている。

プライベートブランド
【プライベートブランド】

同業者との差別化や利益率の向上などのために、小売業者や卸売業者などが開発するブランド、「PB」。これに対し、メーカーが企画・開発・製造までを一貫して行う一般商品をナショナルブランド、「NB」という。

プラス
【プラス】

日本の東京に本社を構える文具・事務機器・オフィス家具メーカー。1948年に今泉商店と鈴木商店が合併して事務用品卸として設立（千代田文具）。その後自ら企画製造するメーカーとなり、アスクルやビズネットなど独自の流通サービス会社の設立などを経て国内外の製造から流通まで多くの会社によるグループを形成している。

プラチナ万年筆
【プラチナまんねんひつ】

日本の東京に本社を構える万年筆・筆記具メーカー。中田俊一（→p127）が1919年に創業（1924年に中屋製作所を設立）。独自のキャップ密閉機構でペン先が乾燥しにくい万年筆#3776センチュリーや安価な普及型万年筆プレピーなどで有名。プラチナの万年筆職人

らが創業した中屋万年筆（→p127）を子会社に持つ。

フラットクリンチ
【フラットクリンチ】

ステープラーの綴じ方の１つ。針が完全に紙束を貫通してから曲げ台（クリンチャー）を叩きつけて一気に曲げるため、貫通した針が根本からほぼ直角に折れ曲がった形で紙を抱き込んで固定する。一般的な綴じ方に比べ、綴じ部の厚みが抑えられる。1987年にマックスが発売したHD-10Fが世界初。

フラットファイル
【フラットファイル】

厚紙または樹脂シートでできた表紙に簡単な綴じ具を取り付けた２穴のファイル。安価で軽いのが特徴。

プラマン
【プラマン】

ぺんてるが1979年から販売する、樹脂製のしなるペン先を持つ細字用水性マーキングペン。鏃のような形の平らなペン先は中央が繊維状でインクを通し、万年筆に似たトメ・ハネ・ハライなどのやわらかな表現ができる独特の筆記感。1993年発売の直液式「トラディオプラマン」は多くのアーティストやデザイナーに人気。

フランクリン・プランナー
【フランクリン・プランナー】

予定やタスクの管理だけでなく、人生における価値観を明確にしそれに基づいた人間的到達目標に向け、優先順位をもって日々の行動計画を立てるのが特徴のシステム手帳。1984年にアメリカのハイラム・W・スミスが、ベンジャミン・フランクリンの自叙伝に記されている手帳術に影響を受けて開発したものを基礎に、1997年にスティーブン・R・コヴィーの著書『７つの習慣』に基づいた「コヴィー手帳」と融合して現在の形になった。

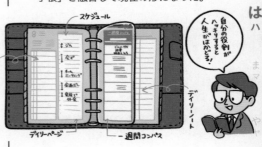

プランジャー式万年筆
【プランジャーしきまんねんひつ】

万年筆のインク吸入方式の１つ。尾栓が空気弁を内蔵するピストンのハンドルになっていて、尾栓を引いた後に勢いよく押し込むと、タンク内が負圧になり、インクを吸い込む仕組み。

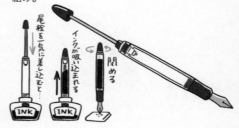

フリーアドレス
【フリーアドレス】

企業や機関において、個人に専有の固定席を割り当てず、共有の机を都度自由に選んで使用するオフィスの運用スタイル。個人専有の引き出しなどもないため、仕事に必要な道具類はロッカーなどに収納し、都度使用する席に持って移動する。この働き方が普及するのに合わせて、働く個人用の収納用品や文房具が多数開発されるようになった。

フリーマーケット
【フリーマーケット】

蚤の市（flea market）。主に個人が不要品や古物を持ち寄って販売する青空市。近年は「メルカリ」など、アプリを利用したネット上の仮想フリーマーケットも利用者が増加。骨董や廃番になった文房具などが見つかることもある。

フリクション
【フリクション】

パイロットがフランスで2006年に先行発売した消せるボールペン（日本での発売は2007年）。約65℃以上の高温で透明化する「フリクションインキ」（メタモカラー）を搭載し、専用のラバーで擦るとその摩擦熱で消字することができる。不正や事故を防止するため、公文書や有価証券などへの使用は禁止されている。なお、万一消えてしまった場合は、コールドスプレーなどで−20℃程度まで冷却すれば再び発色する。

ブリスターパック
【ブリスターパック】

平らな厚紙などの台紙と、透明な半立体の樹脂製のカバーで内容物を挟み込む包装。台紙にカバーを溶着したものもあるが、昨今は分別できるスライドタイプが多い。封入するものが外から見え、台紙のデザインと合わせて配置も固定できることなどから、文房具の商品パッケージにも多用される。ブリスターは「水ぶくれ」の意。

プリ帳
【プリちょう】

写真シール機で作成された写真シールを収集・整理するためのノートやファイル。シールを剥がせる特殊加工を施したものの他、ポケットタイプや、書き込めるものもある。専用ノートを使わずに市販のクリアファイルやノートなどで代用する場合も多い。

ブルーブラック
【ブルーブラック】

元来は、青から黒に色が変化する没食子インクを指したが、現在はブルーブラックと呼ば

れる色名のインクの多くは暗青色の染料インクであり、区別のため前者を「古典ブルーブラック」、「古典インク」(→p71) と呼ぶ場合がある。

フレネルレンズ
【フレネルレンズ】

レンズを同心円状の領域に分割して厚みを減らしたもので、元々は灯台の光を直進させるための大型レンズの薄型化のためにフランスのオーギュスタン・ジャン・フレネルが1819年に発明した。分割数を多くすることでレンズの厚さを極端に薄く均一にできるので、大型の卓上ルーペや携帯用のカード型ルーペなどに利用される。

球面レンズ

↓ 削る

フルネルレンズ

フローティングペン
【フローティングペン】

ボールペンの後軸内にオイルと共に封入された小片が、ペンを傾けることによって軸内を前後にゆっくりと移動することで、絵が変化する。ヌードペンなどさまざまな応用がある。デンマークのエスケセン社が1951年にエッソのノベルティとして開発。

ブロックメモ
【ブロックメモ】

天糊製本の小型卓上メモで、立体的に見えるほど極端に枚数が多いもの。

ドッ

ブロッター
【ブロッター】

吸取紙 (→p89) を固定する半円筒型の本体にハンドルを取り付けたもので、万年筆等で筆記した筆記面に転がすように当てて、乾いていない余剰のインクを吸い取る器具。ノートや書類の汚損を防止する。

pen

プロパー品
【プロパーひん】

メーカーが発売元となり、卸売業者から小売業者に卸される正規商品。

プロフ帳
【プロフちょう】

個人のプロフィールを記入するリーフがセットされたバインダー型ノート。サイン帳（→p76）の発展形で、リーフは華やかなデザインが多く、具体的な質問と回答欄が用意されていて、書き込みやすく工夫されている。

文具王
【ぶんぐおう】

→p108「高畑正幸」参照。

文具券
【ぶんぐけん】

『全国共通「文具券」』。1978年に文房具関連の業界15団体の出資により設立された「日本文具振興株式会社」が販売した、文房具類と引き替えできる額面500円の有価証券。2010年に販売交換共に終了した。

ブング・ジャム
【ブング・ジャム】

2007年に結成された、きだてたく、高畑正幸、他故壁氏の三名で構成される、文房具の啓蒙を主眼とするトークユニット。イベントやメディア出演、執筆などを通じて、文房具の楽しさや奥深さを世に伝える活動を行っている。

文具資料館
【ぶんぐしりょうかん】

東京都台東区の「東京文具販売健康保険組合会館」中にある文房具の資料館。古代から現代までの筆記具を中心とした文房具が展示されている。

文具知識能力検定
【ぶんぐちしきのうりょくけんてい】

2008年から実施されている文房具に関する知識検定。WEBサイトで登録、受験する。紙製品新聞社、全通、日本文具新聞社、文研社の4社が共催し、文房具屋さんドットコムが運営する。

文具のとびら
【ぶんぐのとびら】

2017年に開設された、文房具情報WEBマガジン。文房具業界専門誌『旬刊ステイショナー』やフリーマガジン『Bun 2』を発行するステイショナーが運営する。編集長は文具王の高畑正幸。

文具の日
【ぶんぐのひ】

11月3日。文化の日と同じ。東京都文具事務用品商業組合などが「文具と文化は歴史的にみて同義」として1987年に制定。

ブンゲル係数
【ブンゲルけいすう】

家計の消費支出に占める文房具費の割合。単に支出額を表す場合もある。エンゲル係数（家計の消費支出に占める飲食費の割合）になぞらえた俗語で、生活水準の目安にはならないが、高すぎるブンゲル係数は、文房具が手段を超えて趣味化・目的化してしまっている可能性を示唆しているといわれている。

文鎮
【ぶんちん】

主に金属や石、ガラスなど比重の高い素材の塊で、紙や書類の上に置き動かないようにする重しの総称。筆記する際に紙が動かないように固定したり、書類が風で飛ぶのを防いだりするのに用いる。

Bun2
【ブンツー】

2004年からステイショナーが発行し、全国の文具店等で配布されている文房具情報フリーペーパー。

文通
【ぶんつう】

主に郵便を使った手紙のやり取りによるコミュニケーション。

分度器
【ぶんどき】

平面上の角度を測定するために用いる半円形または円形の定規で、円周には目盛りが施され、円の中心を示す点と目盛りを結ぶ直線が基線との間になす角度が刻まれている。

分別廃棄対応製品
【ぶんべつはいきたいおうせいひん】

その製品を廃棄する際、素材ごとに分別することが容易にできるよう、設計に工夫がされたもの。

文房四宝
【ぶんぼうしほう】

中国で文人が書斎で使用する道具のうち最も重要な筆・墨・硯・紙の4種を指す（文房四宝を筆墨硯紙とした初出は宋代の『避暑録話』）。漢代ごろからはじまった、文房具を鑑賞や愛玩の対象とする文化「文房清玩」に根ざす言葉で、元来は実用よりも趣味愛玩品としての意味合いが強い。「文房四友」「文房四侯」とも。日本の「文房具」の語源の1つとされる。

ぶんまわし
【ぶんまわし】

コンパス（→p73）のこと。

ペイントマーカー
【ペイントマーカー】

不透明油性マーキングペンの総称。隠蔽性が高く、速乾性、固着性、耐水性、耐候性に優れたものが多いため、さまざまな材料に筆記可能。風雨にさらされる環境に置かれるものへの筆記や着色にも適している。

ベークライト
【ベークライト】

アメリカのレオ・ヘンドリック・ベークランドが1907年に工業化したフェノール樹脂。商標だがほとんど一般名称化している。植物以外の原料から人工的に合成されたはじめてのプラスチック。熱硬化性樹脂で、耐熱性、難燃性、絶縁性に優れる。万年筆などの筆記具等の軸材料にも使われた。

ペーパークイリング
【ペーパークイリング】

細長い紙を巻いてつくった部品を組み合わせて装飾的作品をつくる手芸の一種。古代エジプトより金属などで行われていた装飾技法だが、16世紀頃ヨーロッパの修道女が古くなった聖書などを切った紙片を巻いて聖書の表紙や宗教画などを装飾したことで普及したとい

われている。紙を巻く芯に鵞鳥（がちょう）の羽根（quill）を使用したことに由来。

ペーパークロマトグラフィ
【ペーパークロマトグラフィ】

濾紙（ろし）を使って、試料に含まれる物質を分離する方法。試料を付着させた濾紙の一端を溶媒に浸すことで、溶媒が毛細管現象で濾紙に吸い上げられながら試料に含まれる物質を移動させる。しかし物質ごとの紙への吸着性などの違いによって、溶媒によって運ばれる距離に違いが出るため、物質を分離することが可能。特別な装置を必要とせず容易に行えるのが特徴で、筆記具のインクに含まれる色素などの分離によく使われる。

ペーパーセメント
【ペーパーセメント】

福岡工業が製造販売する主として紙の接着に使われる天然ゴム系の接着剤。紙を伸縮させず、完全に乾くまでは貼り剥がしができ、乾燥後でも専用の溶剤（ソルベント）で紙を傷

めずに剝がすことができるため、PCによる
デザイン環境が普及する以前はグラフィック
デザインや版下作業などに欠かせないものだ
った。ハケ付きの専用瓶に移して溶剤で好み
の濃度に調整して使い、はみ出した糊はゴム
のクリーナーで擦るときれいに取れる。黄変
するので長期保管には不向き。

ペーパーナイフ
【ペーパーナイフ】

封筒の開封や本の袋綴じを開くなど、紙の折
り目に差し入れて切り開くに用いる専用
の道具。切るものを紙に限定しているため、
普通はカッターナイフほど鋭利ではない。か
つてヨーロッパでは所有者が必要に応じて製
本することを前提に、折り丁を断裁していな
い簡易製本で書籍を出版しており、購入者は
袋になったページを切り開きながら読んだた
め、ペーパーナイフは読書の必需品でもあっ
た。

ペーパーレス
【ペーパーレス】

業務の効率化や経費削減、資源保護などさま
ざまな目的で、従来情報の記録・閲覧・共有・
保管などの媒体として使ってきた紙を、各種
電子機器とそのネットワークで代替し、紙を
使わない状態。ペーパーレスの実現は旧来の
文房具の役割の終焉を意味するため、多くの
文房具メーカーは危機感を持って新たな文房
具の役割を模索しはじめている。

ペグシル
【ペグシル】

先端に鉛筆芯が埋め込まれた使い切りのプラ
スチック製簡易筆記具。細く短い軸の後部が
薄く平らに広がったクリップ状になっており、
書類等に引っかけることができる。ゴルフの
スコア記入やアンケート用の鉛筆として知ら
れる。1945年に岡屋が発売。「ペグシル」は
同社の商標。2002年には立体商標登録もさ
れている。

ベティ・ネスミス・グラハム
【ベティ・ネスミス・グラハム】

（1924-1980）秘書として働く中でタイプラ
イターの誤字を修正するために、水性のテン
ペラ絵の具で塗りつぶす方法を考案。1951
年に修正液（→p84）の特許を取得、1956
年に「ミステイクアウト」(後に「リキッド
ペーパー」) として販売した。

ベラム
【ベラム】

パーチメント（獣皮紙）のうち、子牛・子羊・子山羊などの皮をなめしてつくった上等な書写材料。中でも子牛の皮を使った高級品を指すことが多い。

ベラム紙
【ベラムし】

ベラム（高級な獣皮紙）のような紙、という意味で、高品質な紙の呼称として、さまざまに使われてきた。古くは、18世紀に発明された網目紙（畝がなくきめ細かくなめらか）を指したり、日本の大蔵省印刷局が1877年に希少な雁皮製の鳥子紙を模して三椏（みつまた）を原料につくった高級和紙「局紙」を「ジャパニーズベラム」と呼ぶなど。フランスのクレールフォンテーヌ社が開発しノートなどに採用しているなめらかな高級筆記用紙の商品名としても知られている。

ペリカン
【ペリカン】

スイスに本社を構える文具メーカー。1832年にカール・ホルネマンが絵の具とインクの製造メーカーとしてドイツで創業。1871年に経営を引き継いだギュンター・ワーグナーの家紋でもあり母性愛を象徴するペリカンの親子をデザインした愛らしいロゴマークと共に、日本では高級万年筆「スーベレーン」などの印象が強いが、事務用品や子供用の筆記具・画材なども取り扱う。

ベルヌーイカーブ
【ベルヌーイカーブ】

対数螺旋、等角螺旋ともいわれ、中心から引かれた直線と交差する角度が常に一定という特徴を持つ。この螺旋を研究した数学者ヤコブ・ベルヌーイの名に由来する。プラスがはさみ「フィットカットカーブ」の根本から刃先まで刃と刃が接する角度を一定に保つ形状に応用。

勉強垢
【べんきょうあか】

勉強へのモチベーションを維持するために、普段のSNSアカウントとは別に、勉強をしている学生同士がつながり、自分の勉強している状況を報告し合うためにつくる別アカウントを指すネットスラング。目標や意気込み共

に整理されたノートや自慢の文房具の画像などがアップされる。韓国発祥とされ日本では2018年頃から流行。

ペンクリニック
【ペンクリニック】

ペンドクター（→p160）が万年筆の不調や使用者の書き癖などを診断し、対面でペン先の調整を行うイベント。主催やペンドクターの所属などにより有償やメーカー限定などさまざまな開催形態があるが、小売店の催事として無料で受けられる場合もある。

ペンケース
【ペンケース】

主に筆記具を収納して携帯するための入れ物の総称。「筆入れ」「筆箱」とも。

ペンシース
【ペンシース】

筆記具を1本、あるいは数本差し入れて収納するペンケース。1本ずつ独立したスペースに分かれているものが多い。

ペンシル
【ペンシル】

英語の「Pencil」は主に鉛筆を指すが、日本語であえて「ペンシル」という場合、インクペンに対し黒鉛芯を持つ筆記具、という意味で、シャープペンシルや芯ホルダーを指すことが多い。黒鉛芯を持つ筆記具の総称。

ペン芯
【ペンしん】

万年筆のペン先の下に密着して配置され、タンクからペン先にインクを連続的に供給する部品。近代的なペン芯は、1883年にルイス・エドソン・ウォーターマン（→p184）が発明。1884年に特許を取得した。毛細管現象と表面張力を利用して、インクをペン先に送りつつ、その妨げとならないように同量の空気を引き込む仕組みにより、インクの漏れを防ぎかつスムーズな吐出を実現する。

ペンスピニング
【ペンスピニング】

筆記具を手の上で操り回転させるなどする手技芸。ペン回し。日本ではKayがプロペンスピナーとして活動している。

ペンチップ
【ペンチップ】

主にボールペンやマーキングペンのペン先。

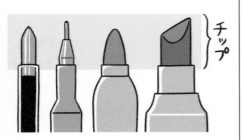

ぺんてる
【ぺんてる】

東京に本社を構える筆記具・画材・文房具メーカー。1946年に堀江幸夫が創業（大日本文具）。クレヨンなどから自社開発商品の幅を広げ、1960年に世界初のポリマー芯「ハイポリマー芯」とノック式のシャープペンシル「ぺんてる鉛筆」を発売。1963年には世界初の水性マーキングペン「サインペン」（→p76）を発売するなど先駆的商品を多く生み出している。

ペンドクター
【ペンドクター】

ペンクリニックなどで万年筆の調整や修理を行う専門技術者。

ペントレー
【ペントレー】

机上や引き出しの中でペンの置き場として使われる浅い器。「ペン皿」とも。

ペントレード
【ペントレード】

筆記具の収集家がコレクションを交換すること、またはコレクションを売買するイベント。

ペンフレンド
【ペンフレンド】

主に文通によって交際する友達。「ペンパル」とも。

ペンポーチ
【ペンポーチ】

容量が大きめのファスナー式ソフトタイプのペンケース。「ペンポ」と略されることもある。

ボール径
【ボールけい】

ボールペンのボールの直径。筆記線幅の目安として表示されるが、ボールが接地する幅はこれよりも小さく、またインクの粘度や浸透

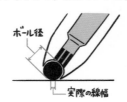

力、ペン先と紙面の接触による干渉などによって紙面上でのインクの拡がりは異なることから、実際の線幅を示す数字ではない。

ボールチャック
【ボールチャック】

シャープペンシルのチャック（芯を掴む機構）に球形の部品を組み込むことで、芯に力が加わった際、芯の移動方向を前進だけに制限するもの。オートマチックシャープペンシルの自動芯出し機構などに採用される。

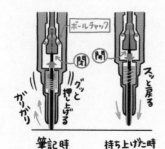

ボールペン
【ボールペン】

先端に小さな球体を有し、内蔵するインクを球の回転によって紙面に転写あるいは滲出させて筆記する筆記具。インクの種類により、大きく油性、水性、ゲルにわかれる。1888年にアメリカのジョン・ロードがマーキング用の筆記具として特許を取得するも、インク漏れを抑えられず実用には至らず。1938年にハンガリーのラズロ・ビロが毛細管現象を利用した改良案の特許をフランスで取得し、1943年にアルゼンチンで「birome」を発売したのが最初。

補強パッチ
【ほきょうパッチ】

ファイルに綴じる書類のパンチ穴周辺が破れるのを防ぐために貼って補強する、中央に穴のあいた円形の粘着シール。パンチ穴補強シール。

BOXY ボールペン
【ボクシーボールペン】

三菱鉛筆が1975年に発売した文房具ブランド「BOXYシリーズ」に含まれるノック式ボールペン。胴軸が四角く、ノックの解除ボタンが同軸の側面に付いているため、机上に寝かせて固定した状態でノックボタンを勢いよく戻すことができる珍しい構造。このペンを使ってスーパーカー消しゴム（→p89）を弾いて走らせるのが流行した。

墨汁
【ぼくじゅう】

①固形墨を磨って液状にしたもの。「墨液」とも。②最初から液体で販売されている墨。墨と膠または合成糊などを混練して水に分散させコロイド状にしたもの。①と区別するために「液体墨」と呼ぶ場合もある。1898年に田口精爾が開発した「開明墨汁」が最初。「墨液」とも。

補助軸
【ほじょじく】

短くなった鉛筆を差し入れて固定し、持ちやすくするために使う筒状の文具。消しゴムやグリップなどを備えるものもある。「ペンシルエクステンダー」とも。

ポスターカラー
【ポスターカラー】

不透明水彩絵の具の一種。隠蔽力が高く、乾燥後に塗り重ねると下の色を隠すことができ、マットな表面は発色が鮮やかでムラになりにくいことから、ポスターなどのくっきりとした表現に向く。しかし耐水性はないので風雨に晒されるような環境への展示には適さない。

ポスト・イット
【ポスト・イット】

1980年にアメリカのスリーエム社が発売した、再剥離可能な粘着剤を塗布した付箋。1969年に同社のスペンサー・シルバーが偶然つくり出したよく着くけれど簡単に剥がれてしまう接着剤をもとに、1974年にアート・フライが本の栞に応用することを考案して製品化した。

ボストンクリップ
【ボストンクリップ】

目玉クリップ（→p174）に似た外観だが、ねじりバネではなくC型に丸められた筒状の板バネにてこを通す構造のクリップ。把持圧力がとても強く、壊れにくい。

ポチ袋
【ポチぶくろ】

お年玉や祝儀、心付けなどの金銭を入れて手渡すための小型の熨斗袋の通称。

ボックスファイル
【ボックスファイル】

ファイルなどを立てて収納するための上端が開口した書類整理箱。「ファイルボックス」とも。

ホッチキス
【ホッチキス】

ステープラー（→p92）のこと。1903年に伊藤喜商店（現在の株式会社イトーキ）が日本に輸入販売した最初のステープラーが、アメリカのE.H.ホッチキスの「Hotchkiss No.1」と「No.2」であったことに由来するが、当初は商標登録をしておらず、その間に伊藤喜商店から製品を仕入れて販売していた東京の梶金物店が商標登録。伊藤喜商店が1917年にその商標権を買い取っている。その後の経緯は不明だが現在文房具類の商標登録はされておらず、普通名称化している。「ホチキス」とも。

ボテ
【ボテ】

ボールペンの筆記時に、引き出されたインクのうち、紙面に転写されなかった余剰のインクが塊となって紙面に落ちたもの（→p127「泣き出し」参照）。

ほぼ日手帳
【ほぼにちてちょう】

糸井重里が代表を務める株式会社ほぼ日が2002年より発行している1日1ページの手帳。各ページにはWEBサイト「ほぼ日刊イトイ新聞」から抜粋された言葉が掲載されている。薄く裏抜けしにくい紙質（トモエリバー、→p122）など、手帳としての評価も高いが方眼罫で自由度が高く、絵日記帳的な使い方のファンが増え、1日1ページタイプ手帳の代名詞的存在となった。

ポメラ
【ポメラ】

キングジムが2008年から販売するポータブル文章入力・編集機。コンパクトに畳めるボディに、標準サイズのキーボードと単色の画面を備え、長時間駆動できるのが特長。文字入力に特化しており、あえてそれ以外の機能をそぎ落としたことで、文章作成に集中できると、プロの作家やライターにも支持され、人気商品に。

ポリカーボネート
【ポリカーボネート】

プラスチックの中でも最高度の耐衝撃性と、ガラスに匹敵する高い透明度を持ち、耐熱性や加工性にも優れた熱可塑性プラスチック。割れにくく透明度が高い材料として、戦闘機の風防や自動車のライトカバーから、携帯電話、日用雑貨など用途は広く、筆記具やルーペをはじめ、文房具にも多用される。アーム筆入（→p28）の材料として有名。

ポリマー芯
【ポリマーしん】

主にシャープペンシルの替芯として使用される、黒鉛と合成樹脂を混合して不完全燃焼させることで得られるほぼ炭素のみを基本構造に持つ筆記用の固形芯。大日本文具（現在のぺんてる株式会社）が開発し、1960年に発売した「ハイポリマー芯」が世界初。粘土芯に比べ、細く精密な成形が可能でかつ筆跡は濃く折れにくい芯をつくることが可能。これによって極細のシャープペンシルが実現可能になった。現在のシャープペンシル用替芯のほとんどに採用されている他、折れにくさを特徴とする一部の鉛筆にも使用されている。「樹脂芯」「高分子焼成芯」とも（→p82「シャープペンシル用芯」参照）。

ホワイト
【ホワイト】

主に漫画やイラスト、グラフィックデザインなどの修正のために使う白色の描画材や修正液を指す。

ホワイトボード
【ホワイトボード】

専用のマーキングペン（ホワイトボードマーカー）を使って文字や図を筆記する白色の表示板。筆記した文字や図は専用のイレイサー

や布などで拭き取ることができ、繰り返し使用できる。講義や告知などに黒板と同様の用途で使われる。黒板に比べ、粉が出ないため清潔に保ちやすい利点がある。紙に書くのと同じく白に黒の筆跡は自然に見える反面、光を反射しやすいという欠点がある。

ホワイトボードマーカー
【ホワイトボードマーカー】

ホワイトボードに筆記するための専用のマーキングペン。揮発性の溶剤と顔料を主とするインクに樹脂と剥離剤が含まれていて、溶剤が揮発する際に顔料が樹脂と結合して被膜状になり剥離剤の上に浮き上がることで、拭き取ると容易に剥がれて消去できる。

ボンド
【ボンド】

英語では接着剤を表す普通名詞だが、日本ではコニシの商標。

ボンナイフ
【ボンナイフ】

1960年頃に発売された、子供用の安価な携帯用小型ナイフ。安全剃刀の刃のような薄い鋼の刃を持つ使い捨てのナイフで、刃の支持部が付け根で回転し、刃が柄の中に収納される。子供たちが鉛筆を削ったり工作などに使う普段使いの道具だった。東日本ではこの「ボンナイフ」が、西日本では、同様の構造を持つ「ミッキーナイフ」が有名だった。ボンナイフはなくなったが、ミッキーナイフは現在も坪米製作所が製造・販売している。

mini column ② ホルダーとフォルダー

　商品名が意味するものがバラバラでややこしいものに、クリアファイル類があります。みなさんは「クリアファイル」と聞いてどんなものを思い浮かべますか？　表紙の中に透明な袋状のページが綴じ込んである冊子でしょうか、それとも樹脂シートを2つ折りにして1辺を溶着した薄い書類入れでしょうか。じつはメーカーや業者によって名称にかなりズレがあります。

　一般的に文具メーカーは、前者の冊子をクリアファイルやクリアブックと呼び、後者の1枚ものをクリアホルダーと呼びますが、その1枚ものに印刷をして販売する業者はなぜかこれをクリアファイルと呼ぶことが多いのです。これに加えてややこしいのが、ホルダーとフォルダーで、これも似て非なるもの。ホルダーは「holder」、入れ物、保持する物、という意味で、フォルダーは「folder」、折るもの。さきほどのホルダーとは別に、キャビネットに立てて書類を整理するための、厚紙を2つ折りにしただけのシンプルなものをフォルダー（または個別フォルダー）と呼びます。パソコンの画面で書類を整理するアイコンでおなじみのあのフォルダーです。さらにいうと、これらは基本的に記入済みの書類を保管するためのものですから大きく分類すればすべてファイルですが、未記入の用紙を綴じてそのまま記入するものはバインダーと呼びますから、もうほんとうにこれはややこしい。

Stationery
column 6

あなたはデジタル派?　アナログ派?

　デジタルVSアナログ、みたいな構図の中でアナログ道具として語られることが多くなってきた文房具ですが、そもそもデジタルやアナログがどういう意味かをご存知ですか? 最近はデジタル文具と呼ばれる、スマホに連動したり、ネットにつながったりするものも増えてきました。デジタルと言えばなんとなく電気を使って記録や表示を行うものをイメージされる方が多いようですが、電気で動作するかどうかとデジタル・アナログはじつは関係がありません。

　「デジタル」は、ラテン語で指を意味する「digitus」に由来していて、あらゆる情報を指折り数えるように数えられる数に置きかえて（離散的に）表現する方法を指し、本当はなめらかに連続している量を段階的に区切って表現します。

　これに対して「アナログ」は、類似や相似を意味する「analogy」に由来し、連続的な量を別の連続的な量で表現する方法です。

　ですから、たとえば算盤は、デジタルな計算器といえますし、連続して流れる時間を区切って数字に置きかえればデジタル時計で、滑らかに回転する針の角度で表せばアナログ時計になります。

　デジタル化された情報は、コンパクトで複製や転送をしても劣化しないので、効率良く便利ですが、これは現実から目的に直接関係している情報のみを取り出して数値に置きかえたもの。ときにデジタル情報に感じる物足りなさは、デジタル化の過程で取り出されなかった部分にあるのかもしれません。

トビラ雑学 **7** ＞ 用紙のサイズ

JIS規格による主な仕上がり寸法

JIS規格による仕上がり寸法にはA列とB列
があります。そしてそれぞれに続く数字が
1つ増すごとにその半分の寸法になります。

[A列]

0	841×1189mm	6	105×148mm
1	594×841mm（A全）	7	74×105mm
2	420×594mm	8	52×74mm
3	297×420mm	9	37×52mm
4	210×297mm	10	26×37mm
5	148×210mm		

[B列]

0	1030×1456mm	6	128×182mm
1	728×1030mm（B全）	7	91×128mm
2	515×728mm	8	64×91mm
3	364×515mm	9	45×64mm
4	257×364mm	10	32×45mm
5	182×257mm		

A(B)3
A(B)2
A(B)5
A(B)4
A(B)7
A(B)6
A(B)1

身近な紙の寸法

リーガル（アメリカ）	8.5"×14"（216×356mm）
レター（アメリカ）	8.5"×11"（216×279mm）
官製はがき	100×148mm
名刺（4号）	55×91mm

Legal (USA)
Letter (USA)
Post card
Business card

マーカー
【マーカー】

「マーキングペン」と同義。「マーカーペン」とも。

マーキングペン
【マーキングペン】

軸内に保持するインクを毛細管現象でペン先に浸潤させて筆記する筆記具の総称。ペン先にはフェルトや合成繊維、多孔質素材、複雑な断面の貫通孔を持つ樹脂成型品などさまざまなものが使用され、用途も方式も多岐にわたる。

マーブリング
【マーブリング】

ゴム樹脂や海藻などを溶いた粘性のある水溶液の水面に、水に反発する牛の胆汁と顔料を混ぜた描画材を落とすことで水面に描かれる複雑な模様や図柄を、紙などに写し取る技法。描かれる模様が大理石（marble）の模様に似ていることからこう呼ばれる。正確な起源は不明だが、中近東で開発され、遅くとも15世紀にはトルコなどで盛んに製造され、カリグラフィー（→p55）や公文書の偽造・改ざん防止用の下地や、書物の装飾などに使われた。

マイネーム
【マイネーム】

サクラクレパスが販売する油性マーキングペ

ン。主に学童の持ち物に名前を書く用途を想定していて、布に書いてもにじみにくく、洗濯をしても落ちにくい。名前書き用のペンとしては圧倒的に知名度が高く、入学のしおりなどにおいて学校から銘柄指定されることも多い。

マグネット
【マグネット】

磁石。または磁石を内蔵して、鉄の壁面（黒板・ホワイトボードをはじめ事務用家具や冷蔵庫の表面など）にメモや掲示物などの紙を留めるのに使うもの。本来の目的を超えて装飾が過多になり、そのものがオブジェとして主張しているものも多い。

眞崎仁六
【まさきにろく】

（1848-1925）三菱鉛筆の創業者。1878年パリ万国博覧会に展示された鉛筆を見て帰国後独力で鉛筆の製造法を開発、

1887年に眞崎鉛筆製造所（現在の三菱鉛筆株式会社）を設立した。

マジックインキ
【マジックインキ】

寺西化学工業が販売する油性マーキングペン。 商標と共に「？」マークのデザインで有名。1951年にアメリカ産業視察団に参加した内田洋行社長の内田憲民が持ち帰ったスピードライ社の油性マーキングペンを参考に寺西化学工業が開発。1953年に発売された。発売当初は内田洋行の商品として発売され、現在も商標は内田洋行が保有している。

マスキングテープ
【マスキングテープ】

塗装の際に、目的の範囲外に塗料が付着することを防ぐために保護する、再剥離が可能な粘着テープ。ユーザーの提案から、2008年にカモ井加工紙が装飾用として多色展開したのをきっかけに、印刷や型抜きなどさまざま

な加工が施されたものへと発展。装飾用のテープとして人気となり、文房具の一ジャンルとして定着した。

マックス
【マックス】

東京に本社（群馬県に工場・開発部門）を構える機械メーカー。ステープラー・釘打ち機の他、オフィス機器・工具・住環境機器などを製造。1942年に山田勝太郎が創業（山田航空工業）し、零戦の尾翼の部品を製造していたが、敗戦に伴い民需品に転換。長年ステープラーの製造に従事していた向野光雄（戦時中山田航空工業のある群馬県に疎開していた）からステープラーの製造設備や金型を継承して1946年より製造を開始。ステープラーの国内トップシェアを誇る。

マップピン
【マップピン】

小さな球形の頭部を持つ細い押しピン。壁に貼った地図上の位置を示すために使う。

169

マニア
【マニア】

特定の分野に熱中する人。関連する物品や情報の収集を伴う者を指す場合が多い。

マニラ封筒
【マニラふうとう】

元来はマニラ麻を原料にした厚手で丈夫な茶褐色の封筒を指したが、現在は化学パルプで代用されている。耐久性が高いのが特長で、回覧や書類の移動など、繰り返し開閉される用途にも多用されるため、玉紐（→p110）や、クラスプ（止め金具）が付けられている場合が多い。

丸善
【まるぜん】

東京に本社をおく書店・出版社・商社。文化施設の設計から図書館業務の代行まで幅広い。1869年に福澤諭吉の門人の早矢仕有的（→p140）が洋書薬品医療機器の輸入販売業として創業（丸屋商社）。登記の際代表者として「丸屋善八」という架空の人物を記載したことから丸善の名が生まれた。文房具の取扱いも多く、輸入万年筆を最初に販売した企業の１つであり、多くの文人に愛された。1912年の『万年筆の印章と図解カタログ』には夏目漱石、北原白秋らが寄稿している。

万年筆
【まんねんひつ】

先の割れた金属製のペン先に軸内の狭い隙間を通して、胴体内に保持したインクを供給し

て筆記する筆記具。紀元前10世紀の古代エジプトからインクを内蔵する筆記具はつくられ、18世紀初頭までには同種のペンが数多く存在したことが複数の文献に残っている。特許としては1809年にイギリスのフレデリック・バーソロミュー・フォルシュが取得した、空気弁を備えたインク室から管を通してインクを供給する筆記具が初。イギリスのジョゼフ・ブラマーも同年、つけペンの軸に指で押圧するインク室を持つ筆記具の特許を取得している。その後多くの発明家がインクを制御する方法を考案するが、決定的な発明は1883年にアメリカのルイス・エドソン・ウォーターマン（→p184）の、毛細管現象を応用してインクを出す細い溝と、空気を入れる太い溝を組み合わせたペン芯を備えた万年筆で、これが現在の万年筆の基本構造をつくった。

ミウラ折り
【ミウラおり】

三浦公亮が考案した紙の折り畳み方。平行四辺形の面を組み合わせた形で、畳んだ状態から対角に当たる点を引き離すと全面が連動して展開し、押し戻すと収納される。人工衛星の太陽電池パネルの展開方法の研究過程で生み出されたが、携帯用の地図などに広く応用されている。

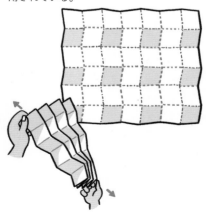

見える・見える
【みえる・みえる】

1967年に放送されたゼブラの透明軸ボールペン「クリスタル」のCMにおいて、特徴的な動く目玉のアニメーションと共に、インク残量が見えるということを強く印象づけたコピー。

ミシン目
【ミシンめ】

特別な器具を使わず紙を任意の線に沿って手でちぎることを可能にするために施された連続した穴または破線状の切れ目。

ミシン目カッター
【ミシンめカッター】

紙にミシン目を施す円盤状の回転刃を持つカッターナイフ。

水糊
【みずのり】

液体糊（→p37）のこと。

水引
【みずひき】

紙縒状にした和紙に糊をひいて着色した細い紐で、祝儀や不祝儀を表す飾りとして、金封や贈答品に巻いたり置物の造形素材として使用される。色や結び方によってさまざまな意味を持つ。

水筆ペン
【みずふでペン】

インクを内蔵せず、水を入れて使う筆ペン（→p150）。内蔵する水で筆先を湿らせて、水溶性の携帯用固形絵の具を溶かして描画したり、水溶性の画材で描画した後、紙面の描画材を溶かして、ぼかしなどの表現を加えるのに使う。

三菱鉛筆
【みつびしえんぴつ】

日本の東京に本社を構える鉛筆・ボールペンなどを中心とする筆記具メーカー。1887年に眞崎仁六（→p168）が鉛筆製造メーカーとして創業（眞崎鉛筆製造所）。水車を利用し日本ではじめて鉛筆を工業的に量産した。鉛筆のuni、シャープペンシルのクルトガ、ボールペンのジェットストリームなどで有名。旧三菱財閥系の三菱グループではない（→p76「財閥三菱と何等関係ありません」参照）。

ミリペン
【ミリペン】

合成樹脂でできた極細の硬いペン先を持つマーキングペン。一定した線幅の細い描線を引くことができ、数字で表した複数の線幅が用意されていて使い分けられるのが普通。簡易な製図ペンとしての他、漫画やイラストレーションなどの描画にも使われる。

虫眼鏡
【むしめがね】

凸レンズに持ち手を付けた簡単な拡大鏡。「ルーペ」とも。

無印良品
【むじるしりょうひん】

良品計画が展開する家具・衣料・生活雑貨などを扱うブランド及び店舗名（海外ではMUJI）。1980年に西友のプライベートブランド（→p150）として「わけあって、安い」をキャッチフレーズに簡素な包装などを特徴としてはじまったが、シンプルなデザインのブランドとして定着している。ラベルを剥がせば、商品本体にロゴマークなどが一切ないことから、写真や映像を撮る際に映り込んでも問題になりにくく、撮影用の小物としてもとても重宝されている。

無線綴じ
【むせんとじ】

積み重ねた紙束の背に接着剤を塗布して表紙を貼り付ける、糸や針金などを使わない製本方式。頁数の多い冊子に対応しやすいが、一般的にページが開きにくく、筆記用のノートや手帳には不向き。「くるみ製本」とも。

名刺
【めいし】

主に初対面の相手に自分の名前や連絡先を保持してもらうために渡す、氏名・所属・連絡先などを記した厚紙製の紙片。電子的な連絡の普及により実質的な意味は薄れつつあるが、初対面の儀礼として交換する習慣が根強く定着している。日本では55×91mmが標準だが欧米では3.5×2inch（89×51mm）が多い。

名刺入れ
【めいしいれ】

名刺を収納、携帯するための入れ物。名刺は直接鞄やポケットなどから出し入れすることが失礼とされるので、名刺交換の際には必須。渡すための自分の名刺と、受け取った相手の名刺を分けて収納できるものが一般的。

メーカー
【メーカー】

原材料を加工して製品を製造・販売する業者。自社の所有する工場で製造を行う業者の他、自社に工場を持たず、企画・開発は自社で行い、製造を外部の工場に委託し、OEM （→p41）供給を受けて自社ブランドとして販売するファブレスメーカーも含まれるが、商社との区別が曖昧な場合もある。

メカニカ
【メカニカ】

ぺんてるが1969年に発売した世界初の0.3mm芯を採用した高級製図用シャープペンシル。グリップを回転させると携帯時に先端を保護するためのガードがせり出す構造や動軸にポリアセタール樹脂を採用するなど特徴的な設計。近年マニアの間で人気となり、数万円の価格で取引される廃番高額シャープペンシルの代名詞的存在に。

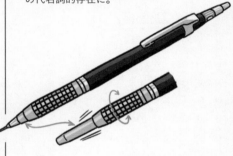

メジャー
【メジャー】

本来は、長さ・体積・重さなどを測定するための尺度を持った測定器具の総称だが、日本では主に長さを測るための帯状の測定器具、即ち帯尺や巻き尺を指す。

目玉クリップ
【めだまクリップ】

横に広い把持部と穴の開いた円形のつまみが特徴のクリップ。金属板をプレス加工した一対のテコとねじりバネからなり、大きく開口でき耐久性が高く、穴に紐を通すなどの使い方もできるため、書類以外のものの固定にも多用される。

メタモインキ
【メタモインキ】

1975年にパイロットインキが開発した示温（サーモクロミック）インク（商標はメタモカラー）。温度変化に反応して無色化したり変色したりする。同社の筆記具フリクション（→p152）シリーズに搭載されていることで有名だが、変色温度や変色する色はさまざまで、筆記用途以外にも飲料の飲み頃サインやマグカップなどの雑貨、玩具などさまざまな用途に利用されている。

メモ帳
【メモちょう】

見聞きした情報や思いついた物事の要点を忘れないように一時的に書き留めておくための雑記帳。小型で携帯しやすいものが一般的。

メルカリ
【メルカリ】

メルカリが2013年から運営するスマートフォンアプリを使ったフリーマーケットサービス。登録が簡単で利用者が急増している。不要品の処分に使われることも多く、オークションとは異なり価格を出品者が決めるため、廃番品やアンティーク文具などが安価に入手できることもある。

メンディングテープ
【メンディングテープ】

1961年にアメリカのスリーエム社が開発した、アセテートフィルムの基材にアクリル系粘着剤を塗布した粘着テープ。セロファンテープに比べ耐候性が高い。透明で艶がなく、紙に貼るとほとんど見えなくなることからアメリカでの商標は「MagicTape」だが、日本ではクラレが面ファスナーの商標として登録していることから、メンディングテープと呼ばれ、同種のテープの一般名称となっている。

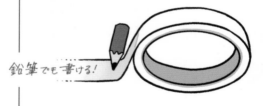

鉛筆でも書ける！

毛細管現象
【もうさいかんげんしょう】

液体の中に細い管を立てると、管内部の液面が外部よりも高く、あるいは低くなる現象。

管内の壁面に対する液体の付着力と表面張力の作用によるもので、液体が壁面を濡らす（接触角が90度より小さい）場合は液面が上昇する。サインペンや万年筆、毛筆などでインクを保持したりペン先にインクを誘導したりするのに利用されている基本的な原理の1つ。

模造紙
【もぞうし】

化学パルプのみで抄造した洋紙の一種。大蔵省印刷局がつくった局紙（紙幣などに使う高級な和紙）「ジャパニーズ・ベラム」を模して、オーストリアの製紙会社がつくった洋紙「シミリー・ジャパニーズ・ベラム」（ジャパニーズ・ベラムの模造紙）に由来するが、現在は掲示物や製図などに使われる大判の紙の呼称として定着している。「鳥の子洋紙」「B紙」「大洋紙」など、地域によって別の呼称がある。

木工用ボンド
【もっこうようボンド】

酢酸ビニルと水を主成分とする接着剤。主に木・紙・布など吸収面どうしの接着用で、白色の液状で、接着する片面に塗布して圧着。水分が抜けることで硬化し透明化する。カンペンケースの表面などの非吸収面に塗布したものは剥離できるため、水性マーキングペンで描いた上に塗布して、透明シート状に乾燥

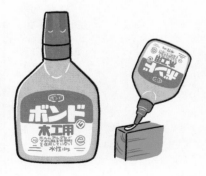

硬化したボンドを剥がしてマスコットなどをつくる遊びがある。

没食子
【もっしょくし】

ブナ科植物の若芽や葉、枝などにタマバチ類が産卵した刺激により防御反応として組織が肥大化して生じた虫癭（虫こぶ）。その主成分はタンニンで、古典インク（→p71）の原料として古くから利用された他、布の染料、革をなめす際タンパク質を除去する薬品などに使われる。「ぼっしょくし」とも読む。

モルトケース
【モルトケース】

水に浸したスポンジ状のものを入れて指や切手を押し当てて濡らすための容器。「モルト」は、海綿の代用として使われたスポンジ状のポリウレタン「モルトプレン」のこと。「指ぬらし」、「海綿ケース」とも。

ジュワ

モレスキン
【モレスキン】

イタリアに本社を構えるノート・文具・雑貨メーカー。1997年にマリア・セブレゴンディがミラノの文具メーカーと創業（Mode&Mode）。19世紀後半にフランスでつくられ、ゴッホやピカソ、ブルース・チャトウィンらが愛用したが、製造業者の廃業により失われたとされる伝説のノート（チャトウィンの著書『ソングライン』によると本文より少し大きい黒のオイルクロス張りの表紙を持つゴムバンドを備えている）を再現し「MOLESKINE」として1998年に発売。かつては「モールスキン」と呼ばれていた。

モンブラン
【モンブラン】

スイスに本社を置く装飾品コングロマリット、リシュモングループの筆記具ブランド。1906年にドイツのアルフレッド・ネヘミアスとアウグスト・エーベルシュタインが万年筆を製造、1908年にクラウス・ヨハネス・フォスが設立（シンプロ フィラーペン カンパニー）。翌年加わったクリスティアン・ラウゼン、ヴィルヘルム・ジャンボアと共に引き継いだ。誰もがイメージする万年筆の原形ともいうべき黒い丸みを帯びたボディ、キャップにホワイトスターを冠し、ペン先にはモンブランの標高を示す4810を刻む「マイスターシュテュック」などで有名。

mini column ③　シヤチハタの「ヤ」はなぜ大きいのか

　社名の表記で、ときどき目にするのが、「シヤチハタ」のように拗音を並字（小文字ではない普通の大きさの文字）で書いたもの。デザイン的なバランスをとるため、とか、大きな文字の方が縁起がよいなどという説もありますが、多くの場合旧仮名遣い（歴史的仮名遣い）が主な原因だと思われます。戦前の日本では公には促音や拗音を小さく書かないのが一般的で、拗音や促音の小文字表記は、第二次世界大戦後、1946年に内閣告示第33号として公布された「現代かなづかい」で正式に採用されました。法令、公文書では、1988年に内閣法制局総発第125号「法令における拗音及び促音に用いる『や、ゆ、よ、つ』の表記について」以降用いられるようになったようです。ですから、1941年に社名を船橋商会からシヤチハタ工業株式会社に変更したシヤチハタのヤが並字で登記されているのは、当時の規則に則っています。ただし、登記上の文字と対外的な表現が異なることは問題なかったようで「パイロット萬年筆」のように、古くから拗音を小文字で表記した表現を使用している会社もあります。

　ちなみに、アルファベットやアラビア数字の使用が商業登記で認められるのは2002年の商業登記規則改正以降なので、1949年創業の「エヌビー社」などは、アルファベットをカタカナ書きした社名となっています。

やらわ. 行

トビラ雑学 **8** > 輪ゴムのサイズ

ゴムバンドの規格

番手	サイズの呼び方（#16など）
内径（mm）	ゴムバンドの円の内側の直径
折径（mm）	ゴムバンドを折り畳んだときの厚みを除いた長さ
切幅（mm）	ゴムバンドの幅
厚み（mm）	ゴムバンドの厚さ

輪ゴムのサイズ

番手（呼称）	内径（mm）	折経（mm）	切幅（mm）	厚さ（mm）
#7	16	17.5	1.1	1.05
#8	22.2	25	1.1	1.05
#10	25.4	35	1.1	1.1
#12	38	40	1.1	1.1
#16	44.5	60	1.1	1.1
#18	51	70	1.1	1.1
#20		80	12	1.1

矢立
【やたて】

筆を収納する筆管と、墨壺を組み合わせた携帯筆記具セット。筆記具を袋に入れて携行することは5世紀頃から行われていたが、それが硯箱になり、平安時代に矢を立て入れる装備（矢立）に納められた硯箱「矢立の硯」が考案された。これがさらに鎌倉時代以降、小型化し、筆管と墨壺を直接組み合わせた道具に発展したもの。

墨液のしみ込んだ綿

山田五郎
【やまだごろう】

編集者・評論家。講談社在籍時、「Hot-Dog PRESS」の編集部にあった持ち主が現れない忘れ物のシャープペンシル（モンブランPix75）を自分のものとして使おうとしたところ、「M. Yamada」と刻印されていたため、自身のペンネームを「山田」にしたという。シャープペンシルや万年筆への拘りは強く造詣が深い。

ヤマト
【ヤマト】

東京に本社を構える糊・接着剤・文具メーカー。1899年に木内弥吉が薪墨商で創業。商品を入れる袋をつくるための糊がすぐに腐ることから、防腐剤を加え、その刺激臭を消すために香料を添加し、腐らない糊を瓶に詰めて販売した。商売が当たるようにと、丸的に当たり矢のマークをつけ、「ヤマト」とした。1975年発売の液状糊「アラビックヤマト」などで有名。

ヤマト株式会社

山根式袋ファイリング
【やまねしきふくろファイリング】

山根一眞が1986年に著書『スーパー書斎の仕事術』（ビジネス・アスキー）で提唱した安価で実践的な個人向け書類整理法。上端を切り落とした角形2号封筒にあらゆる書類を投げ込み、側辺にタイトルを書いて、内容にかかわらず五十音順に並べて整理するのを特徴とする（→p112『『超』整理法』』参照）。

YouTuber
【ユーチューバー】

動画配信サービスYouTube上に制作した動画を公開する人、狭義にはその動画再生による広告収入を得ることを生業とする人。若年層にとってはテレビ以上に普段目にする身近な発信者として人気で、職業として認知されつつあり、所持する文房具についての動画を発信する中高生YouTuberなども現れている。

油性
【ゆせい】

物質の溶媒の主成分が有機化合物であること。インク・塗料では、水には溶解しない着色剤

や固着剤を含み、筆記した描線に耐水性がある場合が多い。

ユニ
【ユニ】

①三菱鉛筆が1958年に発売した高級鉛筆。「unique（唯一の）」にちなんで名付けられた。1966年には、さらに上位の「ハイユニ」が登場。HB、Fを含む10B〜10Hの計22硬度を揃える。②三菱鉛筆が販売する商品全体のブランド名。特に海外では本来の社名以上にこのブランド名が企業名として広く認知されている。

ユニバーサルデザイン
【ユニバーサルデザイン】

年齢、体格、能力、障害の有無などにかかわらず、すべての人が最大限に使用できるようにするためのデザイン。アメリカのロナルド・メイスが1985年に提唱した概念。「UD」と略される。

めくりやすい斜めカット

にぎらず切れる

指サック
【ゆびサック】

紙をめくる際指が滑るのを防ぐために、手の指にかぶせるゴム製品。キャップ状のものが一般的だったが、近年は通気性や見た目への配慮から、リング状のものが増えた。キャップ状のものは指先の保護用としても使われる。

ユポ
【ユポ】

ユポ・コーポレーションが製造するポリプロピレンを主原料とした合成紙（紙のような特性を持つフィルム）。中心の丈夫な基層と、その両面に延伸加工によって表面にミクロボイド（微小な亀裂）を持つ紙状層からなる。表層のミクロボイドによって紙に似た印刷・筆記特性（鉛筆や油性筆記具との相性がよい）や高い白色度を持つ。水に強く耐水ノートやメモに利用される他、破れにくく折り畳んでも復元しやすいので、選挙の投票用紙に使われることで有名。

容器包装リサイクル法
【ようきほうそうリサイクルほう】

1995年に制定され1997年から施行された法律。容器や包装を利用して中身を販売したり、容器そのものを製造する特定事業者は、容器包装をリサイクルする義務を負うと共に、消費者の分別を容易にするため、販売する商品の容器には日本容器包装リサイクル協会が定めた識別マークをつける義務がある。パッケージ類はもちろん、糊やインクのボトルなどは容器・包装にあたるが、ラベルシールやタグは容器でも包装でもないので対象外。はさみのキャップやケース類は、分類しても不要とならないので容器にはあたらず、これも対象外で表示義務はない。

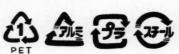

溶剤
【ようざい】

目的とする物質を溶かすための液体。「溶媒」とも。各種の筆記具のインクや接着剤など、またシールはがしや各種クリーナー液などに含まれ、溶質（溶かされる物質）をよく溶かすがその物質とは化学反応せず、濃度を調整したり取り除いたりすることが容易であることを特徴とする。揮発性や可燃性、有毒性が高いものも多い。

洋紙
【ようし】

「和紙」（→p189）に対し、明治時代以降に欧米から日本に輸入された紙及びその製法でつくられた紙の総称。木材パルプや木綿などを原料として、機械抄造された紙を指し、今日利用されるほとんどの紙を含む。

養生テープ
【ようじょうテープ】

建築や塗装、輸送などの作業で、作業対象の周辺を破損や汚損から守るためにシートなどで覆って保護することを養生といい、主にそのシートなどを固定するために使われる、再剥離可能な樹脂フィルム製のテープ。

羊皮紙
【ようひし】

羊の皮でつくった書写材料の意だが、山羊、牛などを含む獣皮をなめしてつくった獣皮紙全体を指す場合が多い。

ヨーク
【ヨーク】

磁石が持つ吸着力を増幅するために磁石に付けて磁力線の流れを変えるための軟鉄板の総称。掲示用のフェライト磁石やペンケースの扉を固定するマグネットなどに付けられる。

ラーフル
【ラーフル】

黒板消しを指す一般名称。鹿児島、宮崎、愛媛などの地域では方言として使われる。オランダ語でこすることなどを意味する「rafel」が語源と考えられる。

ライフ
【ライフ】

東京に本社を構える紙製品メーカー。1946年に齋藤晏弘が紙製品卸商として創業。ノーブルノートなどで有名。

ライフハック
【ライフハック】

主に知的生産における作業の効率化や生産性の向上のための具体的な手順やテクニックなどを含む仕事術の総称。アメリカのテクニカルライターのダニー・オブライエンが2004年に行った講演のタイトルが最初と言われているが、その後流行語となり生活全般のさまざまな領域でも使われるようになった。文房具を含む道具やPC、デジタルガジェット、ソフトウェア、ネットサービスなどを積極的に使いこなす工夫も多く含まれる。

落款
【らっかん】
らくせいかんし
落成款識の意で、書画などの作品が完成したときにその作品の画面内に、署名や捺印の他、その作品にまつわる情報を記すこと。またその際に使用する印章や、その印章で捺した印影（→p33）を指すことも多い（他の工芸品などでは銘）。

ラベルライター
【ラベルライター】

入力した文字を帯状の粘着テープに印字することができる事務機械。「テープワープロ」とも。キングジムのテプラが世界初。ファイルの見出しやラベルの作成に限らず家庭から公共の空間まであらゆる現場で表示や説明不足を補う道具として使われている。

ラミー
【ラミー】

ドイツのハイデルベルクに本社を構える筆記具メーカー。1930年にカール・ヨーゼフ・ラミーが設立。1962年に社長に就任したマンフレート・ラミーが、外部デザイナーを起用し、モダンデザインによって差別化を図った。「LAMY2000」シリーズや、「サファリ」シリーズなどで有名。

ラミネート
【ラミネート】

①複数の素材を貼り合わせて積層する加工。②紙を保護・補強し、防汚性や耐水性を持たせるためにプラスチック製のフィルムの間に挟み込んで積層する加工。専用のラミネートフィルムをラミネーターで加熱圧着するのが一般的。「パウチ」とも。

あ
ア
か
カ
さ
サ
た
タ
な
ナ
は
ハ
ま
マ
や
ヤ
ら
ラ
わ
ワ

ラメ
【ラメ】

金属箔の微細な小片。マーカーペンや筆ペン、ボールペンなどのインクや塗料に混ぜることで描線が光を反射してキラキラと輝く。一般的な顔料に比べて粒子が大きいので沈殿しやすく、筆記具を水平に保管するなど指定がある場合がある。万年筆やつけペン用のインクにも希にラメ入りがあるが、万年筆を詰まらせる恐れもあるので注意が必要。

ランドセル
【ランドセル】

小学生が通学時に教科書や学用品を入れる、革または合成皮革製の箱状の背負い鞄。幕末に洋式軍隊の装備として導入された背嚢「ransel（オランダ語）」が訛ったとされ、現在のような形になったのは1887年に伊藤博文（総理大臣）が嘉仁親王（後の大正天皇）に入学祝として献上したものがはじまりとされる。黒や赤が長く一般的だったが現在は多様化・高級化と共に、教科書のA4サイズ化の影響で大型化している。

リーガル
【リーガル】

アメリカで一般的に使われている紙の寸法。8.5×14インチ＝215.9×355.6mmで、レターサイズよりも3インチ長い。1884年にアメリカのマサチューセッツの製紙業者トマス・ホーリーがつくった紙の寸法。リーガルの名は判事からの注文でリーガルパッドをつくったことに由来し、現在もアメリカで契約文書や法的文書に使われている。

リーガルパッド
【リーガルパッド】

黄色い紙を綴じたリーガルサイズのノートパッド。間隔の広い横罫と、左端からすこしあけたところに赤い縦罫があり、短辺を金属の針で綴じてミシン目で切り取れるものが多い。アメリカのトマス・ホーリーが判事の注文でつくった罫線入りのノートが起源。黄色い色については、「紙色のバラツキをごまかすため」や「他の紙に紛れても目立つ」など複数の説がある。

リーディンググラス
【リーディンググラス】

老眼鏡。主に老化により、近距離にピントを合わせられなくなる老視を矯正するための眼鏡。「シニアグラス」とも。読書など近距離を見る作業のときに一時的に使うため、携帯性を重視したデザインのものも多い。リーディンググラスはあくまで焦点距離を短縮する

のが目的であって、拡大を目的とする「ルーペ」（→p184）とは本質的に考え方が異なる。

リサイクル
【リサイクル】

廃棄物を原料として別の製品につくり替えること。「再資源化」「再生利用」（→p76「再生材料」参照）。これとは別に、同じ製品あるいはその部品をそのまま再利用することを「リユース」（再使用）と呼ぶ。製品寿命を延ばしたり無駄な資源の使用を減らすことで資源の使用量を減らすことを指す「リデュース」と共に、３Ｒと呼ばれる。

リビガク
【リビガク】

「リビング学習」の略。子供が自室ではなくリビングなど、家族のいる空間で学習することを指す。自室よりも学習効果が高いとして2010年頃からWEBをはじめ雑誌などでも取り上げられるようになり実践する家庭も増えている。2015年頃からは専用の学童文具や収納用品などが各メーカーから多数発売されている。

リフィル
【リフィル】

詰め替え用の消耗部品の総称。筆記具なら替芯など、バインダー式の手帳やノートなら替

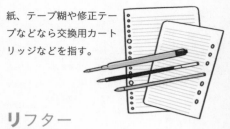

紙、テープ糊や修正テープなどなら交換用カートリッジなどを指す。

リフター
【リフター】

リングバインダーやシステム手帳などのページめくりをスムーズにし、リフィルの傷みを軽減するため、最初のページの前と、最後のページの後に綴じ込む丈夫なプラスチック製の板。

リムーバー
【リムーバー】

文房具においてはステープラーの針を取り除く道具を指すことが多いが、何かを取り除く道具や薬剤全般に使われる範囲の広い語なので、シール剥がし液や汚れ落とし、また特定の筆記具のペン先を交換するために取り外す専用工具といったものを指すこともある。

流通在庫
【りゅうつうざいこ】

卸売業者・小売業者など、流通業者に保有されている在庫のこと。メーカーが保有している在庫とは異なり、保有者が散在するため把握が難しい。発売後人気で売り切れてしまった商品やメーカーでは販売終了し在庫がない商品が、ある店ではまだ販売されているという状況が起こる。

領収書
【りょうしゅうしょ】

金銭を受領したことを証明する書類。受領証書の通称。類似した表記に「領収証」があるが、意味の違いはない。「レシート」も同義。

両面テープ
【りょうめんテープ】

ものを貼り合わせるのに使う、基材の両面に粘着材の層をもつ粘着テープ。通常片面には剥離紙がついていて、片面を貼った後剥離紙を剥がしてもう一面を貼り合わせる。用途に応じて粘着の強度も基材もさまざまな種類がある。

ルイス・エドソン・ウォーターマン
【ルイス・エドソン・ウォーターマン】

（1837-1901）ウォーターマン創業者。1883年に、毛細管現象を応用してインクをペン先に送る細い溝と、インクと等量の空気を取り入れる太い溝を組み合わせた形状の溝を持つ

ペン芯を備えた万年筆「ザ・レギュラー」を発明。現在の万年筆の基本構造をつくった。

ルーズリーフ
【ルーズリーフ】

自在に差し替えのできる多穴リングバインダー専用の、穴の開いた帳票・ノート専用紙。B5サイズが主流だが、A4やA5も多い。明治時代にはすでに「ルーズリーフ」という名前で複数の規格が輸入されているが、現在はJIS Z 8303（帳票の設計基準）で多穴ファイルの穴寸法や間隔が規定されている（B5なら26穴、A4なら30穴）。他の用紙サイズでもこの基準を満たしているものは概ねルーズリーフと呼ばれている。

ルーズリーフの袋
【ルーズリーフのふくろ】

販売時にルーズリーフを包装している袋。多くはOPPフィルムでつくられた胴糊仕様の袋で、購入者の多くがそのまま未使用紙を携帯するのに使用するが「裂けやすい」「取り出したリーフが封かん用の粘着剤に貼り付いてダメになる」など、問題も多い。

ルーペ
【ルーペ】

凸レンズを使った拡大鏡。手持ちのものの他、机上で使うスタンド付きのものや、頭に装着するものなどさまざま。複数枚のレンズを組み合わせて倍率を変えられるものもある。

レイド
【レイド】

洋紙における簧の目（→p93）のこと。漉き
網が使われる以前の漉き枠に使われた金属製
の簧の模様だが、アンティークな雰囲気や表
面の畝が生み出す書き心地を好む人もいるた
め、高級筆記用紙やクロッキー用紙などにあ
えて再現される場合もある。

レジ
【レジ】

キャッシュレジスターの略称。金銭登録機。
店舗で商品を販売する際に、金額を計算、記
録し、レシート（売上明細書）を発行する。
多くは簡易金庫を備えていて、受け取った金
銭などの保管や釣り銭の取り出しなどを行う
機能を持つ。

レターケース
【レターケース】

書類などを入れておくための平らな引き出し
を持つ多段式収納ケース。引き出しの数は、
3段程度から、10段を超えるものまであり、

書類の仕分けや定型用紙のストックなどにも
便利。小物を入れる深く細長い引き出しのも
のは「カセッター」と呼ばれる。

レターサイズ
【レターサイズ】

アメリカで一般的に使われ、規格化されてい
る紙の寸法。8.5×11インチ（215.9×279.4mm）。
国際規格であるA4よりも縦が短く横が長い
アメリカのローカル規格。バインダーに綴じ
る際には3穴のバインダーが使われることが
多い。1600年代にオランダの製紙業者が導
入した製紙用のフレームサイズ（17×44イ
ンチ）の1/8が元になっている。

レターセット
【レターセット】

便箋と封筒を組み合わせて販売する商品形態。
組み合わせを考慮した統一感のある紙質や意
匠で構成されている。手紙を1枚だけで送る
のは失礼とされるので、封筒に対して便箋の
枚数が2倍かそれ以上セットされていること
が多い。

レタリング
【レタリング】

書体をデザインすること、また、その文字。

レバーファイル
【レバーファイル】

書類に穴をあけることなく、金具で書類の端を押さえつけて綴じるファイル。開閉操作用のレバーとバネを介して連動する平行リンク機構(横から見るとZZ型に見える)によって紙を押さえて固定する。書類の閲覧のしやすさではリングファイルなどに劣るが、パンチなどの加工が不要で綴じ外しが容易なので、一時的な書類の保管や持ち運びに便利。「Z式ファイル」「パンチレスファイル」とも。

レポート用紙
【レポートようし】

報告書など、提出する書類の作成を前提とした片面の罫紙。厚紙の台紙に天糊製本されていて、記入後に1枚ずつ剥がし取ることができる。

連射式クリップ
【れんしゃしきクリップ】

本体に多数装填された金属製の強力なクリップをスライダで押し出して紙を綴じる道具。クリップは取り外して繰り返し使用することができる。1979年に佐藤久夫が発明し、

1980年にオートが「ガチャック」として商品化した。

連絡帳
【れんらくちょう】

①初等教育の過程で、教員と保護者が互いに連絡事項を書き、通学する生徒に持たせて往・返信するノート。②業務の交代時に、前任者から後任者へ状況や情報を引き継ぐための連絡ノート。

連量
【れんりょう】

規定の寸法の紙1000枚(1連)の重量。紙の厚みの目安として使われる。単位はkg。同じ紙でも規定寸法によって数値が異なるが、比較のため、紙の品種の多い四六判ベースに換算した値を使うことが多い。「キロ連量」とも。

ロイヒトトゥルム
【ロイヒトトゥルム】

ドイツハンブルグに本社を構える切手・コイン収集用バインダーおよびノートメーカー。1917年にポール・コーチが、切手ストック

ブックメーカーとして創業。2005年から販売している「ロイヒトトゥルム1917ノートブック」が日本では有名。モレスキン（→p176）に似た形状のハードカバーノートだが、裏抜けしにくい本文は目次とページ番号を備えていて、バレットジャーナル（→p141）用としても人気。

蝋板
【ろうばん】

枠のついた木の板に蝋を流し込んだもの。スタイラス（→p92）で筆記し、蝋を溶かして引き直したりなでつけて平らにすることで、繰り返し使用できる。古代ローマで発明され中世まで使われた。

ロータリーカッター
【ロータリーカッター】

シート状のやわらかい素材や薄紙などの材料を、回転する円盤状の刃を押し当てながら進むことで裁断する裁断具。1979年に世界ではじめてオルファが発売した。真上から押し切るので、素材を引っ張らず、通常のカッターナイフでは難しいやわらかい素材をきれいに切ることができる。

ローラーボール
【ローラーボール】

水性ボールペンのこと。

ローレット加工
【ローレットかこう】

加工したい金属軸を回転させながら、「ローレット」と呼ばれる、凹凸を持つローラーを押し当てて軸表面に凹凸を転写する加工方法。筆記具のグリップや製図用コンパスのツマミなどに使われる。加工することにより、指が滑りにくくなるので扱いやすくなる他、金属そのものが加工硬化によって強くなるというメリットもある。

ローロデックス
【ローロデックス】

アメリカのニューウェル・ラバーメイドが販売する回転式名刺ホルダー。自由に抜き差しできるカードホルダーを回転軸の周りにABC順やあいうえお順にはめ込んでおき、ハンドルを回して目当ての名刺を検索する。1956年にH. L. ニールセンが発明（1930年代から類似の発明は存在する）。くるくると回して名刺を検索する所作が印象的で、人脈の象徴として多くの映像作品にも登場する。

ロケット鉛筆
【ロケットえんぴつ】

先端を尖らせた短い鉛筆芯をはめたプラスチック製のユニットを縦に連結したものを内蔵する使い切りタイプの多段式筆記具。芯の先端が摩耗したらユニットごと抜き出して最後尾に押し込むと、内蔵ユニット全体が1個分前進して次のユニットが先端に出て筆記を継続できる。1966年に台湾の洪蠣（Hong Li）が開発、Bensia社が特許を取得。直後から日本でもブームとなった。現在でも製造販売されている。

ニョキ！／／
使い終わった芯を　　最後尾に押し込む

ロットリング
【ロットリング】

ドイツに本社を構える筆記具メーカー。1928年にアメリカで中空パイプ式万年筆（スタイログラフ）に感銘を受けたウィルヘルム・リープが帰国後すぐに改良して特許を取得し、同年に設立（ティンティンクリ ハンドルズ）。1953年に発売したラピッドグラフは、製図ペンの代名詞的製品となり、CADが普及するまでは「ロットリング」が製図ペンを指す程であった。ペン軸に施された赤いリングで有名。

ロディア
【ロディア】

フランスに本拠を構えるメモ・ノートブランド。1934年にアンリ・ヴェリヤックが紙製品メーカーとして創立。翌年アンリの弟、ロベールが加わる（ヴェリヤック兄弟社）。並んで立つ2本の木は兄弟を表している。オレンジ色の表紙に紫の方眼罫の切り取りメモ「ブロックロディア」で有名。

ロフト
【ロフト】

全国展開する都市型ライフスタイル雑貨ショップ。1987年に西武百貨店が別館として開業。店舗数を増やし、1996年に独立した。ファッション要素の強い商品の品揃えに強い。「ほぼ日手帳」を独占販売する他、手帳の品揃えでは日本最大を誇る。

ワードプロセッサー
【ワードプロセッサー】

キーボード、画面、記憶媒体、プリンターを備え、内蔵のコンピューターを使って文書の作成・編集を行う専用の機器。略して「ワープロ」。英文用はアメリカのIBM社が1964年につくったが、日本語は文字数が多く形状も複雑なため入力、出力共に開発は困難で、1978年の東芝JW-10が最初。かな漢字変換の発明により実現した。1980年代には多くの事務所から家庭にまで普及したが1990年代

に入ると汎用のPCとワープロソフト、プリンターが低価格、高性能化し、置き換えられていった。

輪ゴム
【わゴム】

ものを束ねるのに使う輪状のゴム。安価で扱いが簡単なのでさまざまな用途に使われるが、多くは天然ゴム製で、環境の影響を受けて劣化するので長期保存するものを束ねるのには向かない。

和紙
【わし】

本来は原料として楮、三椏、雁皮の繊維を使い、トロロアオイの根などから抽出したネリと呼ばれる粘結剤を加えて手漉きした紙を指すが、現在では、パルプなどを原料とした機械抄きのものでも、高温の鏡面円筒ドラムに片面を押し当てて強制乾燥させる手法でつくった、片面にツヤがあり、片面にざらつきのある紙も和紙と呼ぶ。

和田哲哉
【わだてつや】

信頼文具舗代表・文房具ジャーナリスト。1999年に輸入文房具を中心とした販売サイト「信頼文具舗」を開設、海外デザイン文房具の輸入販売サイトの先駆的存在。ブログやトークイベントなど文房具の使い方や嗜み方を広く啓蒙する活動を続けている。著書に『文房具を楽しく使う』シリーズ（早川書房）などがある。

和文タイプライター
【わぶんタイプライター】

日本語を印字するためのタイプライター。1915年に杉本京太が発明したのが最初。欧文タイプライターがアルファベット26文字と数字や記号を含めても50に満たないキーで文字を網羅できるのに対し、日本語はひらがなカタカナに加え、膨大な漢字があるため、欧文タイプライターとは全く異なる構造で、1000〜4000程度の活字を備え、必要な文字を選び出して打つ仕組みになっている。1980年代から急激に普及したワードプロセッサーに取って代わられた。

ここに文字が打ちこまれる

文字盤

膨大な数の活字

ここで文字を選ぶ

連動

おわりに

　文具王になって20年、文房具メーカーで開発や販売にも関わりつつ、様々な場で語ってきました。文房具に関する知識にも多少の自信はありました。しかし、いざ辞典を執筆するとなると、その知識の曖昧さや根拠の不確かさに、ほとんど全ての項目を調べ直すことになり、気がつけば執筆に2年半もの時間を要してしまいました。

　ネットの情報も参考にはしましたが、なるべく書籍を中心に古書や現物などを入手したり、各国の特許データベースを検索したり、翻訳も含む海外の書籍やWEBサイトなども参照しながら、裏付けをとりました。また、科学や工学に関わる言葉の説明においては、もう一度高校や大学で学んだ化学や物理の教科書を読み直したり、歴史や地理の参考書を何度も開きました。

　本書の執筆は、文房具というテーマを軸に、自分がこれまで学校で学んだことや仕事で経験したこと、マニアとして蒐集してきた多くの史料などから、自分の知識を再確認し、整理整頓する作業であり、少々大袈裟かも知れませんが、ある意味私の半生をまとめ直す機会となりました。

　文具王20周年という節目に、このような機会を与えてくれた誠文堂新光社の皆様と、私のやたら細かい指示の意図を汲んで最高にわかりやすい素敵なイラストを描いて頂いた小林さん、そしてこの本を読んで頂いたあなたに、心から感謝いたします。

　この本を通して文房具のことを少しでも楽しく感じてくれたなら幸いです。

<div align="right">文具王　高畑正幸</div>

参考文献　※「書籍・雑誌・ムック・論文」は発行（発表）年の順に掲載

【書籍・雑誌・ムック・論文】
●通俗文具發達史（野口茂樹／著　紙工界社　1934年）●明治大正大阪市史　第2巻　経済篇 上（本庄栄治郎／編　大阪市　1935年）●日本紙業發達史（西嶋東�લ／編　弘文社創立事務所　1942年）●あゝ風雪五十年　文化の先端を行く（中田俊一／著　日本工業新聞社　1966年）●知的生産の技術（梅棹忠夫／著　岩波新書　1969年）●私と事業 改訂5版（早川徳次／著　実業乃日本社　1970年）●消しゴムをテストする（※収録：『暮しの手帖 第2世紀6号』暮しの手帖社　1970年）●文具と事務機の事典　1971年度版（福地誠／編　ニチマ　1971年）●文具の歴史（田中経人／著　リヒト産業　1972年）●セメダイン50年史（セメダイン株式会社／編　セメダイン　1973年）●コクヨ・70年のあゆみ（コクヨ株式会社70年史編集委員会／編　コクヨ　1975年）●筆（田淵実夫／著　法政大学出版局　1978年）●パイロットの航跡　文化を担って60年（パイロット万年筆株式会社／著　パイロット鉛筆　1979年）●内田洋行70年史（内田洋行70年史編集委員会／編　内田洋行　1980年）●知的生産者たちの現場（藤本ますみ／著　講談社　1984年）●紙の寸法規格とその制定の経緯について（小林清臣／著　※収録：『百万塔　第61号』紙の博物館　1985年）●時代を書きすすむ三菱鉛筆100年（社史編纂室／編　三菱鉛筆1986年）●文房具 知識と使いこなし（市浦潤／著　新潮社　1986年）●スーパー書斎の仕事術（山根一眞／著　ビジネス・アスキー　1986年）●ノートや学校を変えた哲学（久米康生／著　平凡社　1988年）●万年筆の印象と図解カタログ 復刻版（丸善　1989年　※オリジナルは1912年に発行）●ぺんてる社史 円かなる英魂（佐藤清／著　ぺんてる　1990年）●サクラクレパスの七十年　ありがとうを色に、感動を未来に（社史編集会議／編　サクラクレパス　1991年）●イトーキ100年史（株式会社イトーキ100年史編集委員会／編　イトーキ　1991年）●Fountain Pens 万年筆　Vintage and Modern（アンドレアス・ランブロー／著　すみれまさみ／訳　同朋舎出版 1991年）●日本鉛筆史（東京鉛筆加工業協同組合／編纂　東京鉛筆加工協同組合　1992年）●「超」整理法　情報検索と発想の新システム（野口悠紀雄／著　中公新書　1993年）●インダストリアル・デザイン　デザイン・ミュージアムへの50（斎藤忠雄、長島純之、野中寿晴、松丸武、佐野邦雄、永田喬、羽原粛郎／著　住まいの図書館出版局　1993年）●鉛筆と人間（ヘンリー・ペトロスキー／著　渡辺潤、岡田朋之／訳　晶文社1993年）●文房具の歴史 文房具発展概史（野沢松男／著 文研社　1994年）●生分解性プラスチック（土肥義治／著 ※収録：『日本農薬学会誌　19巻1号』日本農薬学会　1994年）●ソングライン（ブルース・チャトウィン／著　芹沢真理子／訳めるくまーる　1994年）●フォークの歯はなぜ四本になったか 実用品の進化論（ヘンリー・ペトロスキー／著　忠平美幸／訳　平凡社　1995年）●矢立史考（新谷与己己／著　光陽出版社1996年）●文具・事務機でみる戦後50年（ニチマ／編　文研社　1996年）●子供の大科学　「あの頃」遊んだふしぎ玩具、教材（串間努／著　光文社文庫　1997年）●スリーエム物語 3Mその礎を築いた人々（バージニア・ハック／著　加藤文夫／訳　東京スリーエム　1997年）●ニチバン80年史（ニチバン社史編纂委員会／編　ニチバン　1999年）●黒板のお話し（全国黒板工業連盟／監修　関東黒板工業会　1999年）●「心を込めて設計します」ショットアロー100　ヤマト糊100年のエピソード集（ヤマト100周年記念誌編集委員会／編　ヤマト　2000年）●「ラーフル」考（上村忠昌／著　※収録：『鹿児島工業高等専門学校研究報告　第35号』鹿児島工業高等専門学校　2000年）●文房具56話（串田孫一／著　ちくま文庫2001年）●ゼムクリップから技術の世界が見える アイデアが形になるまで（ヘンリー・ペトロスキー／著　忠平美幸／訳朝日新聞社　2003年）●ラミーのすべて　デザインプロダクトとしての筆記具（「ラミーのすべて」制作プロジェクト／編ロコモーションパブリッシング　2005年）●図解 アメリカ発

明史　ふしぎで楽しい特許の歴史（スティーヴン・ヴァン・ダルケン／著　松浦俊輔／訳　青土社　2006年）●目で見る駄菓子屋グッズ大図鑑DX　パチ怪獣ブロマイドからガチャガチャまで（堤哲哉／著　扶桑社　2006年）●まだある。今でも買える"懐かしの昭和"カタログ　文具・学校編（初見健一／著　大空ポケット文庫 2006年）●はじまりは大阪にあり！（井上理津子／著　ちくま文庫　2007年）●NOTE & DIARY Style Book vol.2（エイムック　2007年）●東大合格生のノートは必ず美しい（太田あや／著　文藝春秋　2008年）●ペンスピニング ペン回しをはじめよう（日本ペン回し協会／著　集英社2008年）●アジ紙　東欧を旅する雑貨店チャルカの、好きで好きで仕方のない紙のはなし（チャルカ／著　アノニマ・スタジオ　2009年）●筆墨硯紙事典（天来書院／編　天来書院　2009年）●ガムテープで文字を書こう（佐藤修悦／監修　世界文化社　2009年）●紙の知識100（王子製紙／編著　東京書籍2009年）●How to Study in College（Walter Pauk, Ross J. Q. Owens／著　Cengage Learning 2010年）●ケトル VOL.03（太田出版　2011年）●フランス生まれのブロックメモ RHODIA その魅力と活用術（戸田覚／著　ソシム　2011年）●文具の流儀 ロングセラーとなりえた哲学（土橋正／著　東京書籍2011年）●万年筆国産化100年　セーラー万年筆とその仲間たち（桐山勝／著　三五館　2011年）●鉛筆組合「100年の歩み」（全通／制作　日本鉛筆工業協同組合　2012年）●和紙文化研究事典（久米康生／著　法政大学出版局　2012年）●紙の博物館所蔵『日本外史』原稿用紙について（三村泰一／著 ※収録：『日本出版学会 会報139号』日本出版学会　2015年）●「消せるボールペン」30 年の開発物語（滝田誠一郎／著　小学館新書　2015年）●最高に楽しい文房具の歴史雑学（ジェームズ・ウォード／著　関根光宏、岩田千波／訳　エクスナレッジ2015年）●「試し書き」から見えた世界（寺井弘樹／著　ごま書房新社　2015年）●ふでばこ30号（白鳳堂　2015年）●ジョナサン・アイブ　偉大な製品を生み出すアップルの天才デザイナー（リーアンダー・ケイニー／著　関美和／訳 林信行／日本語版序文　日経BP 2015年）●古き良きアンティーク文房具の世界　明治・大正・昭和の文具デザインとその魅力（たいみち／著　誠文堂新光社　2016年）●使える！ ブランド筆記具大図鑑（玄光社MOOK 2016年）●和紙（※収録：『デザインのひきだし 29』グラフィック社　2016年）●PEN BRAND 世界のペンブランド（エイムック　2016年）●紙の世界史 歴史に突き動かされた技術（マーク・カーランスキー／著　川副智子／訳　徳間書店　2016年）●「箇条書き手帳」でうまくいく　はじめてのバレットジャーナル（Marie／著　ディスカヴァー・トゥエンティワン　2017年）●ゼブラ完全ガイドブック（ゼブラ株式会社／監修　実務教育出版　2018年）●日本におけるステープラの開発と製造　1960年代前半までの特許・実用新案を中心に（廣田義人／著　※収録：『大阪経大論集　第68巻第5号』大阪経済大学　2018年）●プラチナ万年筆100年の軌跡（プラチナ万年筆／編　プラチナ万年筆2018年）●サヴィニャック パリにかけたポスターの魔法（DNPアートコミュニケーションズ／制作　練馬区立美術館、宇都宮美術館、三重県立美術館、兵庫県立美術館、広島県立美術館 2018年）●万年筆バイブル（伊藤道風／著　講談社選書メチエ 2019年）●ザ・ペンシル・パーフェクト 文化の象徴"鉛筆"の知られざる物語（キャロライン・ウィーヴァー／著　片桐晶／訳　学研プラス　2019年）

【JIS（日本産業規格）】
JIS S 6005：2019　シャープペンシル用芯／JIS S 6013：2015 シャープペンシル／JIS S 6032：2004　プラスチック製定規／JIS S 6035：1990　ステープラ／JIS S 6036：1992　ステープラ用つづり針／JIS S 6039：2006　油性ボールペン及びレフィル／JIS S 6054：2006　水性ボールペン及びレフィル／JIS S 6061：2010　ゲルインキボールペン及びレフィル

著者

高畑正幸(たかばたけ・まさゆき)

1974年香川県丸亀市生まれ、文房具デザイナー・研究評論家。千葉大学工学部機械工学科卒業、同自然科学研究科(デザイン心理学研究室)博士課程前期修了。小学校の頃から文房具に興味を持ち、文房具についての同人誌を発行。テレビ東京の人気番組「TVチャンピオン」の「全国文房具通選手権」に出場し、1999年、2001年、2005年の3連続で優勝し「文具王」と呼ばれる。文具メーカーサンスター文具にて13年の商品企画・マーケターを経て独立。日本最大の文房具の情報サイト「文具のとびら」の編集長。文房具のデザイン、執筆・講演・各種メディアでの文房具解説のほか、トークイベントやYoutube等で文房具を様々な角度から深く解説する講義スタイルで人気。著書に『究極の文房具カタログ(増補新装版)』『究極の文房具ハック』(以上、河出書房新社)、『文具王・高畑正幸の最強アイテム完全批評』(日経BP社)、『一度は訪れたい文具店&イチ押し文具』(玄光社)などがある。

カバー・本文デザイン

細山田デザイン事務所
(米倉英弘・奥山志乃)

イラスト

小林麻美

編集

DECO(高橋星羽)

校正

佑文社

協力

たいみち

文房具にまつわる言葉を
イラストと豆知識でカリカリと読み解く
文房具語辞典

2020年1月21日　発　行
2020年12月10日　第4刷

NDC590

著　者　高畑正幸

発行者　小川雄一

発行所　株式会社 誠文堂新光社

　　　　〒113-0033 東京都文京区本郷 3-3-11

　　　　[編集] 電話 03-5805-7762

　　　　[販売] 電話 03-5800-5780

　　　　https://www.seibundo-shinkosha.net/

印刷・製本　図書印刷 株式会社